WOMEN
IN THE
ANCIENT
WORLD

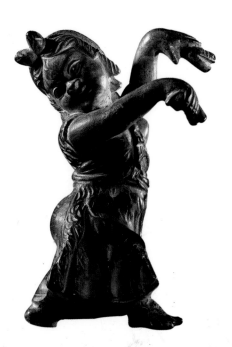

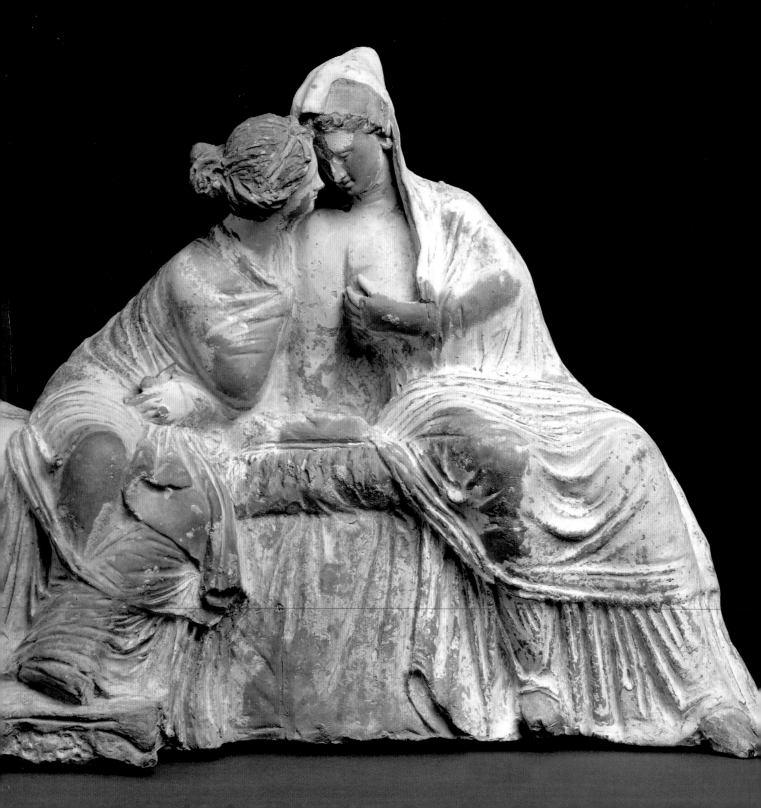

WOMEN
IN THE
ANCIENT
WORLD

JENIFER NEILS

THE BRITISH MUSEUM PRESS

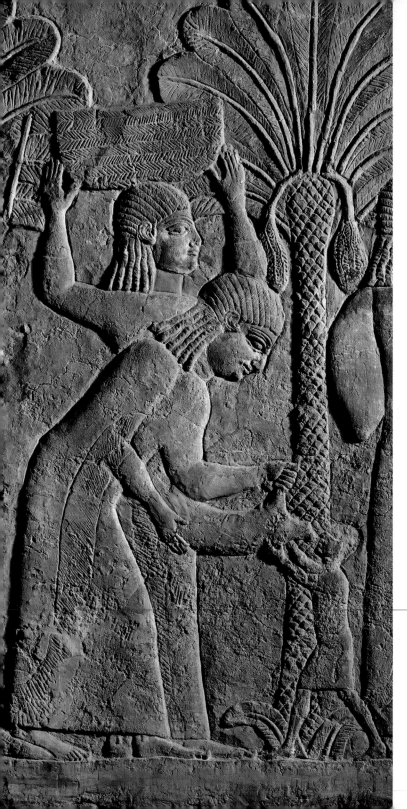

Jenifer Neils has asserted the right to be identified as
the author of this work

First published in 2011 by The British Museum Press
A division of The British Museum Company Ltd
38 Russell Square, London WC1B 3QQ

www.britishmuseum.org

A catalogue record for this book is available from the British Library
ISBN: 978-0-7141-5077-2

The vast majority of objects illustrated in this book are from the
collection of the British Museum. The British Museum object
registration numbers are listed on p. 212. For further reading and
web resources, please see p. 210.

The excerpt on p. 124 is taken from *Homer, Iliad*, transl. Stanley
Lombardo, Hackett Publishing Company, Indianapolis, 1997;
it is reproduced with the kind permission of the publisher.

Designed by Price Watkins
Map by David Hoxley
Printed in China by 1010 Printing International Ltd

The papers used in this book are recyclable products and the
manufacturing processes are expected to conform to the
environmental regulations of the country of origin.

Half-title page: Hellenistic bronze statuette, *c.* 150–100 BC (see p. 108)
Frontispiece: Greek sculpture of two seated women, made at Myrina,
western Turkey, *c.* 100 BC. Terracotta, H. 20.5 cm
Left: Neo-Assyrian gypsum wall relief from Nineveh, *c.* 700 BC (see p. 114)

CONTENTS

TIMELINES 6

MAP 8

I REAL WOMEN: AN INTRODUCTION 10

II FEMALE STEREOTYPES 34

III MOTHERS AND MOURNERS 56

IV WORKING WOMEN 90

V THE BODY BEAUTIFUL 122

VI WOMEN AND RELIGION 158

VII ROYAL WOMEN 186

GLOSSARY 206

GODDESSES 209

FURTHER READING 210

ILLUSTRATION REFERENCES 212

INDEX 214

TIMELINES

All dates are BC unless otherwise stated.

EGYPT

4400–3100	Predynastic Period
3100–2649	Archaic Period (Dynasties 1–2)
2649–2100	Old Kingdom (Dynasties 3–8)
2100–2010	1st Intermediate Period (Dynasties 9–10)
2030–1650	Middle Kingdom (Dynasties 11–13)
1650–1550	2nd Intermediate Period (Dynasties 14–17)
1550–1070	New Kingdom (Dynasties 18–20)
	Hatshepsut, pharaoh
1070–743	3rd Intermediate Period (Dynasties 25–31)
332–30	Ptolemaic Period
	Arsinoe II
	Cleopatra VII
30–AD 476	Roman Period

NEAR EAST

2900–2350	Sumerian Period
	Pu-abi, queen of Ur
2350–2193	Akkadian Period
1900–1595	Old Babylonian Period
1900–1600	Old Assyrian Period
1595–1000	Middle Babylonian Period
1300–1100	Middle Assyrian Period
	Bar-Uli, Elamite princess
1000–539	Neo-Babylonian Period
1000–612	Neo-Assyrian Period
	Ashursharrat, queen of Assyria
612–330	Persian Period

GREECE

7000–3200	Neolithic Period
3200–1000	Bronze Age
1000–700	Iron Age
700–480	Archaic Period
	Artemisia I, commander at Salamis
	Sappho, Greek poet
480–330	Classical Period
	Aspasia, wife of Pericles
	Lysimache, priestess of Athens
	Artemisia II, queen of Halicarnassus
	Kyniska, victor at Olympia
330–30	Hellenistic Period
	Olympias, mother of Alexander the Great
30–AD 529	Roman Period

ROME

753–509	Monarchy
509–27	Republic
	Seianti Hanunia Tlesnasa, Etruscan aristocrat
27–AD 14	Augustan Period
	Livia, wife of Augustus
AD 14–68	Julio-Claudian Period
	Boudica, leader of the Britons
AD 69–96	Flavian Period
	Eumachia, Pompeiian benefactress
AD 98–192	Antonine Period
	Claudia Severa, resident of Vindolanda
AD 193–235	Severan Period
AD 235–476	Late Empire
	Projecta, Roman aristocrat

BLACK

ITALY

Etruria

Chiusi

Vulci

Tarquinia

Cerveteri
Palestrina

Rome

Campania

Cumae

Pompeii

Paestum

Taranto

TYRRHENIAN
SEA

Sicily

GREECE

Actium

Tanagra

Delphi

Thebes

Corinth

Olympia

Peloponnesus

Pylos

Sparta

Samothrace

Thrace

Constantinople

Troy

ANATOLIA
(TURKEY)

Lesbos

Mytilene

Lefkandi

Ephesus

Athens

Eleusis

Cyclades

Cos

Halicarnassus

CYPRUS

Knossos

Crete

MEDITERRANEAN SEA

Cyrene

Alexandria

Lower Egypt

EGYPT

Fayum

Deir el-Bahri

Nile

Karnak

Thebes

Thebes (Luxor)

Upper Egypt

0 500 miles

0 800 km

0 1 mile

0 2 km

𝒩

SEA

CASPIAN SEA

MESOPOTAMIA
(IRAQ)

PERSIA
(IRAN)

ASSYRIA • Nineveh
Nimrud
Ashur •

Tigris

Carchemish •

Aleppo •
Ebla • • Umm el-Marra
Ugarit •
SYRIA

Euphrates

Mari •

PHOENICIA

• Palmyra

LEVANT

Akkad •
Babylon •
Sumer

Girsu •

Elam

• Persepolis

Ur •

THE GULF

ARABIA

RED SEA

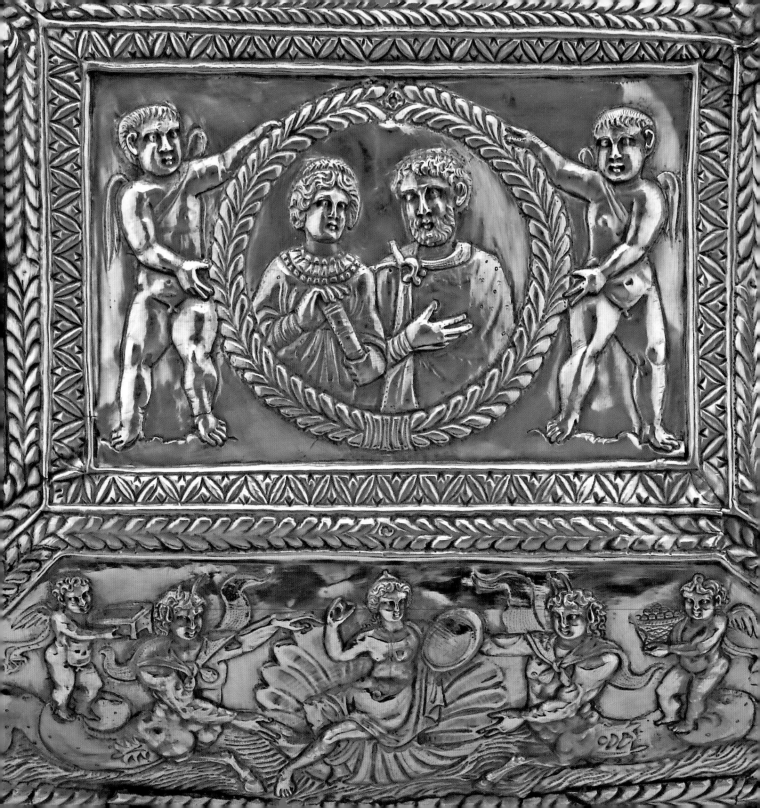

REAL WOMEN:
AN INTRODUCTION

REAL WOMEN: AN INTRODUCTION

I N 1793 well-diggers working at the base of the Esquiline Hill in Rome came upon a hoard of extraordinary silver vessels. The sixty-one objects were produced in the period known as Late Antiquity, that is, around the mid-fourth century AD, at a time when the pagan world was in decline. They represent the personal possessions of a wealthy Roman family, in whose house they were buried for safe keeping. One of these silver objects is a large (nearly sixty centimetres in length) lidded casket with relief scenes on all of its nine sides, as well as an inscription that identifies it as belonging to a woman named Projecta. Because of its extensive female-centred imagery, not the norm for works of art in antiquity, it

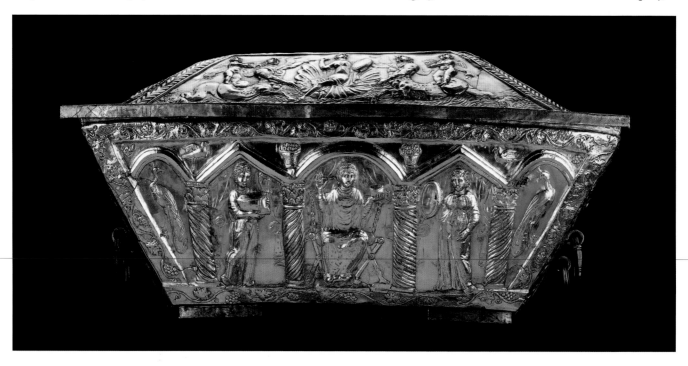

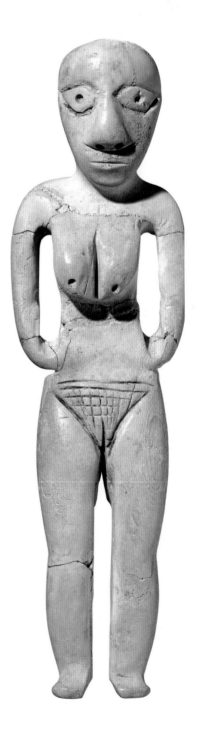

Egyptian figurine, from Badari, *c.* 4400–4000 BC. Hippopotamus ivory, H. 14 cm. One of the oldest human-shaped statuettes from Egypt, this remarkable figure has been carefully worked to emphasize the eyes, breasts and genitalia. It was found in a grave but its function remains uncertain.

is worthwhile examining this exquisite object in some detail. Like many valuable artefacts from the ancient world, it can lead to a better understanding of the roles of women in elite society and the various modes of fashioning their own image.

On the top and front of the box are three repoussé (hammered relief) scenes involving women. Projecta can be identified in the female portrait bust that appears on the casket's lid (see the previous page). Within a wreath supported by two *erotes*, winged gods of love, she is here juxtaposed with an older, bearded man, who is surely her husband. Their union is indicated by the scroll clutched in her hands, presumably their marriage document. Projecta appears again on the front of the box seated on an elaborate chair, poised with a hairpin in her right hand and a round cosmetic box (*pyxis*) in her left. She is flanked by two female attendants, one of whom holds a large mirror and the other a rectangular box. Directly above Projecta on the sloping side of the lid, floating in her cockleshell, is the nude goddess of love, Venus, who also primps while she stares into a large mirror. Here on a single ancient object we find three archetypes of the most characteristic imagery of women in antiquity: the wife, the mistress of the household and the sex goddess.

The aim of this book is to reveal how the imagery of women in the ancient world contributes to our understanding of their lives and roles in society. Not surprisingly it is the elite in all periods and in most cultures of antiquity who were wealthy enough to commission images. Consequently much of the art and most of the utilitarian objects under consideration here come from the upper strata of the population. The poor and the enslaved leave little trace of their existence since they did not usually possess durable personal goods or rate elaborate burials.

Of the three most common types of women depicted in objects from the ancient world, the oldest is the sex goddess, represented by a nude female. The image dates back to the Palaeolithic (Old Stone Age, *c.* 25,000 BC) and continued

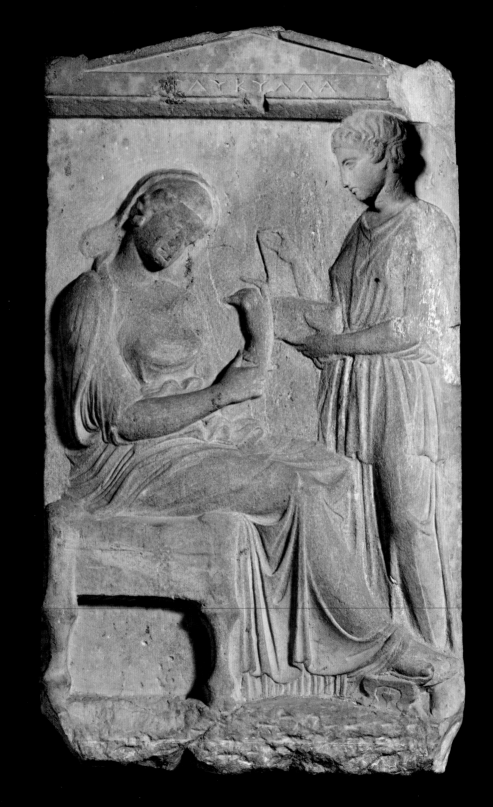

Greek grave stela of Glykylla, *c.* 400 BC. Marble,
H. 97 cm. The deceased woman is shown holding
out her veil with her left hand in a gesture
traditionally associated with marriage. Her maid
servant, at right, is holding her jewellery box.

to appear in an infinite variety of guises throughout antiquity and across much
of Europe and the Middle East. While the Late Roman version is modestly half-
draped, most early examples, such as the bone figurines from Predynastic Egypt
(4400–3100 BC), are completely nude and accentuate the breasts and pudenda,
leading to their identification as fertility idols. Nearly all ancient cultures produced
such functional objects in the form of a well-endowed, often obese female nude;
they could be used as charms to ensure human, animal or agricultural fecundity,
or placed in burials as magical devices to promote rebirth or regeneration in a
blessed afterlife, or worshipped as idols of female fertility and maternity. In Greek
and Roman times the female nude became scarcer and more closely related to
human sexuality, as in erotic sculptures of the goddess Aphrodite/Venus. The
ancient Greek term for sex was *ta aphrodisia*, literally 'the things of Aphrodite'.

The image of the seated, draped female with attendants, on the other
hand, clearly alludes to the domestic sphere, whether a palace or a simple dwell-
ing. The same composition can be found, for instance, on hundreds of Greek
grave stelae of the High Classical period (*c.* 450–300 BC). This so-called 'mistress
and maid' motif neatly encodes the elite status of a deceased woman. Typically,
she is offered a jewellery box by her servant and is swathed in expensive textiles,
as is Projecta. Noteworthy in these depictions is the greater stature of the mistress
in relation to her attendants. And just as Projecta is named on her casket, so is the
deceased on her grave stela. Although it was not considered proper for women
in Classical Athens to be spoken of in public, for good or evil, in death they were
commemorated with their names prominently inscribed. Whatever the circum-
stances of a woman's earthly life, she was portrayed in an idealized manner for all
eternity, as we shall discuss more fully in Chapter 5.

Finally, there is the wife, who acquires her identity by association
with a man. In full-length classical Roman portraits this role is symbolized
by the *dextrarum iunctio* or joined right hands, as on numerous cinerary urns
and sarcophagi which feature husband and wife. On one such urn, that of the

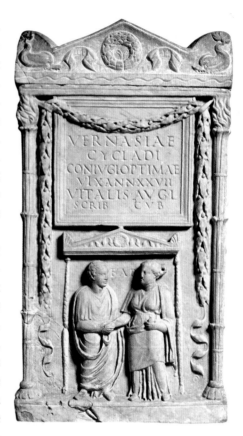

Roman cinerary urn of Vernasia Cyclas, 1st
century AD. Marble, H. 50.5 cm. This ash urn
contained the cremated remains of a young wife
who is lavishly praised by her husband Vitalis,
who worked in the imperial household.

twenty-seven-year-old Vernasia Cyclas, the wife is praised as *optima* (excellent), and the abbreviation 'FAP' may stand for the superlatives *fidelissimae* (most faithful), *amantissimae* (most loving) and *pientissimae* (most devoted). Often the husband clutches the document that seals their union, a marriage that would have been arranged without the consent of the female, who was usually a teenager. Incised into clay cuneiform tablets from the ancient Near East or penned on papyri from Roman Egypt, extant marriage contracts read more like prenuptial agreements since they are primarily concerned with property and the return of the bride's dowry in the case of the dissolution of the marriage.

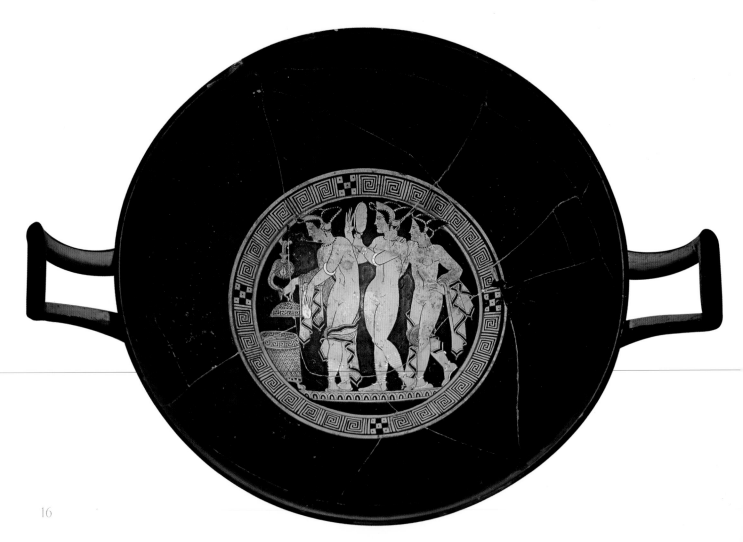

Etruscan cup with three women, *c.* 350–300 BC. Earthenware, diam. 26.6 cm. Used for drinking wine in antiquity, this cup offers a voyeuristic view of three lovely nudes in the act of beautifying themselves.

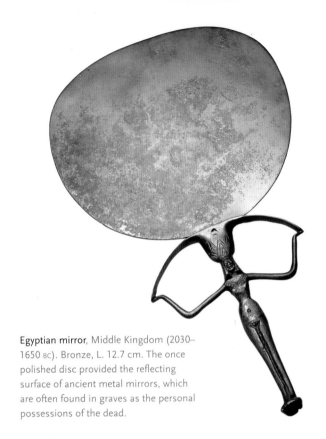

Egyptian mirror, Middle Kingdom (2030–1650 BC). Bronze, L. 12.7 cm. The once polished disc provided the reflecting surface of ancient metal mirrors, which are often found in graves as the personal possessions of the dead.

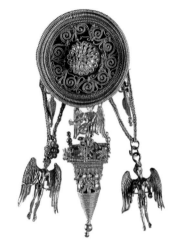

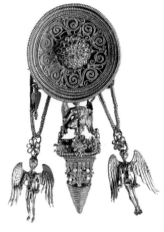

ABOVE: **Greek earrings decorated with *erotes***, *c.* 330–300 BC. Gold, L. 6 cm. The twin figures of Eros on this pair of exquisite earrings may represent two Greek versions of love: Himeros (desire) and Pothos (longing).

LEFT: **Roman pin**, *c.* AD 380. Silver, L. 8.3 cm. The top of this small pin, also part of the Esquiline Treasure, features Venus admiring herself in a mirror.

The beautification activities of Projecta and her divine counterpart Venus are echoed by women throughout antiquity. Although by no means exclusive to women, the adornment of the body with elaborate jewellery, clothing, perfumes, make-up and coiffures or wigs was largely a female preoccupation from at least the time of Homer. In the *Iliad* the poet details at length how the goddess Hera carefully anointed and dressed herself in order to seduce her husband Zeus (see p. 124). Hera's elaborate toilette is the female counterpart of Homer's more common male arming scenarios, but whereas the men prepare for war, Hera prepares for seduction. Both male arming and female dressing scenes are common on Athenian vases, but the latter must have been calculated to appeal to the male gaze, especially if they featured female nudes, which are unusual in Greece but fairly common in the arts of Etruscan Italy.

Many of the attributes and subsidiary figures on Projecta's casket also have distinctly female associations. Mirrors, for example, are frequently found

in women's graves or in the hands of women and goddesses in classical art (note, for example, the one on the Etruscan cup, p. 16). Egyptian bronze hand mirrors often feature a scantily clad young girl as the handle, while on some Greek mirrors a demurely robed female supports the disc; both reference the predominantly female association of mirrors. Stick pins are another common possession of women, the heads of which often carried figural decoration of a feminine type. Domesticated birds such as the peacocks at the ends of Projecta's casket were part of the ancient household and so by extension were affiliated with women. Winged figures of Eros are ubiquitous; they wait upon the bride on Athenian wedding vases and dangle from the ears of wealthy women in the form of Hellenistic gold earrings. As the offspring of the goddess of love they lend a romantic idealism to objects used by mortals.

Clearly the varied imagery on Projecta's casket does not represent real life in the mid-fourth century. Rather, it offers an archetype, which suggests the goals and aspirations of any reputable Roman matron. Projecta, as Everywoman, is portrayed as loyal wife and well-off *matrona*, and is alluded to via Venus as an object of male desire. She has the leisure to attend to her toilette, and the wealth to employ domestic servants. Her appearance is idealized, as is almost always the case for females in ancient art, but her features differ enough from the more anonymous serving women to suggest an attempt at portraiture. Although hardly a snapshot of ancient life, this lavish casket has much to tell about the dreams and desires of upper-class Roman women in antiquity.

It is a commonplace in books about women in antiquity to bemoan the lack of evidence for their 'real' lives. Nearly all ancient texts mentioning women, such as the marriage documents or the epic poems of Homer, were composed by men, and women are rarely, if ever, quoted. The artistic representations that seem to document their lives, such as the casket of Projecta, were almost certainly made by male craftsmen, and possibly commissioned by male relatives. Their relevance to the actual lives of women may be questioned because they represent an idealized and elitist view of life in ancient societies. How then is it possible to know anything about the realities of women's existence in ancient times? Since most of the artefacts come from higher status contexts, how do we know how the other half of the other half – the poor and female slaves – lived?

FOLLOWING PAGES:
RIGHT: **Etruscan sarcophagus**, from Chiusi, *c.* 150–140 BC. Painted terracotta, L. 183 cm. This aristocratic Etruscan woman, Seianti Hanunia Tlesnasa, is portrayed in the exact same manner as a nobleman, lounging on a well-padded couch and bedecked in jewels.
LEFT: **Modern forensic reconstruction** of the head and face of Seianti Hanunia Tlesnasa.

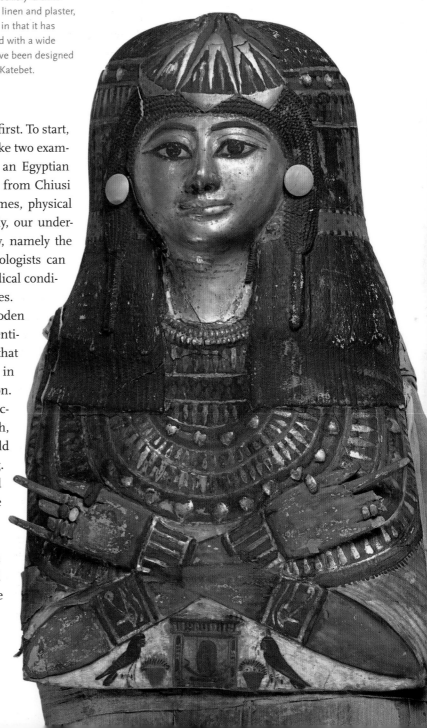

Egyptian mummy mask, from Thebes, probably Graeco-Roman period (332 BC–476 AD). Moulded linen and plaster, H. 58 cm. This mummy mask is unusual in that it has added wooden arms and is richly adorned with a wide selection of jewellery. It may originally have been designed for a man and then was reconfigured for Katebet.

The situation is not as dire as it may seem at first. To start, we have the physical remains of deceased women. Take two examples from the opposite ends of the Mediterranean: an Egyptian mummy from Thebes and an Etruscan sarcophagus from Chiusi in central Italy. In both instances we know the names, physical condition and status of these women. More recently, our understanding has been enhanced by modern technology, namely the CAT scan and forensic science. As a result archaeologists can interpolate a great deal about their lifestyle, diet, medical condition and physiognomy, if not their thoughts and values.

The Egyptian mummy was found in a wooden coffin bearing the name Katebet, a female who is identified as a 'Chantress of Amun'. This title indicates that she performed music during temple rituals held in honour of the king of the gods, a high-status position. As a result of the mummification process her desiccated body, wrapped in multiple layers of linen cloth, is well preserved. CAT scans reveal that she was an old woman when she died, with only two teeth remaining. Her spinal column shows evidence of arthritis and scoliosis, and her brain was surprisingly left inside her skull, not the norm in Egyptian mummification. She wore finger rings on her hands, which were crossed over her pelvis, and on her stomach was a small scarab beetle, a magic amulet that was intended to protect her when she was judged by the gods in the afterlife.

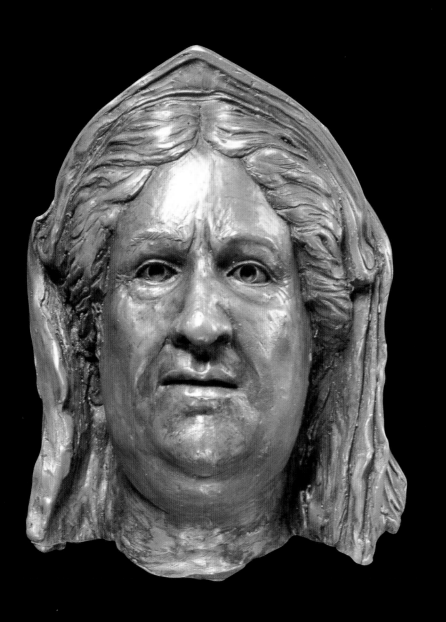

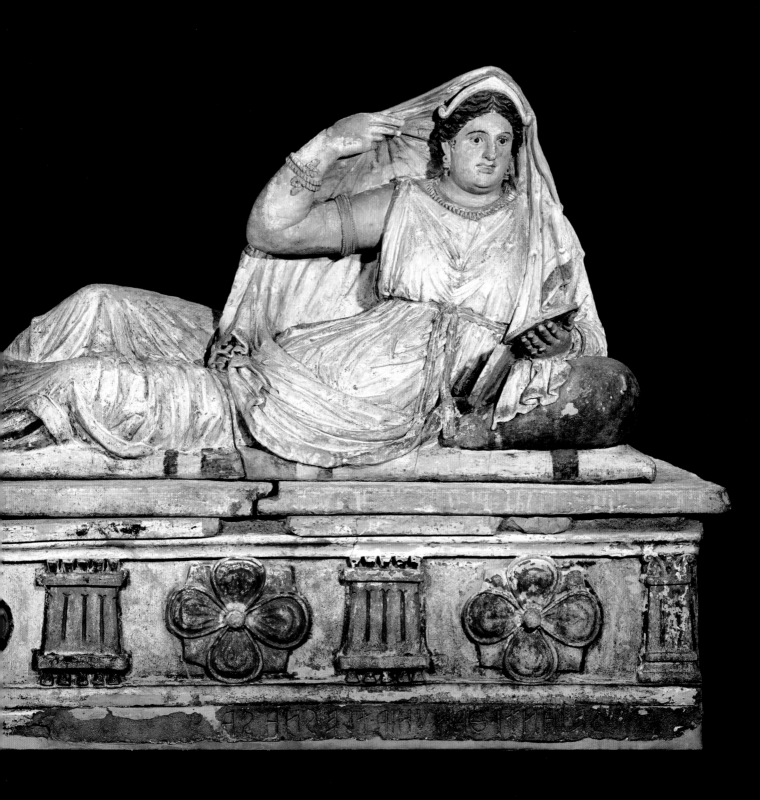

The Etruscan sarcophagus is inscribed with the name of a noblewoman, Seianti Hanunia Tlesnasa. Unlike her Egyptian counterpart, who is portrayed with her arms crossed in the stiffened pose of Osiris, the god of death, Seianti lounges on a pillow and gazes at her reflection in a round mirror. But like Katebet, she is elaborately dressed and bejewelled, albeit in painted plaster. Her gesture of holding open her veil is one typical of wives, who reveal themselves in this mannered way to their husbands. Because she was buried rather than mummified, all that remains of Seianti is her nearly intact skeleton, but it is enough to tell us that she was between fifty and fifty-five years old when she died and to allow for a forensic reconstruction of her head and face. Comparing the reconstructed face with the portrait on her coffin shows the extent to which the artist has 'improved' her features. He has given her a shorter chin and more deeply set eyes, thus making her appear younger, but the overall proportions are accurate. Scientific examination of the skeleton shows that she had severe arthritis in her right hip and jaw, possibly the result of a serious riding accident when younger.

Thus with the help of modern scientific methods, we can glean valuable information about women who lived thousands of years ago. Both Katebet and Seianti were wealthy women who were buried in state, one with a gilded face mask and the other with a made-to-order sarcophagus. In spite of their medical problems, they enjoyed long lives for their time, and were buried beside their husbands in death. Both no doubt entertained the notion of a blessed afterlife. While not constituting a complete biography of these women, these facts none-theless help us to assess the otherwise undocumented lives of women in antiquity and to penetrate the facade presented by their funerary masks.

Before examining specific aspects of the lives of ancient women, a general overview of the various cultures considered in this book may prove useful. The Neolithic period until Late Antiquity and pre-literate Mesopotamia to Roman Britain are vast in terms of time and space, and so the focus here will primarily be on the Near East, Egypt, Greece and Rome, cultures which provide the most extensive evidence for the lives of ancient women.

PREHISTORY

In the era of prehistory that extends from the Stone Age to the beginning of the Bronze Age (c. 25,000–3000 BC) all our information about women comes from

archaeological sources. Skeletal studies place the average Neolithic lifespan, excluding the many who must have died in childbirth, at around thirty years for females. In this early period group survival depended in large part on reproduction and so the majority of nubile women spent most of their adulthood being pregnant and nursing infants up to three years. Women would naturally choose activities compatible with childbearing and survival, and so were gatherers rather than hunters, producers rather than warriors. Because of their developed knowledge of ecology, plant life and its potential as food, medicine and clothing, they were at this stage of civilization no doubt the equals or even superiors of their male partners. The development of agriculture and animal husbandry around 8000 BC resulted in more highly structured societies and the concept of private property, at which point women became a medium of exchange. While the status of women in earlier society is still unknown, in later times women moved to the homes of their new husbands and most societies were patriarchal.

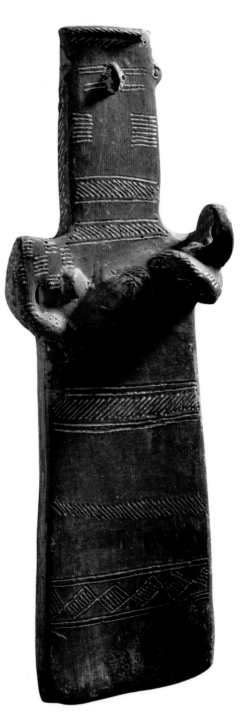

Engraved gouge, from Montastruc, Late Magdalenian, *c.* 11,000 BC. Antler, L. 12.8 cm. This Stone Age tool is engraved with a frontal figure of a woman composed of overlapping lozenges. An inverted triangle accentuates her pudenda.

Cypriot 'plank figurine', *c.* 2100–1900 BC. Red-polished terracotta, H. 29 cm. This plank-like woman is holding a child nestled in a cradle in her left arm. Her surviving ear is pierced for the attachment of a metal earring, now lost.

Elamite bead, from Iran, 12th century BC. Chalcedony, L. 4 cm. This pierced stone pendant bears an inscription declaring that it was a gift from the king to his daughter, the princess Bar-Uli. The accompanying scene, which shows him bestowing the gift on a little girl, is touchingly personal and extremely rare in ancient art.

The earliest extant representations of women in ancient art are clearly sexual in nature and are often, perhaps erroneously, referred to as fertility goddesses. From prehistoric contexts, both funerary and domestic, in the Mediterranean come hundreds of figurines of clay, bone or stone representing nude females in a range of postures. In the Cyclades in the Early Bronze Age (*c.* 3000–2000 BC) these were made of fine marble and the trim bodies attain a high degree of abstraction, as do the Cypriot 'plank figurines' of the Middle Bronze Age. In the case of Minoan Crete, where women are represented clothed but with open bodices revealing their breasts, as in the so-called Snake Goddesses from Knossos, it is unclear whether the artists were representing goddesses, priestesses or simply worshippers.

NEAR EAST

Eventually the Neolithic villages with economies based on agriculture and livestock became urban centres characterized by distinct property classes, specialized labour, slavery, trade and often kingship. Civilization, as we call it, began to emerge at the beginning of the third millennium BC with the invention of writing

in two fertile river valleys, the Tigris–Euphrates of ancient Mesopotamia (modern-day Iraq) and the Nile of Egypt. Geographical designations of Mesopotamia, which means 'the land between the two rivers' in Greek, change over time. In the third millennium BC it comprises Sumer in the south and Akkad in the north. In the second and first millennia BC Babylonia occupied the south and Assyria the north. Eventually the vast Assyrian empire extended as far as the south-eastern part of Anatolia (modern Turkey) and traded with the Hittites, who controlled central Anatolia in the second millennium BC. In the seventh century BC, Persia (now Iran) emerged as a major imperial power and conquered the entire Middle and Near East, including the Greek city-states on the west Anatolian coast.

Sumerian bureaucrats have left us with over 100,000 cuneiform tablets, but because they deal with male spheres of influence (palaces and temples), women are not highly visible. Legal documents from the Early Dynastic Period (2900–2300 BC), however, indicate that women could buy and sell houses, act as guarantors for other persons, and become involved in court cases. Babylonia and Assyria shared a common culture and language, Akkadian; they too used clay tablets to record everything from the epic of Gilgamesh to the sale of slaves. At this time female subordination became the norm and was codified in some of the first laws. Of the 282 laws in the Code of Hammurabi (dated 1750 BC but based on a body of law in practice for hundreds of years), seventy-three deal with regulations concerning marriage and sexual conduct. So, for instance, it exacts the death penalty for women who commit adultery. Women are treated differently depending on their class; upper-class women had marriage contracts with certain rights while lower-class women were, for all intents and purposes,

FOLLOWING PAGES:
Neo-Assyrian wall relief, from Nimrud, 728 BC. Gypsum, H. 99 cm. Women are rare in Assyrian art, and most are portrayed as prisoners of war or as deportees. Here a veiled woman with her two children is driven off in a bullock-cart from a city in Babylonia captured by the Assyrian ruler Tiglath-Pileser III.

Assyrian tablet, from Nineveh, c. 625–617 BC. Clay, H. 7.4 cm. The inscribed tablet records the sale of the daughter of Nabu-rehtu-usur to a woman as a bride for her son for eighteen shekels of silver. The contract had fourteen witnesses and was signed with the seals of the father and his two sons.

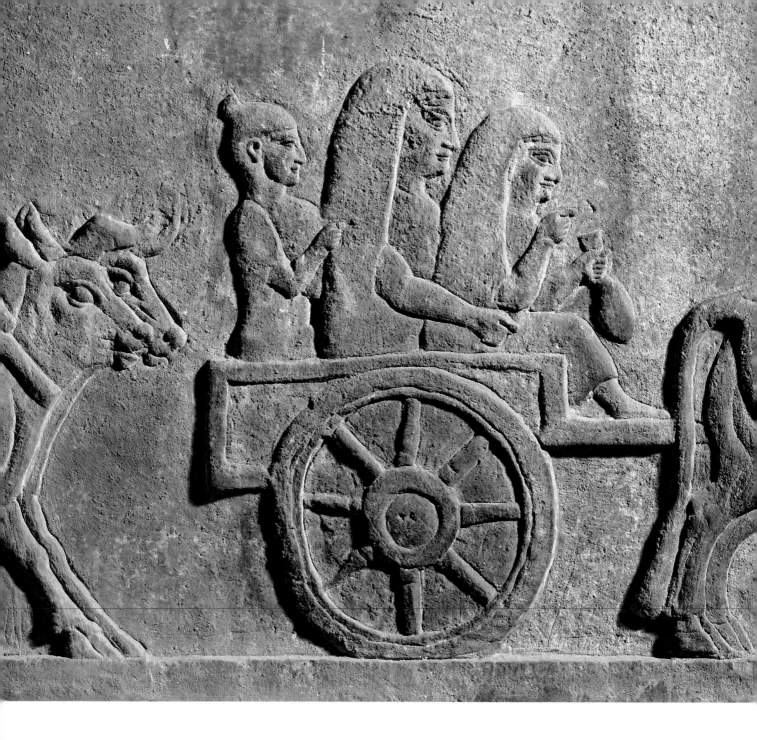

WOMEN IN THE ANCIENT WORLD

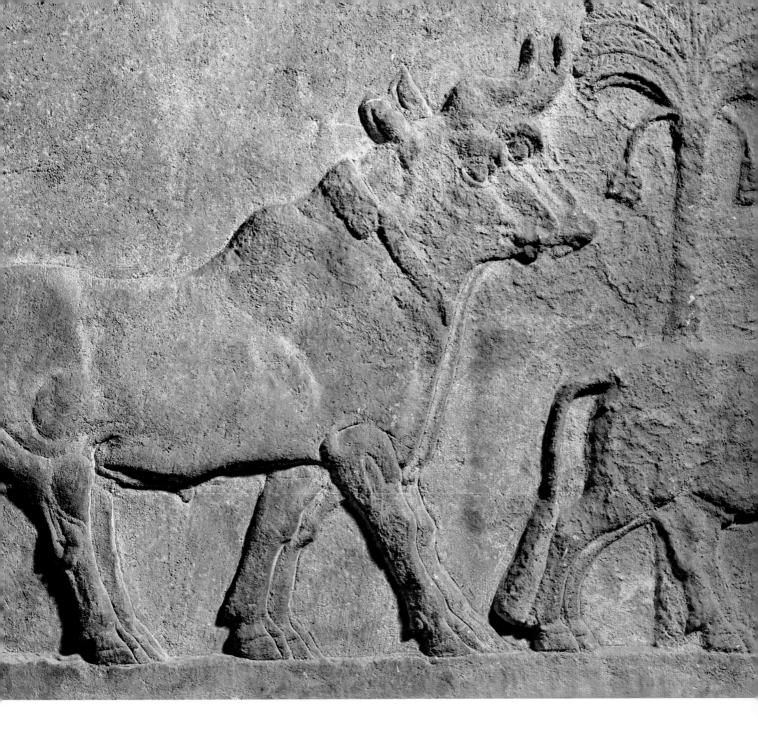

domestic slaves. An Assyrian trading colony in central Turkey, which was burned to the ground around 1750 BC, fortunately preserves baked clay tablets, some of which were letters that the merchants' wives wrote to them from Ashur, the capital of Assyria, some six hundred miles away. The texts indicate that women were free to bargain in the marketplace, buy wool, hire women to weave it, and negotiate with donkey drivers to transport textiles abroad. Later, life for Assyrian women became much more oppressive and they were confined to harems.

EGYPT

Contemporary with the development of Mesopotamia was the rise of Egypt into a powerful and long-lasting realm headed by rulers who were considered divine kings. The first of these combined northern and southern Egypt into one land around 3000 BC, while the last, Cleopatra VII, was forced to cede her kingdom to Rome in 31 BC. The Old (Dynasties 3–8), Middle (Dynasties 11–13) and New (Dynasties 18–20) Kingdoms into which Egyptian history is divided were relatively stable, conservative and highly religious. Hieroglyphic texts are found in tombs and on temples, and in later times on papyri, and record many important aspects of Egyptian culture, including the rights of women, which were fairly liberal compared to their Graeco-Roman counterparts. They could own, manage and bequeath their own property without male intervention, and they could institute legal proceedings.

The Egyptian interest in the afterlife means that much of the visual evidence comes from tombs, mummies and funerary objects. Daily life is less well documented because houses and household equipment were not made to last for centuries. Often the burials of Egyptian queens were more lavish than those of the

WOMEN IN THE ANCIENT WORLD

pharaohs and attest to the importance of women in the royal household. Female pharaohs, although rare, are not unheard of, and for the first time in ancient art girls are regularly depicted.

GREECE

The Greek historian Herodotus, writing of the ancient Egyptians (*The Histories*, 2.35), stated: 'In their manners and customs the Egyptians seem to have reversed the ordinary practices of mankind. For instance, women go to the market and engage in trade, while men stay home and do the weaving.' This passage reveals more about the Greeks' expectations for proper female behaviour than it does about ancient Egypt. From Hesiod to Plutarch, Greek authors writing about women tend to be misogynistic; even someone as enlightened as Aristotle claimed that women were 'mutilated' males. Women were characterized as weak, unable to control their emotions, lacking a soul, and destined to be ruled rather than to rule. As a result they were legally defined as minors and denied any participation in civic life, although they held important religious offices.

Images of women in Greek art are less prevalent than those of men and more limited in their typology, reflecting their more confined and restricted lives. They are most commonly depicted in a religious context where they may have exerted some authority as priestesses. The Archaic period (700–480 BC) sees a virtual explosion of sculpted images of females, who stand atop graves or are mounted on inscribed bases in sanctuaries, usually of goddesses such as Athena, Hera and Artemis. The most common location for images of women in the Classical period (480–330 BC) is the marble grave stela (see p. 14) and the marble votive relief. In the Hellenistic period (330–30 BC) portraits of elite and royal women appear on coins and gems and in sculpture, and, although recognizable, their likenesses are always idealized to some degree. A broader range of female types is depicted in the less elite arts of vase painting and small-scale terracotta figurines; imagery ranges from the nude *hetaira* (courtesan) at the *symposium* to slaves fetching water at the fountain house, and from the matron mourning the dead to a young girl doing her homework. One of the more extraordinary portrayals of women in Greek art is on the east frieze of the Parthenon, where thirty-two women congregate at the head of the Panathenaic procession in honour of Athena, including a priestess and two young female assistants.

OPPOSITE: **Hellenistic figurine**, from Cyprus, *c.* 300 BC. Terracotta, H. 13 cm. Although in earlier periods there is no evidence that women were taught to read and write, in the Hellenistic period, girls were given a modest education. This girl is studiously engaged with the wax writing tablet on her lap.

ETRURIA

Because we lack any Etruscan literature, there are no texts to offer insights on the pre-Roman women of Italy. Therefore we rely heavily on art, artefacts and burials for an understanding of their roles in Etruscan society. Women are depicted early and often in the art of Etruria, where it seems that they had near equality with men. In the seventh century BC they appear on canopic jars or cinerary urns, and in the next century they are shown reclining as life-size effigies on terracotta sarcophagi, often accompanied by their husbands, a theme that recurs in stone in later centuries. Women are also portrayed in the tomb paintings of southern Etruria, dancing with young men or banqueting with their husbands, and their bronze mirrors are engraved with scenes of women at their toilette. Etruscan mothers are often portrayed naturalistically, nursing their infants, in contrast with Greek or Roman art where this type of portrayal is shunned. Some Etruscan tombs of women include the remains of two-wheeled carts, which provide some idea of their status and mobility in contrast with other ancient women.

ROME

The most common role of women in Roman life and art is that of wife; their identities are often inseparable from those of their husbands and families. A Roman woman was almost always the responsibility of a male relative who represented her in public life and administered her property, which she could inherit under Roman law. From the Republican tombstones of the first century BC to the marble sarcophagi of the third century AD, women are routinely portrayed alongside their husbands. The images are fairly formulaic, with the joined hands (*dextrarum iunctio*) indicating the relationship, or the couple shown together, like their Etruscan predecessors, reclining on the lids of sarcophagi. This imagery continues into early Christian art. Portrait statues of elegantly dressed women with a subdued demeanour were erected by Roman fathers and husbands to honour them in their exemplary roles as mothers, wives and priestesses. In the imperial age portraits of the wives of the emperors are common, beginning with

BELOW: Etruscan *cista* (casket) handle, from Palestrina, *c.* 325–250 BC. Bronze, W. 14.5 cm. The Etruscans used human figures, like this acrobatic young girl, as handles for metal cosmetic boxes.

Augustus's wife Livia; they appear in a variety of media: coins, portrait busts, life-size statues and cameos.

Before proceeding to examine the evidence for ancient women in their fundamental roles as wives, mothers, mourners, priestesses, wool-workers, musicians, dancers, slaves, courtesans and queens, we will look first at some of the stereotypes of females that have persisted throughout the ancient world from the beginnings of advanced civilization in the ancient Near and Middle East to the end of antiquity. These shed some light on the perceptions and misconceptions that have prevailed about women for the last few thousand years.

Romano-British writing tablet, from Vindolanda, Northumberland, AD 97–103. Wood, L. 22.3 cm. One of the earliest known examples of writing in Latin by a woman, this tablet preserves a birthday party invitation that partially reads: 'Claudia Severa to her Lepidina greetings. On 11 September, sister, for the day of the celebration of my birthday, I give you a warm invitation to make sure that you come to us, to make the day more enjoyable for me by your arrival.'

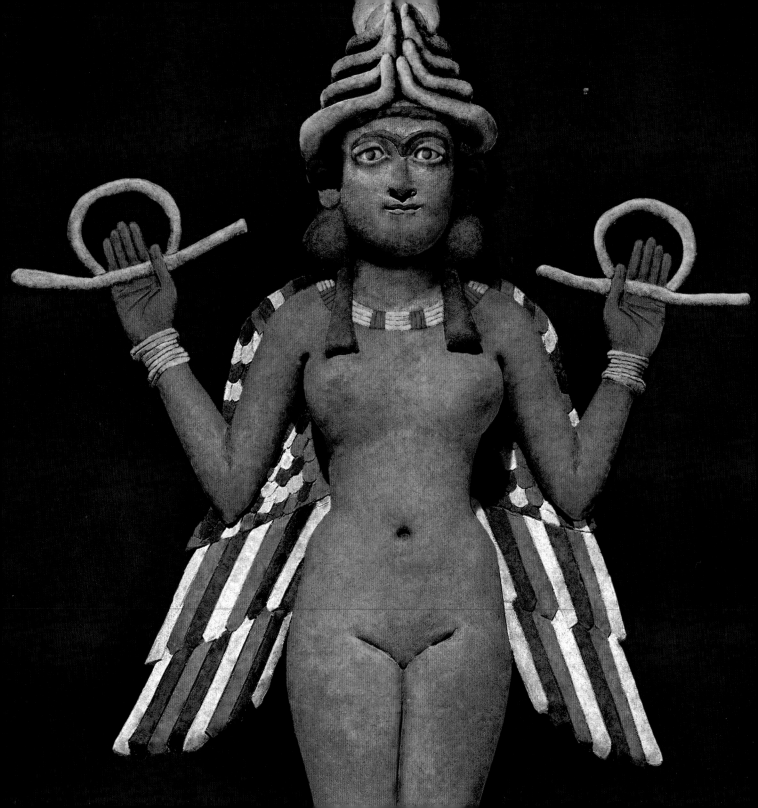

FEMALE STEREOTYPES

FEMALE STEREOTYPES

ABOVE: The 'Queen of the Night', Old Babylonian plaque, c. 1750 BC. Clay, H. 49.5 cm. A frontal nude female with wings and talons is standing on two lions and is flanked by a pair of barn owls.
PREVIOUS PAGE (DETAIL): Modern painted reconstruction of the 'Queen of the Night'.

OPPOSITE: Athenian *stamnos* (storage jar) with a scene of Odysseus and the Sirens, c. 470 BC. Red-figure pottery, H. 35.2 cm. In Homer's *Odyssey* Sirens were human-headed birds who lured sailors to their deaths with their enchanting song.

A FAMOUS and unique Near Eastern relief of unknown origin has been dubbed the 'Queen of the Night'. At first glance the curvaceous female depicted on it resembles a typical ancient monster, half human, half bird. Her association with wild animals (lions) and birds (owls) lends her a sinister appearance, and her frontal nudity is striking, to say the least. She resembles a harpy or siren, some female monster whose purpose is to entrap men. Who is she? At first she was identified, not surprisingly, as a demoness, namely the Near Eastern Lilitu. Associated with owls, Lilitu made it difficult for women to give birth. Her biblical equivalent is Lilith, Adam's first wife, who attacked men, causing impotence. However, the horned headdress and the rod and ring in each hand are attributes of divinities in Near Eastern art, and so she should be a goddess, even though they are not usually shown nude. Some experts identify her as Ishtar, the goddess of love and war, one of whose attributes is the lion. Alternatively she could be Ishtar's underworld sister, because of the owls and the black painted background, which connote night and death. Although hundreds of gods, goddesses and demons are known from ancient Mesopotamia, we still cannot pin a name to this impressive figure. Whoever she is, like many female figures from ancient mythologies, she wields power over men and controls their fate in some way.

Just as today, so in the ancient world one can find countless female stereotypes that reveal more about the hopes and fears of men than about women themselves. Many of these female types are described in religious or mythological texts, and their narratives are often the subject of works of art. In the Sumerian epic *Gilgamesh*, composed around 2200 BC, a prostitute plays a key role, seducing the strong-man Enkidu to leave his idyllic life in the wild for civilization. She is instructed: 'Now use your love-arts. Strip off your robe and lie here naked, with your legs apart. Stir up his lust when he approaches, touch him, excite him,

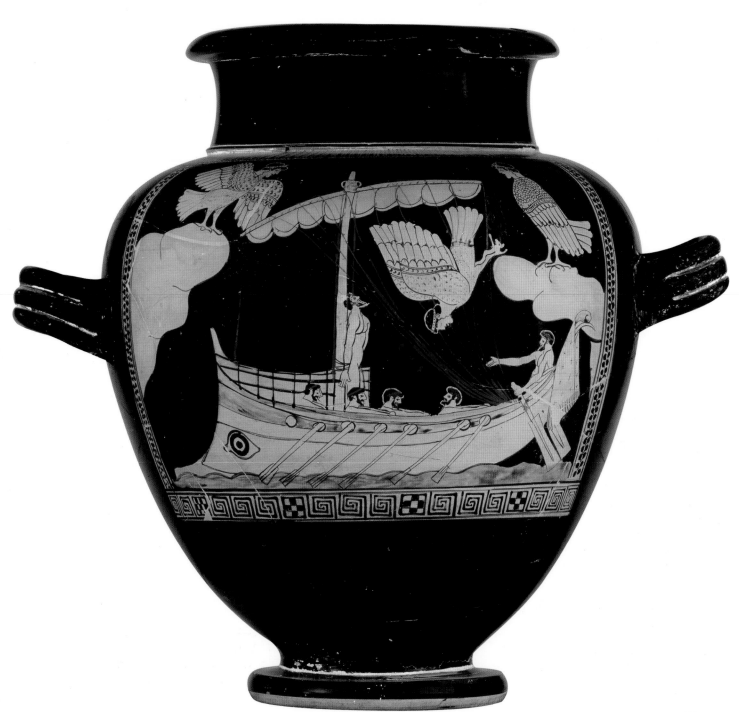

37

Boeotian cup with a scene of Odysseus and Circe, from Thebes, *c.* 450–420 BC. Black-figure pottery, H. 19 cm. Her name inscribed above her head, the witch Circe is here offering the hero Odysseus some of her magic potion which transforms men into swine. The loom at the right is both a symbol of female virtue, as in the case of Penelope, and of feminine wiles.

OPPOSITE: Athenian *krater* (wine bowl) with a scene of the birth of Pandora, from Altamura, *c.* 460–450 BC. Red-figure pottery, H. 49 cm. The upper zone of this painted vase shows the Greeks' version of the creation of the first woman, Pandora. Flanked by various gods she stands frontally in the centre like a statue, a young girl giving no hint of an evil nature.

take his breath with your kisses, show him what a woman is' (transl. Stephen Mitchell). Homer's *Odyssey*, composed one and a half millennia later, is filled with a variety of female creatures who represent a range of male fantasies. There are those ideal types who are helpful to the hero, such as his faithful wife Penelope, his loyal nurse Eurycleia, or the virgin girl Nausicaa, who rescues him after his last shipwreck. Then there are the femmes fatales who hinder or delay his journey home: the enchanting Sirens who lure sailors with song to their deaths, the magician Circe who changes men into swine, the seductress Calypso, and the hybrid Scylla whose canine body-parts literally devour those who chance to sail past. And most omnipresent is the martial goddess Athena, armed with *metis* (wisdom), who aids the hero at every turn. Homer's extensive panorama of womanhood is unequalled in ancient literature.

Common to many cultures is the concept of a 'first' woman, who introduces some sort of evil into a previously all-male paradise. In the Hebrew Bible it is Eve who eats the forbidden fruit and offers some to Adam, thereby committing the first sin and bringing about their expulsion from the Garden of Eden. In Greek mythology, first recorded by the poet Hesiod, it is Pandora who disobeys by opening a jar (*pithos* in Greek, but mis-transcribed as *pyxis* or box) and thereby fills the world with assorted evils. These first women were both created by a supreme male deity from strange raw materials: Yahweh used a rib extracted from Adam, while Zeus had his creation made of clay. Hesiod calls Pandora 'a beautiful evil', and this characterization (or character assassination) typifies many accounts of notorious ancient women: Jezebel, Medea, Cleopatra and Messalina, to name a few.

Many of these evil, stereotypical women exhibit voracious sexual appetites which sap men of their strength and even their lives. Beautiful and alluring as Ishtar was, the Mesopotamian hero Gilgamesh refused to wed the goddess, citing her nasty transformations of her cast-off lovers into birds and wild animals, not unlike Homer's Circe. Her Phoenician equivalent is the goddess Astarte, while the Graeco-Roman version is Aphrodite/Venus. Typically, these sex goddesses are represented nude or partially draped, as on Projecta's casket (see Chapter 1). The Greeks believed that women had little control over their sexual desires and so, if not sequestered in the home, they might wander off, as Helen did when the Trojan prince Paris came to visit. The lower-class counterpart was the butt of Aristophanic comedy, the old hag, who is portrayed as a nymphomaniac, and references to lustful women using dildos to satisfy their urges are abundant in Greek comedy, although somewhat rare in Athenian vase painting.

Late Roman intaglio showing Eve tempting Adam, 4th century AD. Nicolo, L. 1.5 cm. This is the only surviving Roman gem to depict Adam and Eve. They are flanking the tree of life, which is entwined with the serpent. Both are scantily clad, but Eve has long hair and raises her hand to the snake.

Athenian cup, from Vulci, c. 520–500 BC. Red-figure pottery, diam. 30.5 cm. A caricatured nude woman is about to penetrate her body with two dildos. She may be a performer in the act of entertaining men but she also typifies the male Greek attitude towards women as sexually insatiable.

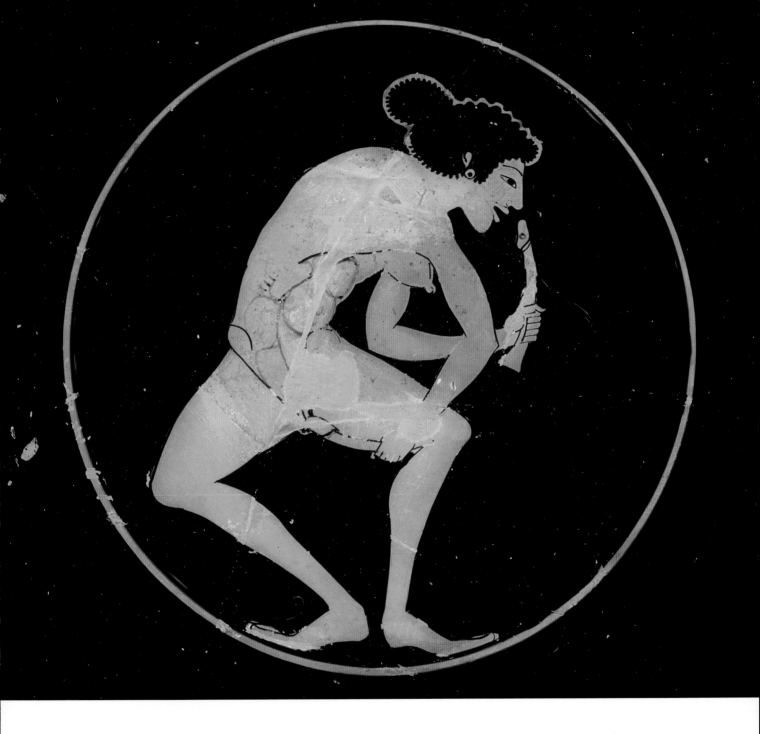

Cypriot pendant, *c.* 1550–1200 BC. Gold, L. 2.4 cm. On this luxury pendant, a figure that possibly represents the sexual goddess Astarte is reduced to her essentials: alluring face, breasts, navel and pubic triangle.

Middle Assyrian statue, from Kouyunjik, 11th century BC. Limestone, H. 97 cm. The only known Assyrian statue of a naked woman, this metre-tall statue probably represents an attendant of the goddess Ishtar, in whose temple it was found. An inscription on the back states that King Ashur-bel-kala erected it for the enjoyment of his people.

Many of these goddesses also had a martial aspect, demonstrating that their prowess was not purely sexual. Ishtar, like Athena, is a goddess of war and so is depicted holding a scimitar-sword. An armed goddess appears in the Minoan and Mycenaean art of the Aegean Bronze Age, and an armed Aphrodite is not uncommon in the Classical period. A female in armour eventually came to personify cities, for example Rome or Constantinople, or ecclesiastical power, as in the church militant. Like Athena/Minerva, these powerful figures wear female dress but also don male armour and weaponry. As we shall see in Chapter 7, there were several historic women who successfully led armies into battle or commanded navies.

MAN-SLAYERS AND MARTYRS

The man-slaying warrioress, an ancient version of Wonder Woman, is a stock-in-trade of classical mythology and art. Called Amazons, these foreign women lived apart in an all-female society and managed to achieve the Greek ideal in hunting, warfare and equestrianism. They dressed in barbarian male attire, wielded outré weapons, the axe and bow, and could shoot backwards from their mounts. The misconception that they cut off or seared one breast in order to be better archers derives from the false etymology of their name: *a* 'without' and *mastos* 'breast'. Amazons were considered both terrifying and sexy, and in the Classical period a popular motif was the wounded Amazon, which provided the sculptor with an excuse to reveal her breast.

In Greek tragedy women were often driven to murder – their husbands, their children, or themselves – although when male heroes killed their children (Herakles) or commited suicide (Ajax) the cause was temporary insanity. These

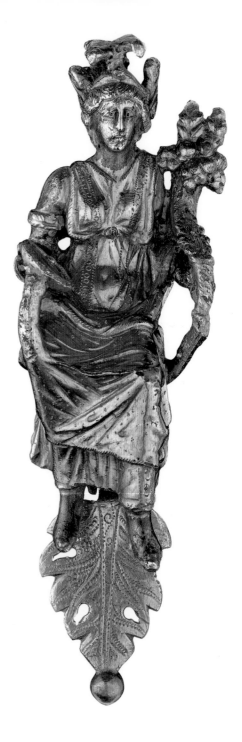

Late Roman statuette, mid-4th century AD. Silver, H. 14 cm. Wearing a helmet and holding a large cornucopia, this female personifies the city of Constantinople, the capital of the Roman Empire from AD 330. Her attributes are symbolic of military power and abundance.

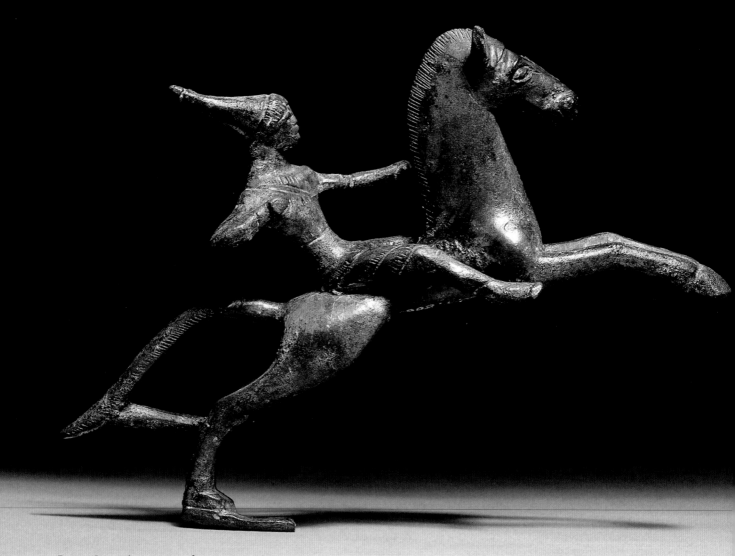

Etrusco-Campanian statuettes, from Capua, *c.* 500 BC. Bronze, H. 11.4 cm. Female warriors known as Amazons are often shown riding horses, an activity that was not acceptable for most ancient women. They were known as fierce fighters who, as allies of the Trojans, fought Greeks in the Trojan War.

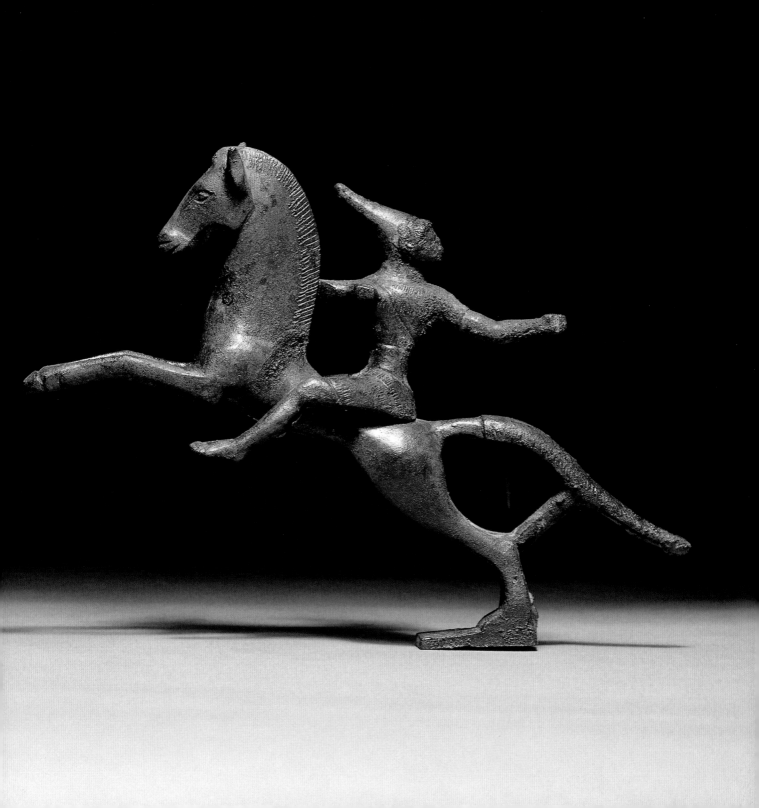

Athenian *amphora* (wine jar), *c.* 570–550 BC.
Black-figure pottery, H. 38 cm. A rare depiction
in Greek art, this bloody sacrifice of the Trojan
virgin princess Polyxena at the tomb of Achilles
reflects a not uncommon consequence of war.

WOMEN IN THE ANCIENT WORLD

brutal female acts were often crimes of vengeance, as in the case of Clytemnestra, who slayed her husband Agamemnon upon his return from Troy with a concubine, and that of Medea, who killed her children when her husband Jason made plans to marry another woman. Queen Jocasta was driven to suicide when she discovered that she was not only the wife but also the mother of Oedipus, and Phaedra also took her life when she was spurned by her stepson Hippolytus, for whom she harboured an ungovernable erotic attraction. A model of the virtuous Roman wife, Lucretia, killed herself after being raped by her husband's cousin, thus leading to the downfall of the kings and the establishment of the Republic.

Like Lucretia, young women in antiquity were often martyred for certain political or military causes. In Greek myth the Trojan War is framed by the sacrifice of two virgin girls: the Greek princess Iphigenia, in order to appease Artemis so the Greeks can sail for Troy, and her Trojan counterpart Polyxena, to soothe the ghost of the dead Achilles. The daughters of the Athenian king Erechtheus were also sacrificed like animals at an altar to save their city, while their brothers died valiantly as heroes on the battlefield. In Rome the vestals who guarded the hearth at the centre of the city took vows of chastity; if they transgressed they were buried alive. Many of the early Christian martyrs were female virgins, such as Agnes of Rome who refused to marry the son of a prefect and so was executed at the age of twelve in AD 304. She is now the Catholic saint of chastity and virgins.

WITCHES

Several stories about ancient women highlight their prowess as witches or female magicians. Circe's ability to transform men has already been mentioned, but an even more famous example is Medea, who sailed with Jason and the Argonauts from the eastern shores of the Black Sea to Greece. Although best known for slaying her sons in revenge for Jason's disloyalty, Medea had craftier means of destroying her victims. She gave a poisoned robe to Jason's fiancée, and advised Pelias's daughters to attempt to rejuvenate their father by boiling, but neglected to give them the necessary secret elixir. In Egypt the goddess Isis was renowned for her magical powers; she reassembled the dispersed pieces of her husband–brother Osiris's mutilated body and brought him back to life. Because of her promise of everlasting life, cults of Isis spread throughout the ancient world, and as far north as Britain.

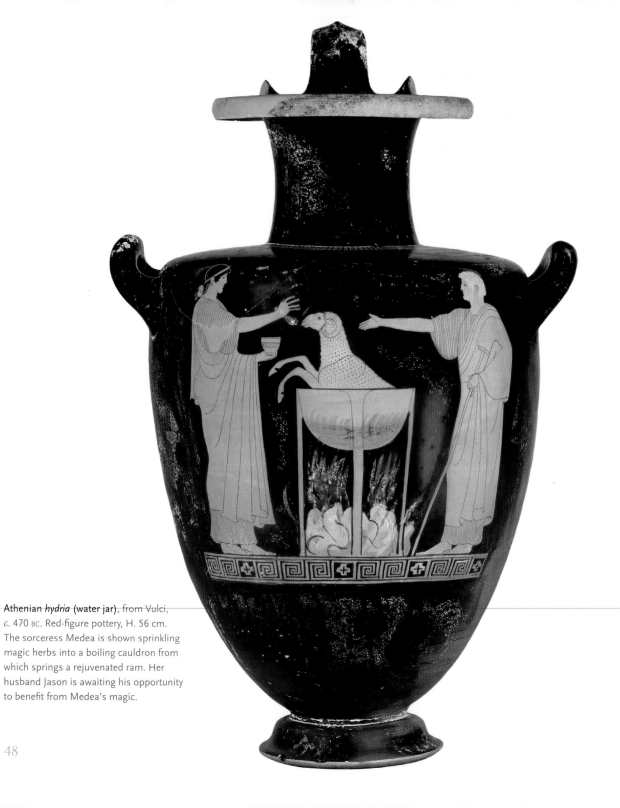

Athenian *hydria* (water jar), from Vulci,
c. 470 BC. Red-figure pottery, H. 56 cm.
The sorceress Medea is shown sprinkling
magic herbs into a boiling cauldron from
which springs a rejuvenated ram. Her
husband Jason is awaiting his opportunity
to benefit from Medea's magic.

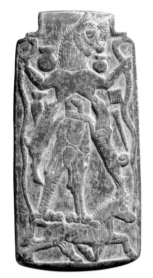

A monstrous female who survives in different guises in the Near East and Greece is the infamous baby-snatcher, perhaps a personification of what we now term SIDS (sudden infant death syndrome). Variously known as Lamia or Mormo, the Greek version is a hideous woman who has lost her own children and so robs other mothers of theirs. The Mesopotamian child-eating vampire was known as Lamashtu, and women wore special amulets to prevent her from causing infertility, miscarriages and infant death. Furies were winged female demons who hounded humans who had committed some form of sacrilege, such as Orestes, who killed his mother. Like the Near Eastern Lamashtu, furies often wielded snakes as they terrorized their victims. Another female monster strongly associated with snakes was the Gorgon Medusa. Despite being decapitated by the hero Perseus, her head lived on as a magical talisman that could turn men to stone if she caught their gaze.

Misogyny was rampant in the ancient classical world. In Greek physiology women and reptiles were considered to have much in common. While men's bodies were believed to be hot and dry, the ideal state, women's were cold and wet. Their menstrual blood demonstrated their surfeit of liquid. Likewise, according to Greek philosophers, the male was associated with the right and the good, and the female with the left and the bad. Greek and Roman authors were notoriously misogynistic if

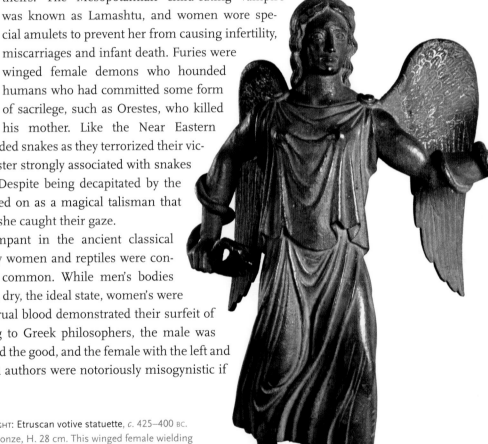

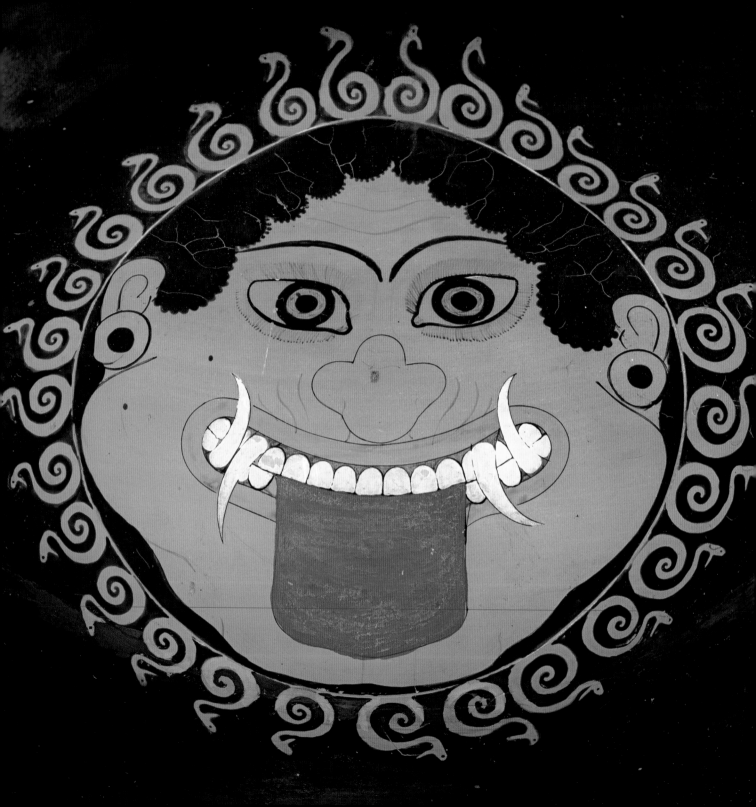

their writings are to be believed: 'So high-thundering Zeus made an evil for men, women, conspirators in cruel works' (Hesiod, *c.* 700 BC); 'A woman should be seen, not heard' (Sophocles, 5th century BC); 'A man is best off with a nonentity – a woman who sits in the house useless in her stupidity' (Euripides, 428 BC); 'A man who teaches a woman to write should recognize that he is providing poison to an asp' (Menander, 4th century BC); 'A fickle and changeful thing is woman ever' (Virgil, 1st century BC).

EARTH (AND SKY) MOTHERS

In some ancient cultures women are, not unnaturally, viewed as fertility figures. They are often depicted as goddesses of agriculture, like Demeter/Ceres, or as personifications of the earth itself. Thus, in Greek cosmology, the earth goddess Ge/Gaia mates with Uranus, the male god of the sky, to create the world. Winter and the absence of fertility in the land are explained by the obligation of Demeter's daughter Persephone to reside in the underworld for half the year. However, in Egypt this characterization is reversed. The earth divinity Geb is male, while the sky goddess Nut is female. She is often shown as a beautiful woman in an arched pose with her feet touching the western horizon and her fingers the eastern. Egyptians believed that Nut swallowed the sun every night and gave birth to it the following morning. She thereby not only embodied the belief in life after death, but also the Egyptian

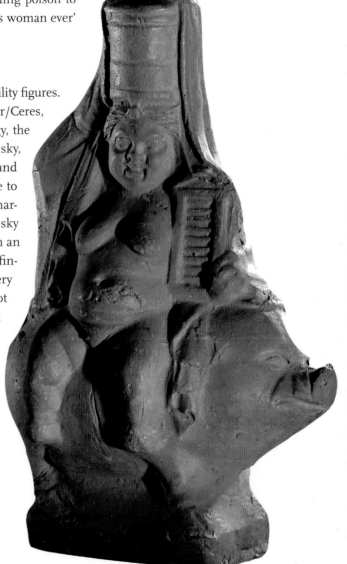

RIGHT: **Hellenistic statuette**, from Egypt, 1st century BC. Terracotta, H. 13.8 cm. This fat, nude elderly woman riding a pig resembles a caricature of the lazy, lascivious and all-consuming female, but in fact she may represent a devotee of the fertility goddess Demeter.

OPPOSITE: **Athenian *hydria* (water jar)**, *c.* 480 BC. Red-figure pottery, H. 41 cm. This decapitated head of Medusa is encircled with snakes. With her bared teeth and fangs she is the embodiment of the *vagina dentata*, and her myth is said to allude to male fears of castration.

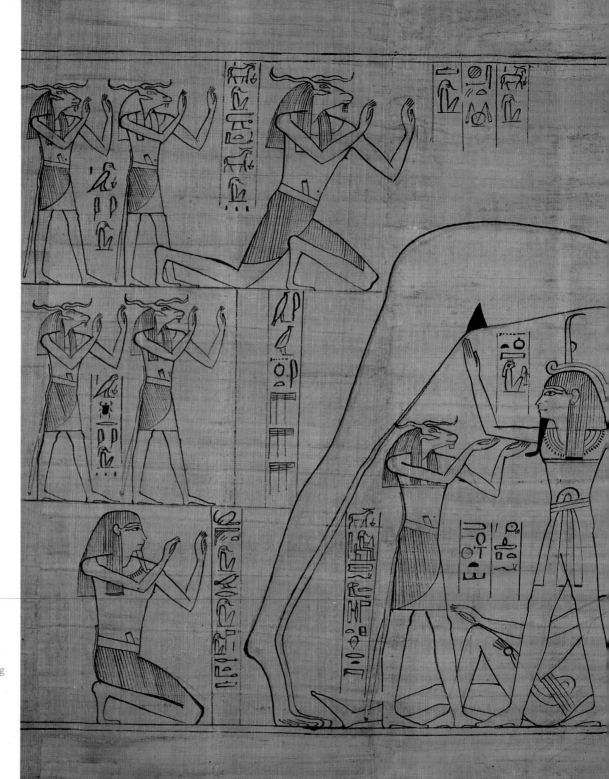

Egyptian Book of the Dead, *c.* 940 BC. Papyrus, H. 47 cm. The elongated sky goddess Nut dominates this scene while the smaller earth god Geb stretches out below her. This papyrus belonged to a woman, Nestanebtasheru, who is shown kneeling at the right.

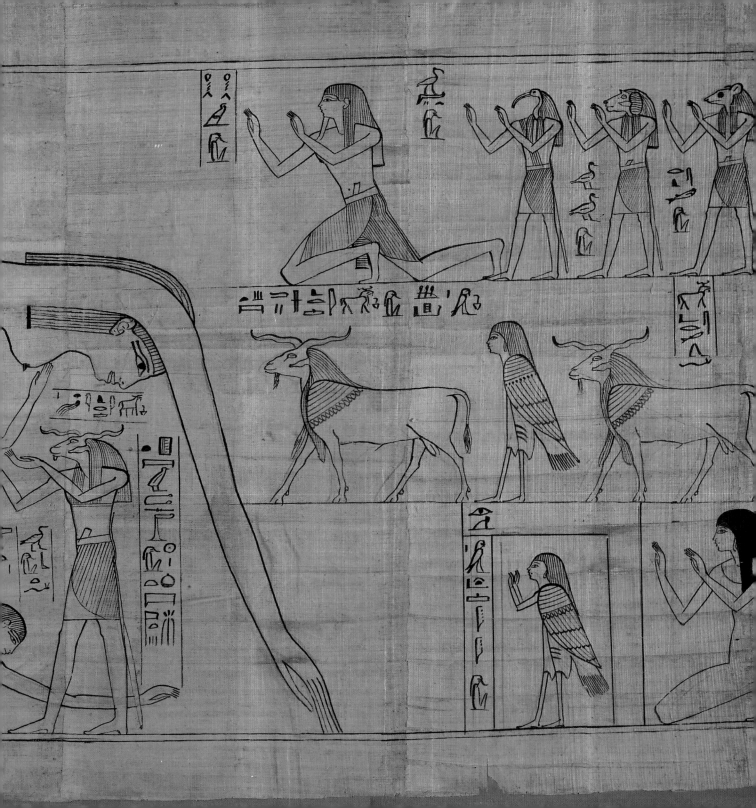

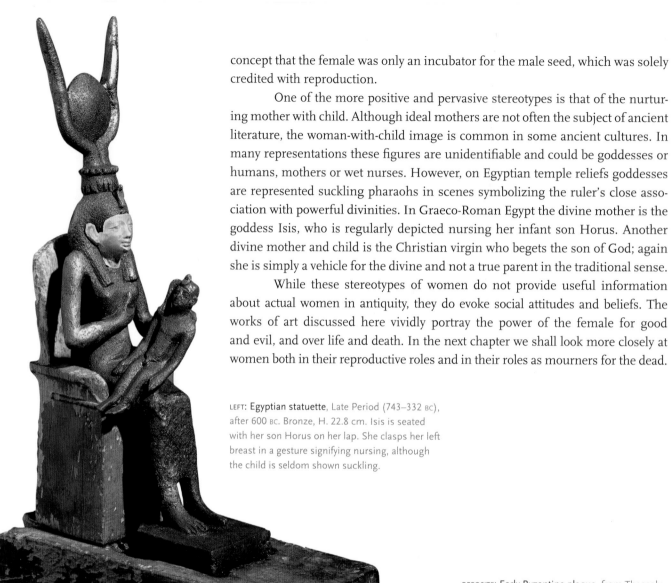

concept that the female was only an incubator for the male seed, which was solely credited with reproduction.

One of the more positive and pervasive stereotypes is that of the nurturing mother with child. Although ideal mothers are not often the subject of ancient literature, the woman-with-child image is common in some ancient cultures. In many representations these figures are unidentifiable and could be goddesses or humans, mothers or wet nurses. However, on Egyptian temple reliefs goddesses are represented suckling pharaohs in scenes symbolizing the ruler's close association with powerful divinities. In Graeco-Roman Egypt the divine mother is the goddess Isis, who is regularly depicted nursing her infant son Horus. Another divine mother and child is the Christian virgin who begets the son of God; again she is simply a vehicle for the divine and not a true parent in the traditional sense.

While these stereotypes of women do not provide useful information about actual women in antiquity, they do evoke social attitudes and beliefs. The works of art discussed here vividly portray the power of the female for good and evil, and over life and death. In the next chapter we shall look more closely at women both in their reproductive roles and in their roles as mourners for the dead.

LEFT: **Egyptian statuette**, Late Period (743–332 BC), after 600 BC. Bronze, H. 22.8 cm. Isis is seated with her son Horus on her lap. She clasps her left breast in a gesture signifying nursing, although the child is seldom shown suckling.

OPPOSITE: **Early Byzantine plaque**, from Thessaly, early 6th century AD. Ivory, H. 21.7 cm. The Virgin Mary, the mother of Jesus, holds her child frontally on her lap in a rigid, hieratic pose which conveys their spiritual qualities rather than the intimacy of motherhood.

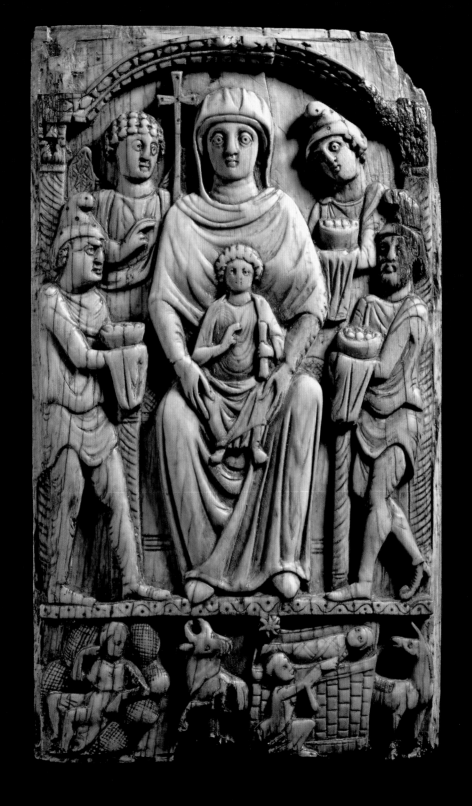

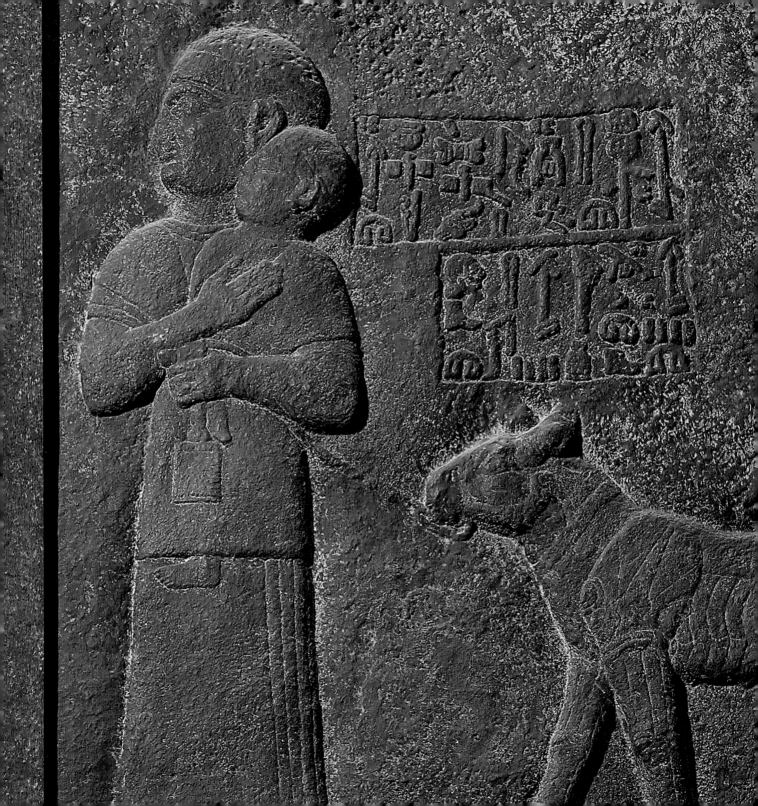

MOTHERS AND MOURNERS

MOTHERS AND MOURNERS

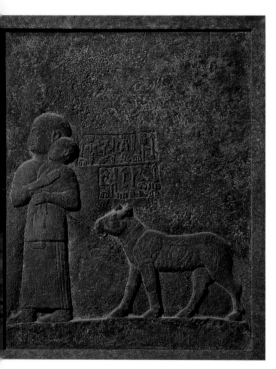

PREVIOUS PAGE (DETAIL) AND ABOVE:
Plaster cast of a Neo-Hittite relief, original from Carchemish, 10th century BC. H. 125 cm. The wife (or nurse) of the Hittite king Yariris is here carrying their youngest son Tuwarais and leading a sheep. The original inscribed basalt relief is in Ankara.

THE INSCRIPTION on a famous tomb from Republican Rome, for a woman named Claudia, neatly encapsulates the key roles of women in the ancient world:

Stranger, I have little to say: stop and read.
This is the unbeautiful tomb of a beautiful woman.
Her parents called her Claudia by name.
She loved her husband with her heart.
She bore two children: one of these
She leaves on the earth, the other she buries under the earth.
Her speech was delightful, her gait graceful.
She kept house, she made wool. I have finished. Go.

The chief goal imposed on young girls in antiquity was to marry in order to bear children, preferably sons, or so say our sources. And one of her final duties in life, if she survived childbirth, was to mourn the dead: parents, husbands, sons and daughters, and all too frequently newborns. Approximately half of all children born in antiquity died before the age of ten. Women prevailed over the beginning and the end of life, performing the obligatory familial duties of wives, mothers, midwives and mourners. Because childbirth and death both involved the shedding of blood, and so were tainted with associations of pollution in many ancient societies, their rites and procedures were relegated to the domain of women. Death was often interpreted metaphorically as a re-enactment of birth. In Rome the mother of the dying person, if still living, was granted the final kiss to end formally the life of her child and close their eyelids. According to a Hittite ritual text, when the priest asked the whereabouts of the deceased, the answer came as, 'The mother came to him and took him by the hand and she led him away'.

Childbirth is rarely represented in art, the exception being terracotta figurines from Cyprus and Phoenicia. Mothers are characterized not by any specific action, but by a child, ideally male, cradled in a woman's arms. Nurture in general, and the actual act of breastfeeding specifically, are also seldom depicted, but do occur in Egyptian and Etruscan art, where mother–child bonds can be intimately expressed. While child nurturing is conspicuous by its absence, mourning over corpses by women is a ubiquitous theme in ancient art. Female mourners are portrayed most dramatically, tearing their hair, scoring their cheeks, rending their garments and wailing lamentations. The funeral was one of the few socially sanctioned arenas in which women could vent their emotions.

WIVES

Marriage represented the key transition in a girl's life. Much of the scholarship on ancient wedlock deals with contractual rights between the bride's family and her future husband, with dower rights and obligations, and with the ramifications stemming from infertility and adultery. Most of these issues are seen from the male perspective, and the female is treated more or less like a piece of property, no different from slaves or livestock. Extant marriage contracts and royal letters attest that wedlock was often a commercial, political or social alliance between noble families, rather than a romantic love-match. Belying the imagery that idealizes marriage as a state of conjugal bliss is the fact that divorce was not uncommon in antiquity. None of these legal or social factors addresses what it must have been like for a young girl to leave her natural, lifelong home and take up residence in that of a stranger; only the Greek myth of Persephone's rape by the underworld god Hades conveys a sense of the trauma and dislocation experienced by teenage girls on the day of their nuptials.

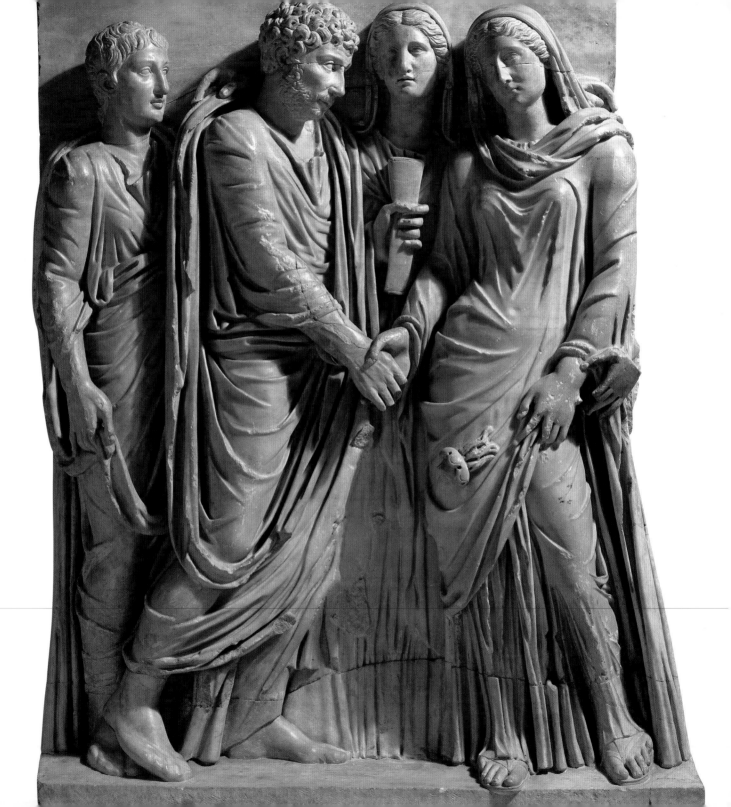

Virginity in girls was a prerequisite for marriage in ancient Greece, and so girls' lives were heavily circumscribed to avoid contact with unrelated boys or men. The popular myth that the goddess Hera could renew her virginity periodically after relations with Zeus demonstrates the importance and desirability of virginity to the Greeks. The early laws of Athens stipulated that a father could sell his daughter into slavery if he discovered that she had been seduced or had become pregnant before marriage. One *archon* (magistrate) reputedly fed his wayward daughter to a starved horse, thereby avoiding a charge of murder. In Egypt, by contrast, there was no word for virginity, and sexual liaisons were permitted for both sexes before marriage.

It is not certain how old the institution of marriage is, but because in ancient tales most divinities and heroes had regular consorts and produced children, it must have been an ancient and venerable practice. As many myths attest, these unions did not always come about peacefully, as demonstrated, for example, in Peleus's wrestling match with the sea nymph Thetis, or the Romans' rape of the Sabine women. In historic Sparta brides were 'captured' by their husbands who came to them surreptitiously at night. In the ancient Mediterranean simple cohabitation often constituted lawful marriage; it was a private oral compact requiring neither a legal nor a religious ceremony. In ancient Egyptian the verb 'to marry' can also be translated as 'to establish a household' or 'to live together'.

Roman sarcophagus fragment (restored), from Rome, 2nd century AD. Marble, H. 98.4 cm. The Roman wedding ceremony consisted of the *dextrarum iunctio* or joining of right hands. Typically Roman bridegrooms were aged thirty, while their brides were often still teenagers.

South Italian *pelike* (storage jar), from Basilicata, c. 370–360 BC. Red-figure pottery, H. 36.6 cm. This unusual scene perhaps represents a Greek male's fantasy of his wedding night. The handsome young groom lounges on a luxurious bed while the god of love, Eros, pours perfume on his head. His young bride, her ablutions referenced by the nude woman washing behind her, is shown disrobing from her diaphanous gown. Another attendant at the right is cleaning a pair of shoes, which also refer to nuptials, as does the sash hanging above.

Etruscan votive plaque, *c.* 300–200 BC. Terracotta, H. 21.7 cm. A couple is seated on a bed within a building, and they share an enveloping mantle. It is probably a marriage scene as the groom grasps the bride's right breast in a gesture of ownership.

Weddings were fairly simple family affairs. Usually, after an agreement was concluded by the two families, the young bride was transferred from her birth home to that of her husband. She might receive gifts from her family and some sort of celebration or feast took place, after which the couple slept together. In Greece a bride (*nymphe*) did not become a wife (*gyne*) until she bore a child. Marriages between slaves were usually arranged by their owners since they did not have the right to marry on their own. The age of the bride is a vexed question, but in Classical times it seems that she was a teenager and her groom a man of around thirty.

WOMEN IN THE ANCIENT WORLD

Polygamy and incest were not prohibited but were not at all common in the ancient world. In theory a man could cohabit with more than one woman, but the expense and physical constraints of the house would be limiting factors. Brother–sister marriage had precedents in ancient mythology, as with the Egyptian gods Isis and Osiris, or the Greek divinities Zeus and Hera. These two practices are closely associated with Egyptian royalty. Multiple, simultaneous marriages for the pharaoh are attested from the Old Kingdom onwards, and sibling marriage was frequent in the New Kingdom, and especially among the later Ptolemies. The infamous Cleopatra VII married her two brothers, and managed to put an end to

Egyptian stela of Intef, 11th Dynasty, c. 2102–2070 BC. Limestone, H. 102 cm. Behind the main figure of Intef, who is receiving funerary offerings from a male servant, are three identical women named Mery, Iutu and Iru. They are identified as his wives, but whether this represents polygamy or serial marriages is not certain.

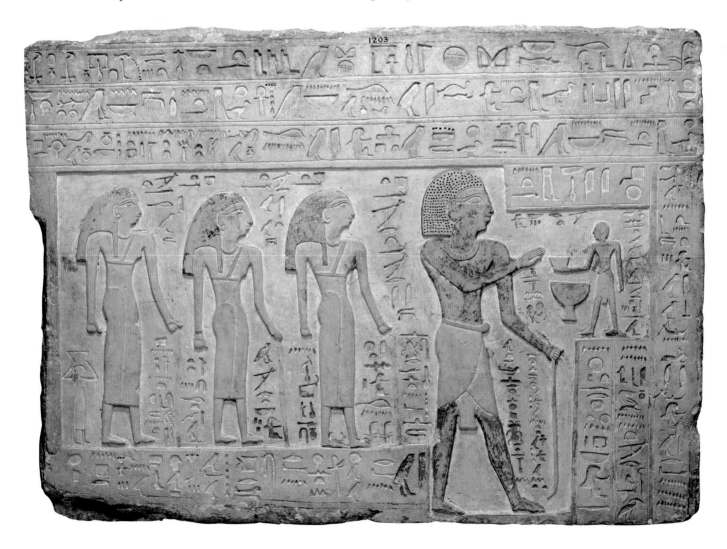

Paestan bell-*krater* (wine bowl), *c.* 350 BC. Red-figure pottery, H. 37.5 cm. In this comic scene an elderly man climbs a ladder up to his lover who is framed in a window. The slave holding a torch indicates that it is night, and so this is likely to be an adulterous tryst. Such relationships were often the subject of Greek comedy and the padded costumes are those of actors.

both of them. In the area of the Fayum in Egypt during the Roman period, census returns report a twenty-five per cent rate of sibling unions, one of the few times in human history during which incestuous marriage became the social norm.

Divorce, on the other hand, was not unusual and could be effected rather easily. It was often instituted by the husband on the grounds of infertility or adultery. A divorced woman usually retained her dowry, and returned to live with her paternal family. Remarriage was also common, although in ancient Rome a woman who married only once, known as a *univira*, was regarded as an ideal.

Adultery was considered a serious crime in most societies because the cuckolded husband could never be certain that the children to whom he bequeathed his property were indeed his own. In Athens it was considered justifiable homicide for a man to kill not only the lover of his wife, but also any man who seduced or raped his mother, daughter, sister or concubine. An Athenian woman taken in adultery was barred by law from temples and religious festivals, and her husband was required to divorce her.

The emotional and sexual dynamics of ancient marriage are hard to access and so assess. While scenes of copulation exist in most ancient cultures, one cannot necessarily assume that they represent marital coupling. Egyptian art portrays married couples with their arms embracing one another, but this is a highly conventionalized gesture indicating their marital status, not necessarily mutual love and affection. Greek vase painting, especially wine cups used in the all-male *symposium* or drinking party, celebrates a variety of sexual practices, but the females are prostitutes, not proper citizen wives. Only in Roman wall paintings preserved in the houses buried by the eruption of Vesuvius in AD 79 do we find what looks to be uninhibited sex among married couples.

The Mesopotamians may have taken the greatest delight in female sexuality as there were few taboos. The large literary corpus that has survived celebrates female sexuality in general, and the vulva in particular. The Akkadian language has five terms for the female genitals, all of them positive, whereas the Greeks, for instance, used the derogatory word 'pig'. There also existed special magical incantations and charms whose purpose was to ensure that the woman had as much physical pleasure as her partner.

Domestic females in the ancient Near East conjure up the image of the harem, a secluded part of the palace allotted to the royal wives, female relatives,

WOMEN IN THE ANCIENT WORLD

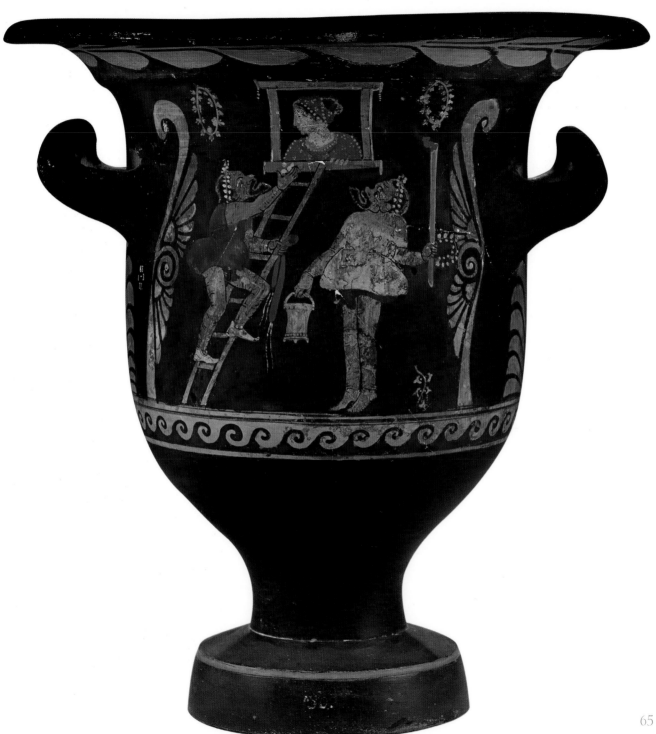

OPPOSITE: **Athenian cup**, from Vulci, *c.* 480 BC. Red-figure pottery, diam. 22.6 cm. On the interior of this wine cup, the drinker would see the image of a nude woman lowering herself gently on to the erect penis of her older lover. Her short-cropped hair indicates that she is a slave or prostitute.

ABOVE: **Old Babylonian plaque**, *c.* 2000–1750 BC. Clay, H. 10.5 cm. A couple stands facing each other and their quasi-embrace suggests they are husband and wife. She is wearing a choker and a crossed halter, items also worn by the goddess of love Ishtar and probably signalling erotic messages. The couple is standing in a doorway, which may also have conjugal associations, as it does in Greek art.

RIGHT: **Old Babylonian plaque**, *c.* 2000–1750 BC. Clay, H. 8.9 cm. This plaque shows a couple copulating; he penetrates her from the rear while she is bending over sipping beer from a jar. The scene may illustrate a Sumerian poem from the Third Dynasty of Ur: 'The beer of my . . . Il-Ummiya, the tapstress, is sweet. And her vulva is sweet like her beer, and her beer is sweet!' Because she is nude and drinking beer she has been identified as a prostitute, but she wears the same choker as the wife in the contemporary plaque illustrated above.

concubines and slaves of a ruler. The three hundred concubines present at the Persian court were, according to Greek historians, almost certainly of foreign origin. They accompanied the king on royal hunts during the day, entertained him with music and song at night, and protected him while he slept. Egyptian pharaohs had numerous wives as well as concubines. Mentuhotep II's funerary complex at Deir el-Bahri had burial chambers for his queen and his six 'Royal Favourites'; some of these women are represented with black skin and may have been Nubian by birth or ancestry. Because concubines were not legal wives, their offspring were not usually considered to be in the line of succession.

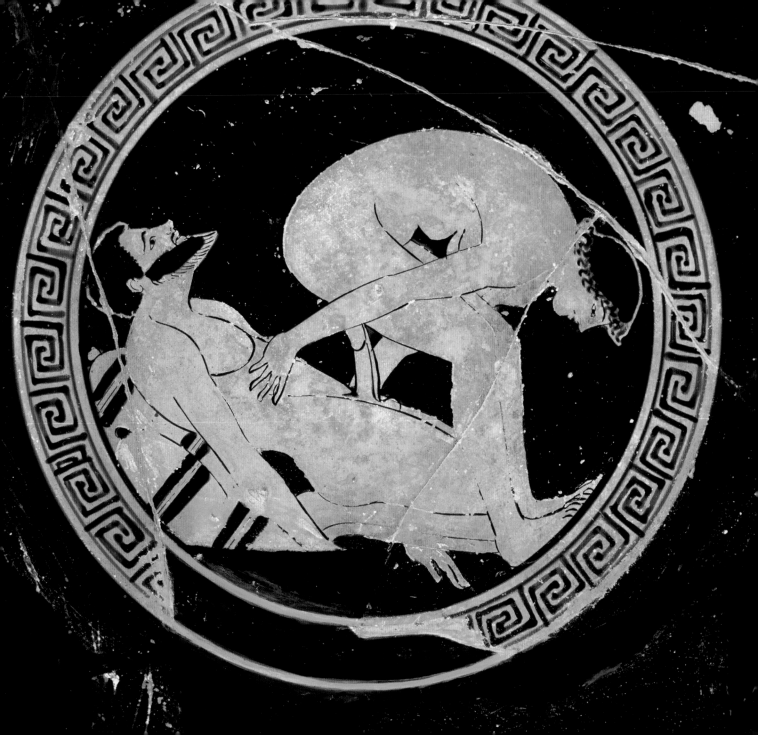

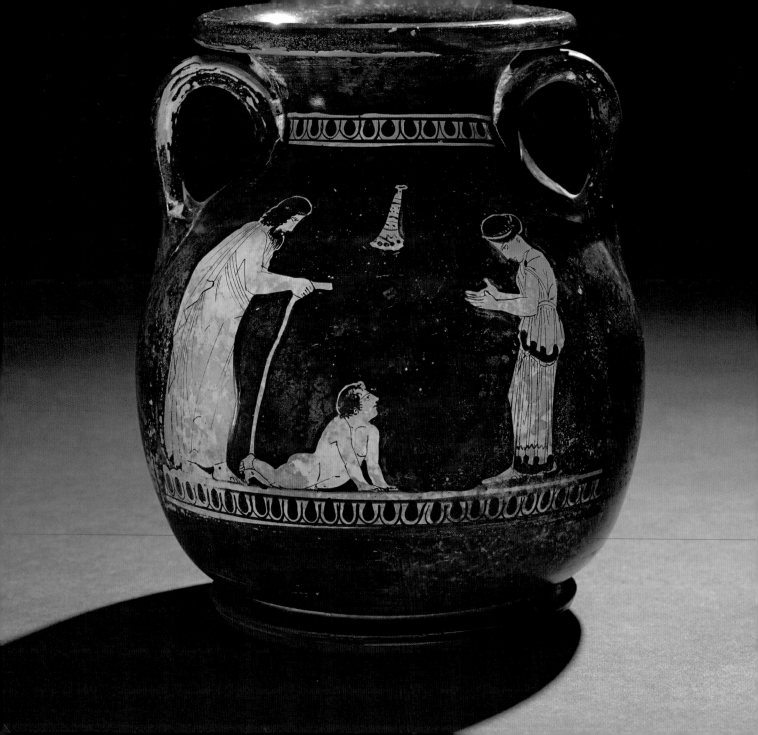

MOTHERS

The principal aim of marriage was to produce legal offspring; the Latin term *matrimonium* implies that the institution's purpose was to make mothers (*matres*). A popular image from antiquity and well beyond is the woman with child, which appears in a variety of forms depending on the culture. So, for instance, in Bronze Age Cyprus the woman with child is nude and the emphasis is not so much on maternity as fertility. In Classical Greek art the woman cradling the child is often not the birth mother but the loyal nurse. When Odysseus returned from his twenty-year odyssey, it was his aged nursemaid Eurycleia who recognized him, not his long-suffering wife Penelope. In Roman imagery the *mater* is concerned to show off her fashionable appearance as much as her offspring.

ABOVE: **Neo-Assyrian relief**, from Nineveh, *c.* 700 BC. Limestone, H. 21 cm. A Phoenician woman, possibly a queen, is shown cradling her child as she flees in a boat from the invading Assyrian army.

OPPOSITE: Athenian *pelike* (storage jar), from Rhodes, *c.* 430 BC. Red-figure pottery, H. 18.5 cm. Family scenes are rare in Greek vase painting, and this intimate scene of two adults encouraging a baby to crawl is unique. We cannot be sure whether the adults represent the parents or domestic servants – the male tutor and nurse – who were often more intimate with the children of well-to-do families.

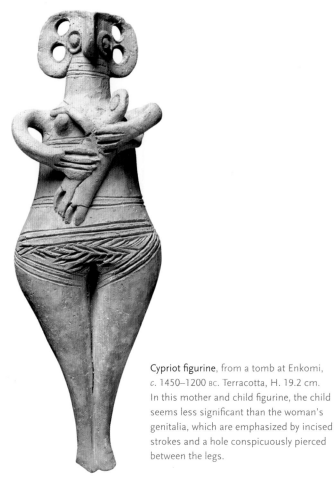

Cypriot figurine, from a tomb at Enkomi, *c*. 1450–1200 BC. Terracotta, H. 19.2 cm. In this mother and child figurine, the child seems less significant than the woman's genitalia, which are emphasized by incised strokes and a hole conspicuously pierced between the legs.

Romano-British statuette, from a grave at Welwyn Grange, Hertfordshire, 2nd century AD. Pipeclay, H. 14.5 cm. This fashionably coiffed mother is seated on a basketwork chair and nursing her child. Roman medical writers recommended that mothers breastfeed their children until the age of eighteen months to two years.

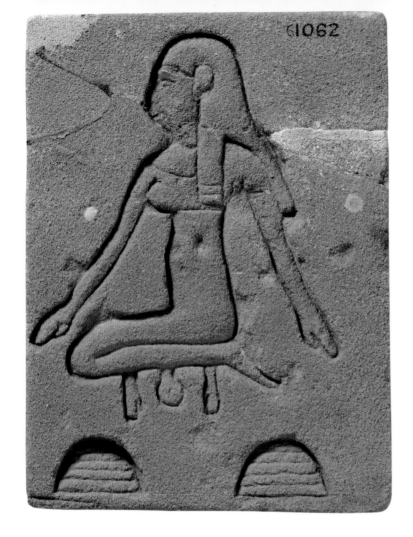

Egyptian trial piece, Graeco-Roman period (332 BC–476 AD). Sandstone, H. 18 cm. A kneeling woman is shown giving birth to a child whose head and hands are just visible. This stylized image represents the hieroglyph for childbearing. Egyptian women knelt on two bricks (shown below) placed apart to allow the newborn to emerge.

While most ancient cultures seem reluctant to depict pregnancy and childbirth, Egyptian art provides illustrations of all stages of motherhood, albeit not in formal settings such as tombs. The informal sketches found on ostracons (substantial flakes of limestone) were perhaps preliminary drawings for wall paintings in houses, specifically in rooms where conception and childbirth took place. Some show the post-partum mother in a special bower nursing her new-born; in many cultures women in childbirth were separated from the community. In Greece the house in which birth took place was considered polluted for three days, and only on the tenth day after birth was the new mother 'pure' again. It

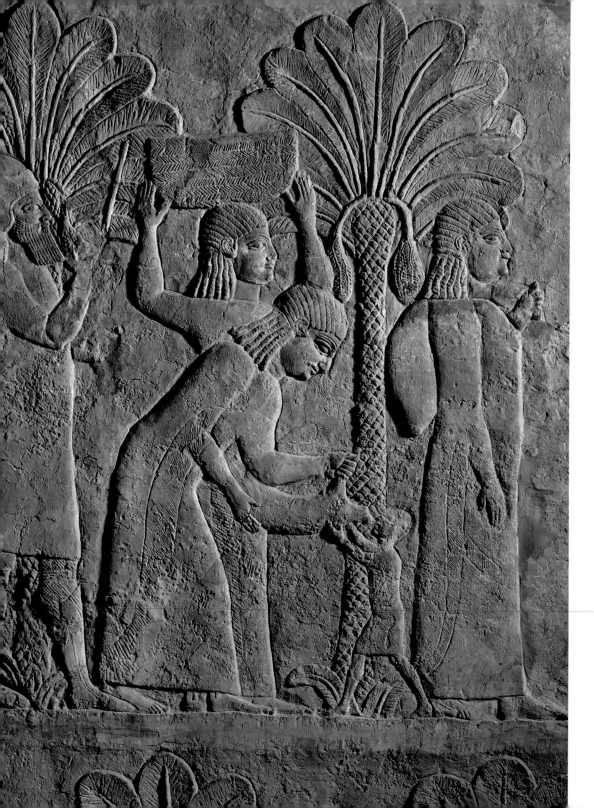

Neo-Assyrian relief, from Nineveh, *c.* 640–620 BC. Gypsum, H. 199 cm. In a grove of date palms, prisoners are being driven from home by Assyrian soldiers. Here a woman stoops to give a child some liquid from an animal-skin sack.

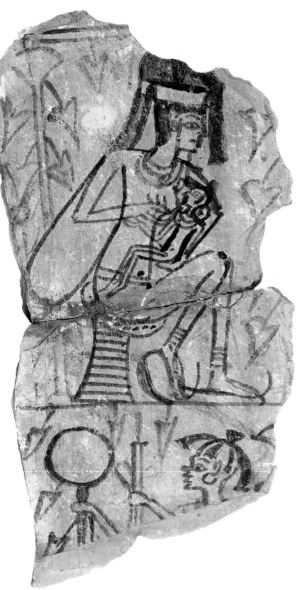

LEFT: **Egyptian ostracon (sherd)**, probably from Thebes, New Kingdom (1550–1070 BC). Painted limestone, H. 16.5 cm. Within a vine-covered bower a nude woman, her hair tied up, sits on a stool suckling her infant. Below her a Nubian slave holds up a mirror and an eye make-up (kohl) container.

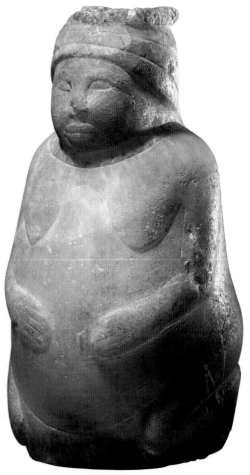

RIGHT: **Egyptian vase**, *c.* 1400 BC. Calcite, H. 15.9 cm. This anthropomorphous vase takes the form of a very pregnant, kneeling woman, possibly in childbirth. Vessels like this may have held oil used to massage the tight skin on the abdomen of a pregnant woman or to prevent stretch marks.

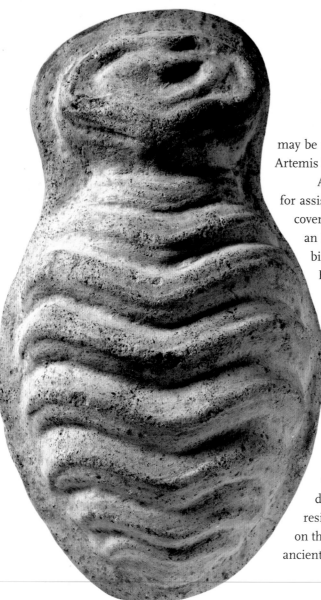

LEFT: **Italic votive uterus**, *c.* 400–200 BC. Terracotta, L. 18 cm. This model of a gravid uterus proves that the Etruscans were familiar with internal body organs through dissection. Presumably mothers-to-be dedicated these objects in healing sanctuaries for a healthy pregnancy.

may be at this time that they dedicated their used clothing to the goddess Artemis in thanks for successful childbirth.

As attested in literature, there appear to have been two main devices for assisting the pregnant woman in childbirth. One was a pair of bricks covered with cushions on which the woman kneeled, as illustrated in an Egyptian relief (p. 71). The other, perhaps more common, was the birthing stool, often supplied by midwives. It is first mentioned in Hittite texts of the second millennium BC, where the stool (*harnau-*) is purified before use. In both methods, the mother-to-be is often supported from the back by the embrace of another woman, while the midwife receives the newborn, in a blanket according to some sources. In his handbook on gynaecology the Greek physician Soranus, who practised in Alexandria and Rome in the first to second century AD, gives precise instructions for the manufacture and use of the birthing stool.

It was a common belief in antiquity that it was much harder to give birth to a girl than to a boy. In the Talmud it is observed that a female is born with her face upward and a male with his face downward, mimicking the positions they assume during intercourse. The Greeks believed that the female foetus resided on the left, or unlucky, side of the womb, while the male lay on the right. Uterine contractions were not properly understood, and so ancients believed that the child fought its way out of the womb like a chick

OPPOSITE: **Egyptian figurine**, New Kingdom (1550–1070 BC). Rock crystal, H. 9.8 cm. A female hippopotamus with lion's paws and a crocodile tail, Taweret is the Egyptian goddess of childbirth. Her pendulous breasts and swollen abdomen suggest the form of a pregnant woman.

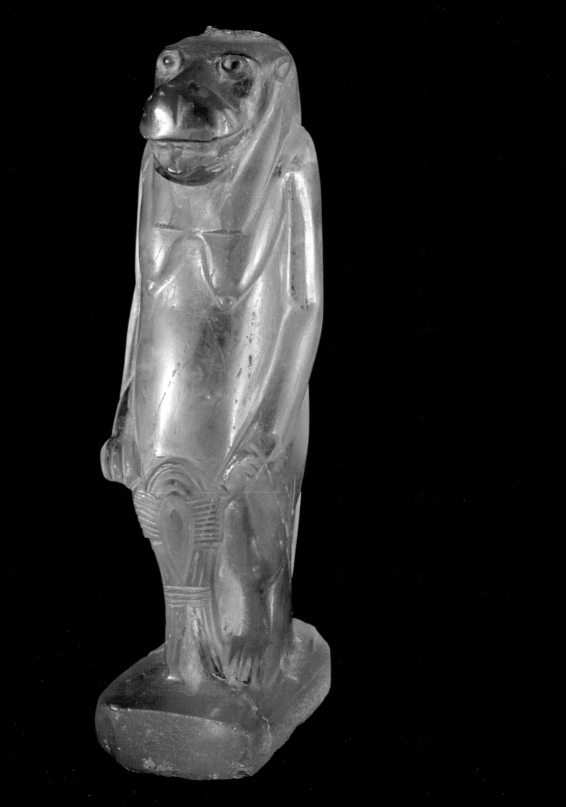

Romano-British *lamella* (sheet), from Cholsey, Oxfordshire, *c.* AD 100–300. Gold foil, L. 3.7 cm. The Greek cursive inscription on this precious gold charm calls on the gods to ensure a safe delivery for a woman named Fabia. It also has twelve magical characters.

out of its shell. An old Roman law (*lex regia de mortuo inferendo*) stipulated that if a pregnant woman died, the foetus had to be excised from her body before burial.

Given the inherent dangers of childbirth, Euripides's Medea claimed that she would rather stand in the front line of battle three times than give birth to one child. The stress and pain of parturition is similarly described in a Middle Assyrian text that characterizes the mother thus: 'Like a warrior in the fray, she is cast down in her blood.' Women took a variety of precautions to ensure successful delivery and their own survival. They had special deities to whom they prayed for assistance: for the Egyptians the hippopotamus Taweret, the frog Hekat and bestial Bes; for the Greeks the huntress Artemis and midwife Eileithyia; for the Romans Diana and the Carmentes. Votive terracotta uteruses are common in Etruscan religious contexts, presumably dedicated by women for divine aid in some aspect of reproduction. Some Greek women tied a special amulet to their thighs to speed the birthing process; known as a 'quick-birther' (*okytokion*), it was often reddish in colour and featured a uterus symbol and an inscription ordering the foetus to come forth.

Professional assistance was provided by experienced midwives, who in Greece were required to be post-menopausal. The Hittite terms for midwife translate literally as 'woman who knows the internal organs' and 'one who is skilled in causing to give birth'. Rarely is a midwife portrayed, but she played an important role in both pre- and post-natal

Eastern Mediterranean gem, 3rd century AD. Haematite, L. 1.8 cm. This uterine magical amulet is made of haematite or 'bloodstone', which was thought to control the flow of blood. Incised on it is a representation of a uterus with a special key at its opening. The key regulated the opening (for menses, sperm and childbirth) and closing of the womb (during pregnancy).

WOMEN IN THE ANCIENT WORLD

rituals. She recited incantations before, during and after birth to ward off evil. She may have punctured the amniotic sac, delivered the baby, cut the umbilical cord and disposed of the afterbirth. She applied ointments to the mother and would have bathed and swaddled the newborn. Possibly she presented it for inspection to the father, who had the right to decide whether it should live or die and, if the latter, exposed the child. She may also have marked the door of the house with an object indicating the sex of the newborn, a tuft of wool or spindle for a girl.

While ancient physicians did write about delivery, they probably did not often attend women in labour except in emergencies. Some medical instruments such as the vaginal speculum existed in antiquity, but there is no evidence for the use of forceps and Caesarean sections; dead or undeliverable foetuses were excised from the womb, a process that often proved fatal to the mother.

Two pathological conditions were highlighted by the Hippocratic scientists who wrote gynaecological treatises in the late fifth and fourth centuries BC. One concerned adolescent girls who suffered from strange visions, which often

resulted in attempted suicide. This syndrome was ascribed to delayed menarche and an accumulation of blood in the lungs which could be released by having the girl promptly married and deflowered. The other condition was the 'wandering womb' or the concept that the uterus could relocate to other parts of the body unless anchored in place by pregnancy or kept moist through frequent intercourse. Both of these medical fallacies clearly served men's needs and desires rather than promoting the health of the female.

It is now known that ancient women could to a certain extent regulate their own reproduction. Many certainly resorted to magic and charms in attempts to conceive, avoid miscarriage, or prevent conception. Egyptian texts specify that certain materials such as honey or crocodile dung could be inserted into the vagina to act as a contraceptive, but the acacia gum which is also listed does in fact have spermicidal effects. The juice of a now-extinct plant called silphium, which once grew only near the Libyan city of Cyrene, was used extensively in classical antiquity as a contraceptive and as an abortifacient. The seeds of a wild carrot known today as Queen Anne's Lace were also used as a 'morning-after' pill or post-coital anti-fertility agent. While the Hippocratic Oath has been misinterpreted as forbidding doctors to perform abortions, in fact it simply prohibits abortive suppositories, and thus presumably allows other procedures.

MOURNERS

The all-important function of ancient women as mourners of the dead was not only prescribed by society but was also modelled on the actions of many major female deities. In Egypt the goddess Isis mourns for Osiris, in Mesopotamia Inanna grieves for Dumuzi, in Babylonia Ishtar mourns Tammuz, and in Greece Aphrodite laments the dead Adonis. Clearly a god, hero or man's status was enhanced in death by the number of females lamenting his passing. After what must have been a grand funeral procession, the king of Ur buried in the third millennium BC had his richly attired female attendants killed outside his burial chamber so they could accompany him in the hereafter (see p. 156). In Greek myth, the Trojan princess Polyxena was sacrificed at the tomb of Achilles (see p. 46) in a rite which might be confirmed as historic practice by Greek archaeological evidence from the tenth-century BC burial site of a cremated chieftain at Lefkandi, who is accompanied by an interred woman.

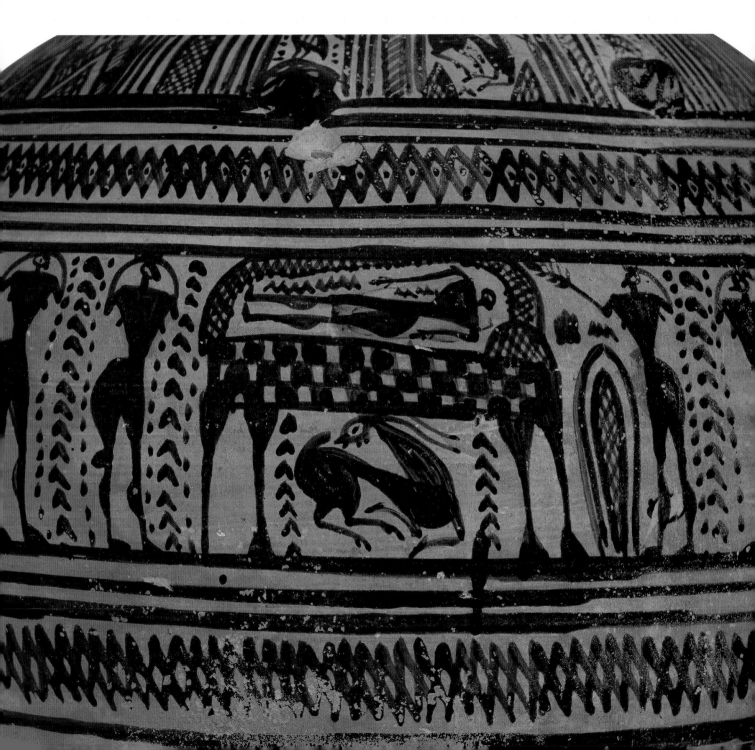

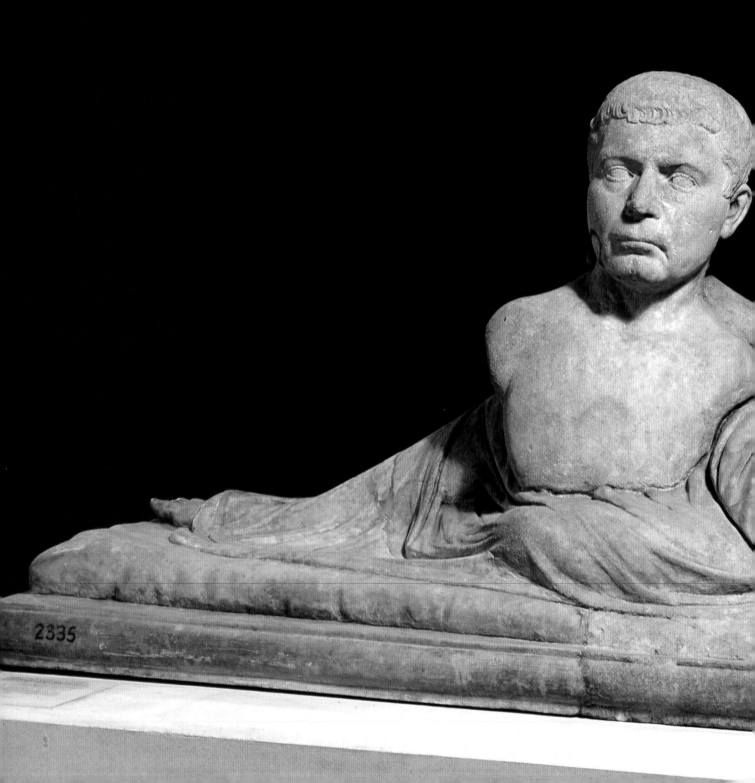

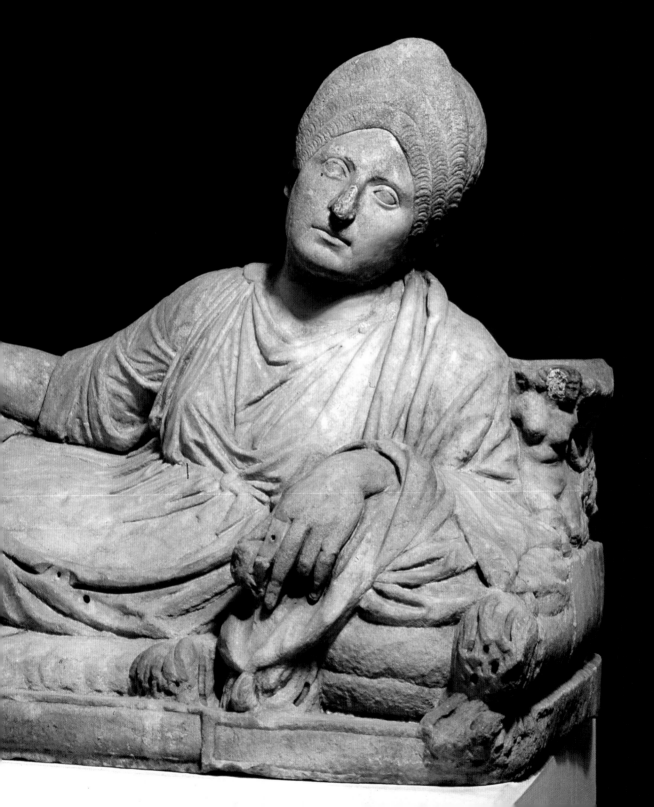

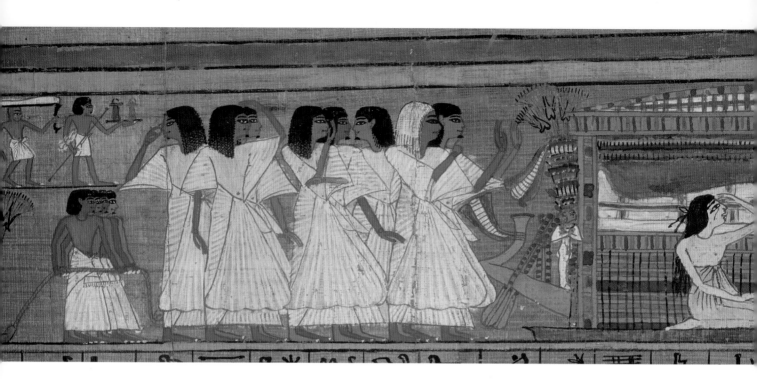

Egyptian Book of the Dead, from Thebes, 19th Dynasty (1295–1186 BC). Papyrus, H. 42.3 cm. The mummy of the deceased scribe Ani is lying on its bier, which is in turn on a sledge being pulled by oxen. Ani's widow Tutu kneels before her husband, tears running down her cheeks with her chest bared in sorrow.

The numerous depictions of funerals in Egypt and the Graeco-Roman world highlight the role of women in mourning the dead. Most of these female mourners are presumably kinswomen, although professional mourners for hire are mentioned in ancient texts. Women are usually shown in closer proximity to the corpse and more demonstrative in their grief than their kinsmen, who in Greek representations stand at a distance with a single arm raised in salute to the dead. In Egyptian funeral processions two women were dressed up as the goddesses Isis and Nephthys to escort the dead.

Except in Egypt, where professional embalmers prepared the body for burial, women were charged with the washing, anointing, dressing and shrouding of the corpse. Women wove the funeral shrouds for their relatives, as did Penelope for her father-in-law Laertes. Groups of them sang the funeral dirges that aided the journey of the deceased to the next world. In Greece these rites were not only custom, but were also a necessity if the spirits of the dead were to find

Etruscan *kyathos* (cup), *c.* 540–520 BC. Black-figure pottery, H. 30.5 cm. A deceased man lying on his bier is flanked by mourners, eleven men to the left and ten women to the right. At his side are an additional man and a woman who is touching the shroud.

Athenian *lekythos* (oil flask), *c.* 460–450 BC. White-ground pottery, H. 38.8 cm. Two draped women are standing at a grave stela. The one on the left holds forth a large perfume flask known as an *alabastron*, while on the steps of the monuments are two more vases. These represent ongoing offerings to the dead on the part of the women of the family.

peace in the afterlife. For this reason Oedipus's daughter, the princess Antigone, was willing to defy the king of Thebes at the cost of her life in order to perform the proper rituals for her slain brother.

In Athens obsequies for the dead continued long after their burial with rites conducted on the ninth and thirtieth days after death, and annual commemorations thereafter. The tending of the tomb with regular visits and offerings fell to women, as we see on the numerous Athenian white-ground funerary *lekythoi* (oil flasks) where the most frequent theme is the visit to the grave. Women are pictured with baskets filled with ribbons, wreaths, oil flasks and other gifts for the dead, and the grave marker is usually decked out with fillets and perfume vases. Although most of these scenes are calm and demure, some depict women fallen to the ground, their hair dishevelled, beating their breasts in grief. Given the fact that Athenian women tended the corpse and the grave, they were the likely purchasers of funerary vases, and were possibly even the painters, since none is signed by a known male artist.

Because of the contagion associated with death, burial within the city limits was often banned, and so Classical cemeteries are usually found along roads outside the city gates. Contagion was also assumed to affect the house of the deceased, and elaborate precautions were therefore taken to prevent it from seeping into the outside community. The Athenian lawgiver Solon dictated that only close relatives and women over sixty could enter the house and take part in mourning. Other precautionary measures included placing a bowl of water outside the door of the house so visitors could purify themselves, and hanging a cypress branch on the door to warn of the presence of a corpse. Not only did the mourners bathe after the funeral, but the house was sprinkled with sea water. In ancient Rome a ritual sweeping took place with a special broom.

The period of mourning was not always clearly defined, but in Rome widows were expected to mourn their husbands for ten months in order to avoid *tubatio sanguinis* or a 'confusion of the blood'. If pregnant, they could marry immediately after giving birth. A woman who remarried before ten months earned a bad reputation (*infamia*). Men, on the other hand, were not required to observe any form of mourning for their wives. That they did mourn their wives' deaths is indicated by funerary inscriptions which praise their piety, their industriousness and their fidelity.

WOMEN IN THE ANCIENT WORLD

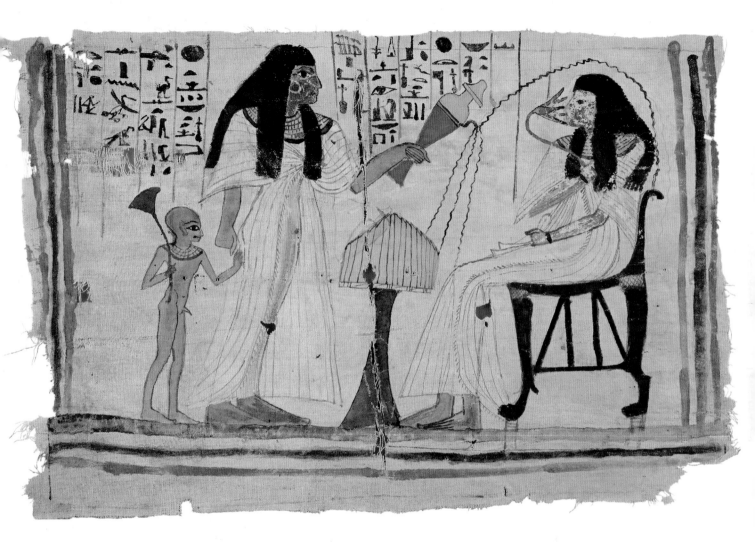

Egyptian funerary cloth, Ramesside
period (1295–1070 BC). Linen, L. 43 cm.
The deceased woman Astnefret is shown
seated on an elaborate chair receiving
lustral offerings from her daughter Tii
and son Penpare.

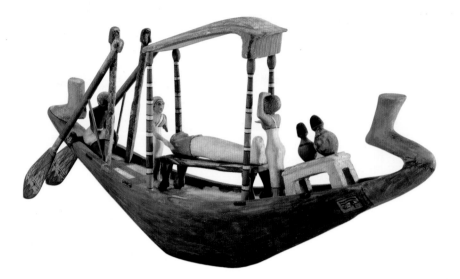

There are few funerary images of females that actually portray them as dead. In Egypt they are often shown as mummified coffins or seated and receiving offerings in the afterlife. Most of the tomb paintings and reliefs depict the husband with his wife in the background and on a smaller scale, but occasionally women with titles are shown in their own right. In Classical funerary art dead women are commemorated in a moment of life, as on Greek grave stelae, or in the guise of a goddess, as in Roman art. Throughout antiquity female burials demonstrate the same level of wealth as those of men of similar social status. While men are regularly buried with their weapons, a variety of ornaments and jewellery is found in female graves. In Iron Age Europe some exceptionally rich female burials, such as those discovered at Vix in France and Heuneberg in Germany, indicate the high status of women, possibly rulers, who were buried with their own chariots.

While in many instances women enjoyed rank and perhaps power, they were still required to minister to what many cultures considered the most polluting and dangerous of life's transitions: birth and death. As mothers, midwives and mourners, they dealt with the miasmic conditions attendant on the shedding of blood, sexual relations and the passing of the soul from the body. These roles were essential to the well-being of ancient societies, perhaps more so than the actual work performed by women, which is the subject of the next chapter.

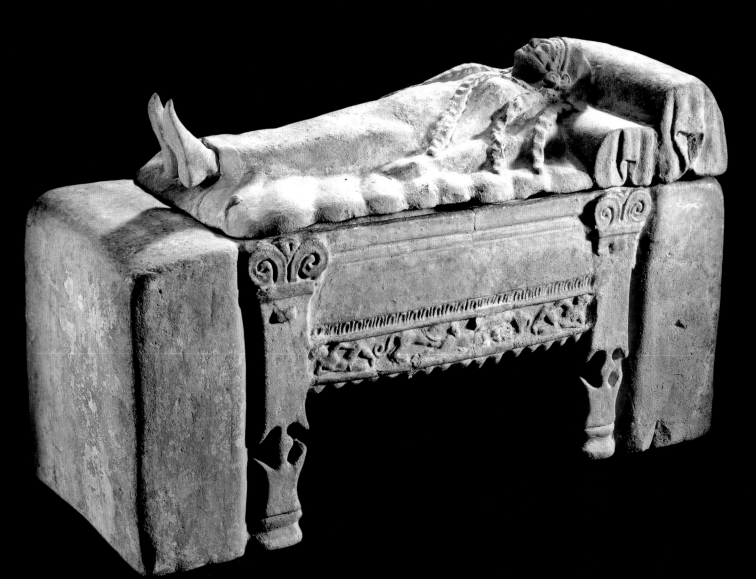

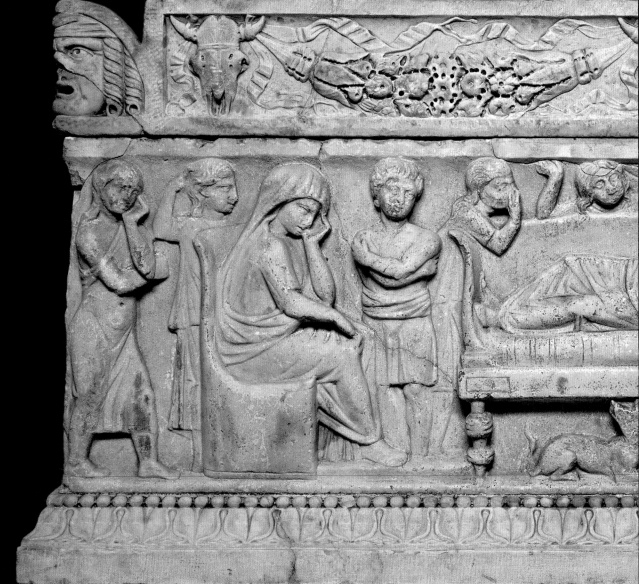

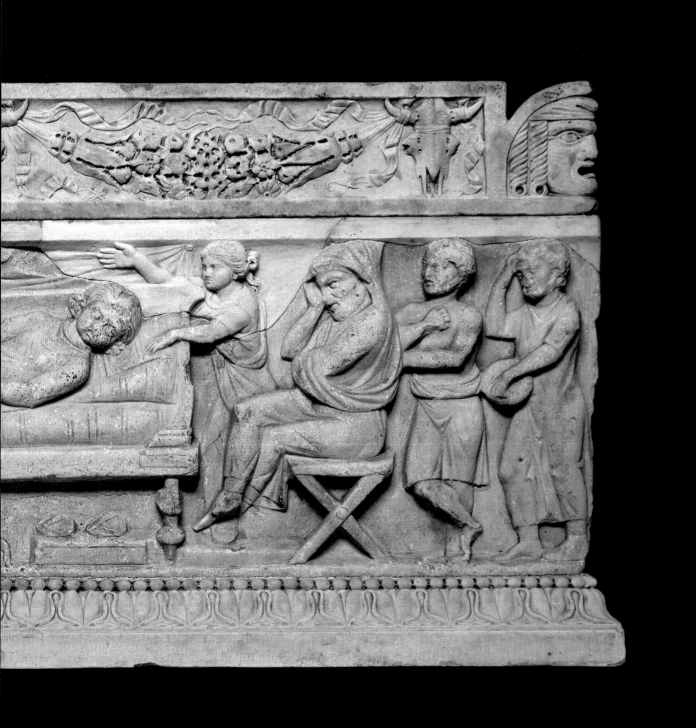

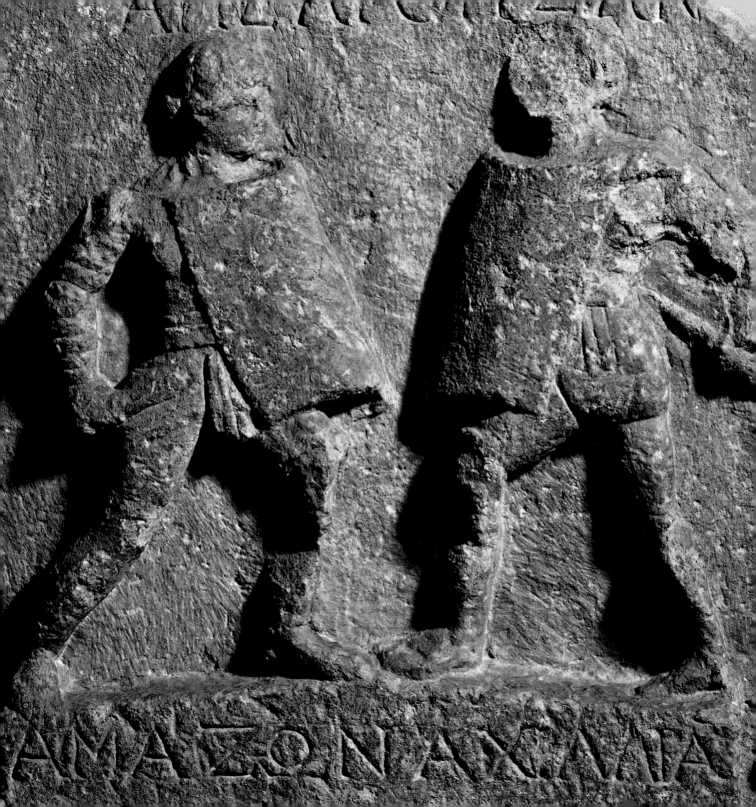

WORKING WOMEN

WORKING WOMEN

PREVIOUS PAGE (DETAIL):
Roman relief, from Halicarnassus, 1st–2nd century AD. Marble, H. 66 cm. This unusual relief commemorates the honourable discharge of two female gladiators from the arena. While dressed like male gladiators, they are depicted without helmets, perhaps to make their gender apparent. The inscription identifies them by what must be their macho stage names, Amazon and Achilla (the feminine of Achilles). This relief represents the only archaeological evidence for female gladiatorial combat, although the practice is mentioned by several Roman writers.

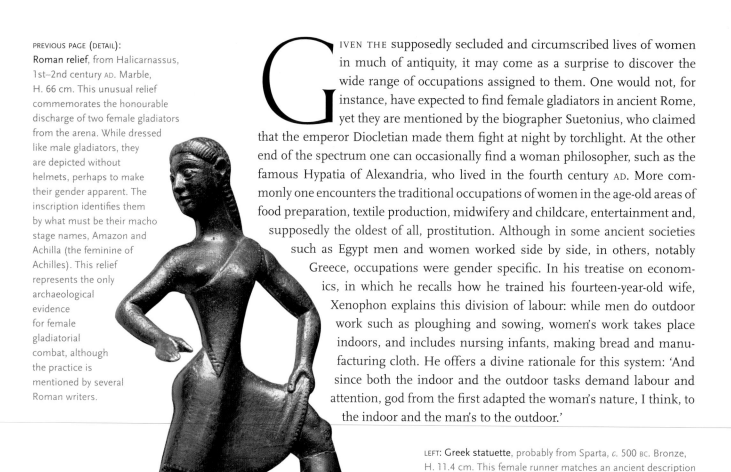

GIVEN THE supposedly secluded and circumscribed lives of women in much of antiquity, it may come as a surprise to discover the wide range of occupations assigned to them. One would not, for instance, have expected to find female gladiators in ancient Rome, yet they are mentioned by the biographer Suetonius, who claimed that the emperor Diocletian made them fight at night by torchlight. At the other end of the spectrum one can occasionally find a woman philosopher, such as the famous Hypatia of Alexandria, who lived in the fourth century AD. More commonly one encounters the traditional occupations of women in the age-old areas of food preparation, textile production, midwifery and childcare, entertainment and, supposedly the oldest of all, prostitution. Although in some ancient societies such as Egypt men and women worked side by side, in others, notably Greece, occupations were gender specific. In his treatise on economics, in which he recalls how he trained his fourteen-year-old wife, Xenophon explains this division of labour: while men do outdoor work such as ploughing and sowing, women's work takes place indoors, and includes nursing infants, making bread and manufacturing cloth. He offers a divine rationale for this system: 'And since both the indoor and the outdoor tasks demand labour and attention, god from the first adapted the woman's nature, I think, to the indoor and the man's to the outdoor.'

LEFT: **Greek statuette**, probably from Sparta, c. 500 BC. Bronze, H. 11.4 cm. This female runner matches an ancient description of the girls who ran races at ancient Olympia: 'They bare the right shoulder as far as the breast.' These girls took part in a festival in honour of Hera in the stadium at the Olympic site.

Campanian *hydria* (water jar), *c.* 340 BC. Red-figure pottery, H. 28 cm. This scantily clad female acrobat is performing a somersault. Such a scene is reminiscent of one described in Xenophon's *Symposium* when the Athenian Kallias hired a girl acrobat to entertain Socrates and his friends: 'This girl's feat, gentlemen, is only one of many proofs that woman's nature is really not a whit inferior to man's, except in its lack of judgement and physical strength. So if any one of you has a wife, let him confidently set about teaching her whatever he would like to have her know.'

Many of these occupations were unpaid, as they still are today, and were mastered not by formal training, but by informal apprenticeships. Girls were taught at a young age to perform domestic tasks, and some – often slave girls – were educated in music, dance and gymnastics to become future entertainers. Before the Hellenistic period it seems that women were seldom taught to read or write, and we know of no formal schools for girls, even in Roman times. Rarely did they receive physical education, but in Sparta athletic training for girls was both part of a eugenics programme and preparation for competition. The Spartans believed that strong, healthy female bodies produced the best warriors. At Olympia footraces for girls were held in the stadium in honour of Hera, and the winners were allowed to dedicate images of themselves in her temple, not unlike the male athletes who could set up life-size statues after three wins.

An interesting and not untypical example of female economic autonomy is preserved in the archive of an institution called the *é-MI* (household of the wife) or *é-bau*, in the Mesopotamian city of Girsu. Here the queen personally oversaw an extensive household parallel and nearly equal to the king's in the mid-twenty-fourth century BC. It grew over the years from employing fifty people to fifteen hundred, mostly in agriculture.

Lower-class Roman women were active in the service economy, ranging from selling vegetables in the public marketplace to serving wine in taverns. Greek women also sold food, and we are told that the

playwright Euripides's mother was the most famous Athenian vegetable seller. A dedication to Athena by a thankful washerwoman was found on the Athenian Acropolis. Luxury goods such as ribbons and garlands for the *symposium* were another product of women's handiwork in Athens. However, financial limits were imposed, so trade was always on a small scale; Athenian women were not allowed to conduct transactions above the value of one *medimnos* of barley, roughly equivalent to between three and six *drachma*, or a week's wages.

TEXTILE PRODUCTION

The old adage 'a woman's work is never done' certainly applies to the necessities of human life: food and clothing. Because food preparation and cloth production are compatible with child rearing, these activities fell to women from earliest times; unlike hunting and herding, for instance, they could be interrupted as needed for the nursing and tending of children. These were demanding and full-time jobs both for the women of the house and their slaves. In describing what is probably a typical Iron Age palace, Homer states: 'And fifty serving women he has in his house; some grind the apple-coloured grain at the mills, and others weave at the looms and whirl the spindles.' Archaeological evidence confirms this with an abundance of loomweights and spindle whorls often found side by side with grinders and cooking pots in domestic contexts.

The processing of wool and linen, the two basic raw materials for cloth in the ancient Mediterranean, was a labour-intensive and time-consuming task. The organic material first had to be collected, then spun into yarn, dyed, and finally woven into fabric. Raw sheep's wool required washing, combing and roving into bundles, and flax was plucked by hand, dried, soaked in water to loosen the fibres, pounded, and finally combed, all before spinning could begin. Spinning was a never-ending task; to spin enough wool for a single garment (two-metre-square cloth) would take a woman at least twelve days if she spun for six hours each day. The setting up of the warp-weighted loom involved two women for about a week, and they could weave two metres of plain cloth in about six days. To put it another way, it took ten spinners in continuous employment to keep one loom supplied with yarn. That is perhaps why the Paionian woman in Herodotus's tale was so dazzling: she could lead a horse and simultaneously carry a jar of water on her head, all the while spinning with her distaff!

Spindle whorl, from Troy, 3000–2000 BC. Clay, diam. 3.1 cm. Excavated by Heinrich Schliemann at Troy, this modest clay object attests to the production of cloth in the Early Bronze Age. The clay weight was attached to a spindle and with the distaff was used in spinning wool into thread. Spindles have been found in women's graves from the third millennium BC to late Roman times.

WOMEN IN THE ANCIENT WORLD

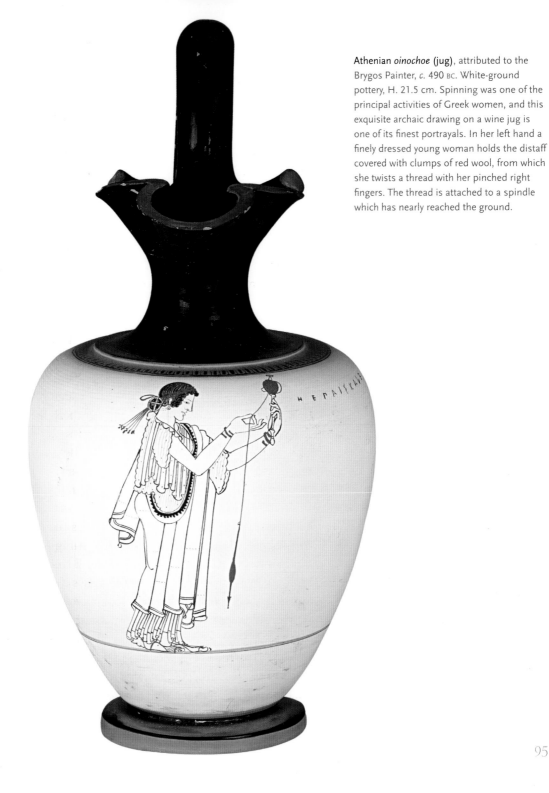

Athenian *oinochoe* (jug), attributed to the Brygos Painter, *c.* 490 BC. White-ground pottery, H. 21.5 cm. Spinning was one of the principal activities of Greek women, and this exquisite archaic drawing on a wine jug is one of its finest portrayals. In her left hand a finely dressed young woman holds the distaff covered with clumps of red wool, from which she twists a thread with her pinched right fingers. The thread is attached to a spindle which has nearly reached the ground.

Two studies of an Athenian *epinetron* (thigh protector), *c.* 500–480 BC. Black-figure pottery, L. 31.1 cm (drawing: pen and ink with bodycolour on paper, 18.3 x 25 cm). This terracotta piece of domestic equipment was used to protect the thigh of a woman during the process of bundling combed wool into balls called roves. Along its side are women working in pairs at their wool baskets.

Because textile manufacture in general and wool-working in particular are so demanding, they were performed at all levels of society. Women of noble rank on Palmyrene grave reliefs are often portrayed with their distaffs in hand (see p. 131). In the *Odyssey* the dutiful wife Penelope sits faithfully at her loom, and Helen, the queen of Sparta, returned from her Trojan adventure, is portrayed with her silver wool basket and golden distaff. The Roman Republican heroine Lucretia was a symbol of female industry as she worked at night by lamplight with her maids. Augustus claimed that his togas were produced by his wife Livia or daughter Julia. It is not certain, though, whether idealized depictions of upper-class women spinning are affectations or representative of an actual pastime. Clearly the wife or *mater familias*, even if she did not actually spin or weave herself, supervised the household staff, consisting largely of female slaves.

Perhaps a more realistic picture of female labour in the textile industry is presented by extant ancient clay tablets. Those from Ur and Girsu (Mesopotamia) and from Pylos and Knossos (Greece) are remarkably similar. In Girsu there is evidence that more than six thousand female textile workers were active at the same period. At Ur the weaving was sent out to about twelve thousand female weavers in nearby villages. The women were paid for their labour in rations of barley and oil, but received considerably less than that paid to the men: 30–60

litres of barley as opposed to 60–300 for male workers. The Pylos tablets indicate specialization of labour; some women were charged with preparing the wool or flax, others spun, wove or made borders, and some sewed garments. There appear to have been workshops for these specific tasks, some located in Pylos and others further away. Middle Kingdom models from Egypt, on the other hand, show women producing cloth from start to finish in self-contained factories with two looms.

FOOD PRODUCTION

The second most time-consuming activity in the ancient household was preparing cereals for consumption. Until the invention of mechanized milling in the late fifth century BC, most of the arduous work of husking and grinding grain and barley for flour was done by hand, and by women. Once the grain was ground it had to be sifted, kneaded and baked into bread, or boiled into porridge. Another grain product, beer, was the beverage of choice in ancient Egypt and an important part of the diet. Bread and beer were produced in the same establishments in ancient Egypt, by both men and women.

What few representations of cooking that do survive from the ancient world seem to suggest that women did most of the food preparation, with the exception of meat and fish, which were high-status foods. Butchering and roasting animal flesh seems to have been a man's job, not unlike grilling today. Professional cooks were always male, it being a paid profession which required advanced training. Once more mechanized and labour-saving means of production were devised, such as the vertical loom in Egypt or the rotary flour mill, and industries consequently became more profitable, men took over much of the business of food and textile production.

In upper-class Roman households men and women dined together reclining on couches, whereas in classical Greece they ate separately, except for informal family dinners. On Athenian vases men are commonly depicted convivially drinking their after-dinner wine in the *andron*, or men's dining room, while women, mostly alone, are rarely shown eating and almost never drinking. Osteological evidence from Bronze Age Greece shows that men ate more meat and fish than women, and women of child-bearing age were more likely to suffer malnutrition.

Egyptian model group of brewers and bakers, from Deir el-Bahri, c. 2000 BC. Wood, L. 78 cm. Various phases of bread and beer production are illustrated in this small-scale model, from the thirteen women with grindstones leaning over their querns, to those crouching in front of the ovens. A male supervisor stands at the right.

WOMEN IN THE ANCIENT WORLD

Greek figurines, 5th century BC. Terracotta, H. 6 to 13 cm. These charming figurines show women in a variety of domestic tasks: two are grinding grain, one tends the oven, an old nurse holds a child, while the fifth takes a bath.

MEDICINE AND CHILDCARE

Because of their sex, women were indispensable in the area of obstetrics and gynaecology. Although most doctors in Greece and Rome were male, there is evidence for a minority of freelance female physicians. Midwives were always women, and mostly freeborn, who apprenticed for the job under the tutelage of older experts. Socrates's mother Phainarete, for instance, was a citizen midwife. They not only supervised the pregnancy and treated gynaecological disorders, but were also expected to make decisions in a crisis, even in the presence of a doctor. In his textbook on gynaecology, Soranus stipulates the strict prerequisites for midwives: 'A suitable person will be literate, with her wits about her, possessed of a good memory, loving work, respectable and generally not unduly handicapped as regards her senses, sound of limb, robust, and according to some people, endowed with long, slim fingers and short nails at her fingertips.'

Another area in which women were by nature indispensable was nursing, and in the ancient world wet-nursing was one of the few paid professions open to freeborn women. Either because a new mother was unable to nurse or because she wanted to save her energy for her next pregnancy, newborns were often turned over to nurses for lactation. Again Soranus expects high standards of wet nurses: they should be between twenty and forty years old and have had two or three babies of their own. Ancient Sumerian and Akkadian texts as well as Greek papyri state the belief that intercourse inhibits a woman's ability to suckle, or spoils the milk. Three years appears to be the normal term of duty for a wet nurse. Tacitus indicates that upper-class Roman mothers automatically delegated lactation to slave nurses, and their services often earned them manumission (the granting of their freedom).

Although fictional, the tale of Eurycleia, the faithful servant of Odysseus's household, may be typical of many successful female slaves in antiquity. She was bought by king Laertes for twenty oxen when she was still a young girl. Homer goes on to say, 'he favoured her in his house as much as his own devoted wife, but never slept with her, for fear of his wife's anger'. Besides bringing up both Odysseus and his son Telemachus, she supervised the fifty serving women in the palace. In her own words, she states, 'these I have taught to work at their own tasks, the carding of the wool, and how to endure their own slavery'. Even in her old age she cares for the young prince Telemachus, lighting his way to bed with

Greek figurine, *c.* 300 BC. Terracotta, H. 13.5 cm. This huge-headed woman holding a baby is a parody of a nurse. Nurses were often faithful family retainers who had a closer intimacy with children than did their birth mothers.

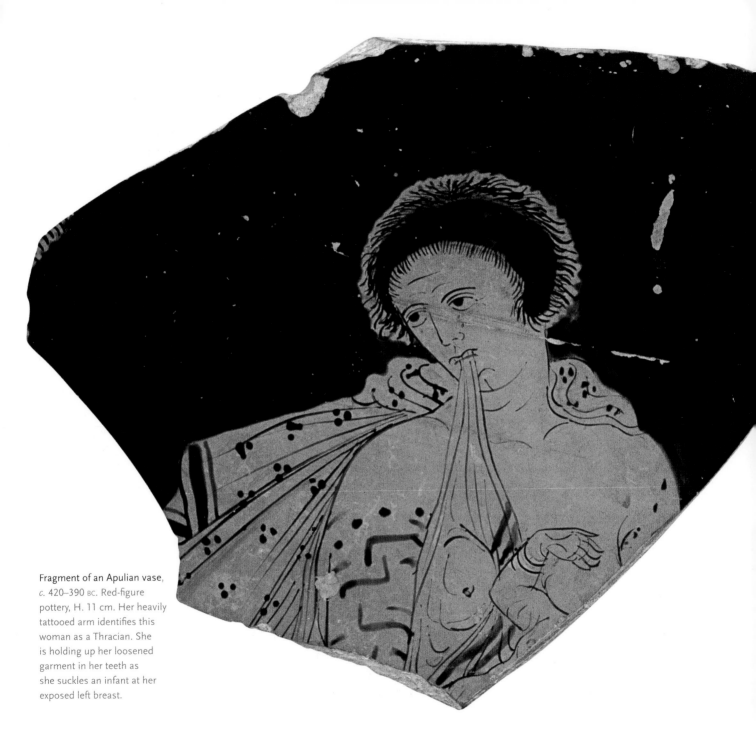

Fragment of an Apulian vase, *c.* 420–390 BC. Red-figure pottery, H. 11 cm. Her heavily tattooed arm identifies this woman as a Thracian. She is holding up her loosened garment in her teeth as she suckles an infant at her exposed left breast.

torches and folding his clothes, and she washes the feet of a strange visitor to the palace who turns out to be Odysseus.

ENTERTAINMENT

In most ancient societies there were various levels of entertainment provided by females, ranging from stately choral dances accompanied by music at high religious festivals to more raucous pipe-playing and nude performances at banquets and *symposia*. Women who engaged in musical and dance performances could come from the royal court or be lowly slaves, depending on the venue. Besides religious ceremonies, music often accompanied weddings and funerals, athletic and theatrical performances and routine activities such as weaving or cooking.

The most famous female musician in antiquity was the poet Sappho, who is credited with combining Lydian musical forms with Greek tunes. She was well known for her wedding songs (*epithalamia*), which were performed by girls' choruses at marriage ceremonies. In the aristocratic society of Lesbos it was apparently traditional for young women to receive instruction in poetry and music from an older woman. Sappho was the leader of an informal group of women who were possibly united in their worship of Aphrodite, the Graces and the Muses, in whose honour many of the songs were composed.

In ancient Greece most of the visual evidence comes from Athens, where boys are often shown receiving instruction in music as a basic part of their education; in later life they are known to play instruments regularly and sing in a variety of venues, such as the *symposium* and the gymnasium, and in musical contests. Women were restricted to two extremes, flute-playing as sympotic entertainment and private performance on the lyre. What are presumably upper-class women are sometimes depicted on classical Attic vases making music in domestic settings. At the other extreme are the flute girls who were paid to entertain men at

Roman coin, minted in Mytilene, 2nd century AD. Copper, diam. 2 cm. One side of this coin shows the profile bust of a woman and the other side a lyre. The woman is identified as Sappho, the famous Greek poet, who was born on the island of Lesbos around 612 BC.

Athenian *hydria* (water jar), *c.* 440 BC. Red-figure pottery, H. 39.4 cm. Here Greek women are making music in a private setting. One plays the pipes (*auloi*) while the other strums a lyre. The god of love, Eros, flutters overhead.

the all-male *symposium*. In the *Constitution of Athens* the first duty listed for the Athenian police was to control the price of the flute girl (*auletris*) as she was often auctioned off at the end of the evening for sex.

While professional musicians in antiquity were mostly male, music was one area in which women could achieve some level of competence. Music was an important form of courtly entertainment and ensembles of female musicians are regularly depicted in Egyptian tomb paintings. In the early period women were confined to harps and hand-clapping or shaking beaded necklaces, but by the end of the Old Kingdom female instrumentalists appear alongside men. By the time of the New Kingdom, all-female groups become dominant. Royal women often participated in these musical ensembles, which played in temples, tombs and palaces.

Neo-Assyrian *pyxis* (box), *c.* 900–700 BC. Ivory, diam. 9.5 cm. The elaborate reliefs on this toilette box show musicians in procession towards an enthroned woman. They are playing double pipes, zithers and the tambourine.

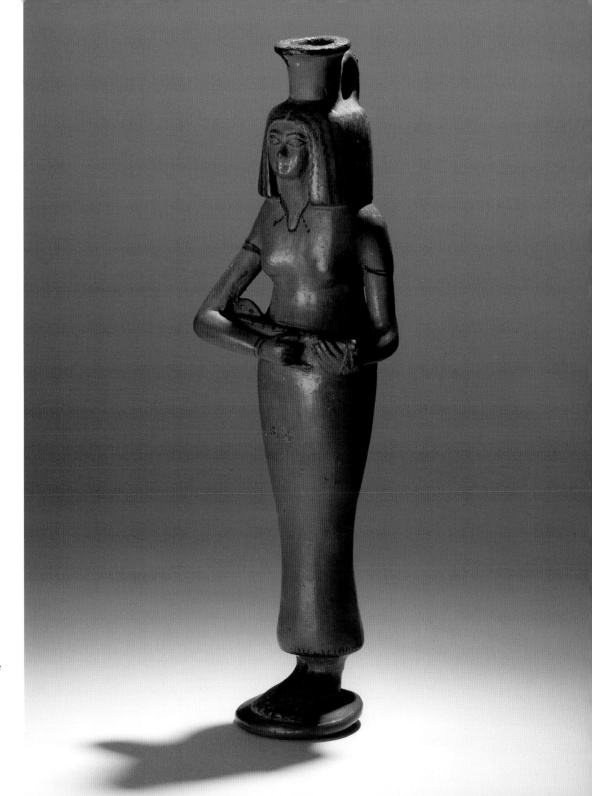

Egyptian bottle, from Thebes, 18th Dynasty (1550–1295 BC). Terracotta, H. 23 cm. This fine mould-made vessel takes the form of a female lute player.

Egyptian wall painting, from the tomb of Nebamun, Thebes, 18th Dynasty, c. 1400 BC. Painted plaster, H. 29 cm. Four female musicians and two nude dancers are entertaining at a banquet, depicted above. The first three women are clapping while the fourth plays a double flute. The hieroglyphs above them indicate that they are singing of the annual life-giving flood of the Nile. Because these women are servants they can be posed in a less formal style and with freer hairdos than is the norm in Egyptian art.

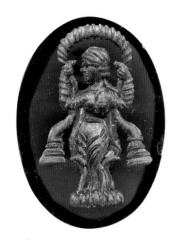

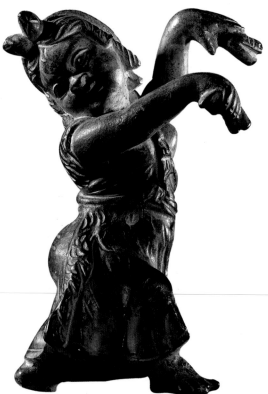

In ancient Egypt dance was a means of marking or celebrating transitions such as the New Year, birth, or the all-important rebirth in the afterlife. Funerals in Egypt therefore featured dancing. A specialized group known as 'the ladies of the acacia house' danced in celebration of the successful mummification process. At religious festivals such as the sacred marriage of Amun and Mut, acrobatic dances were performed by groups of women. Young nude girl dancers are depicted in New Kingdom tombs as part of the entertainment at funerary banquets.

Female dancers in the ancient world often wore elaborate and expensive costumes. Veiled dancers seem to have had a particular allure, and while Salome's 'dance of the seven veils' may be apocryphal, it has a curious parallel with an old Near Eastern myth. During her descent to the underworld to visit her sister, the fertility goddess Ishtar was required to remove her seven garments one at a time. Another alluring costume was male military attire; young girls on Attic vases are occasionally shown nude except for a helmet and wielding a shield and spear while performing an armed dance, known as the pyrrhic.

In the classical theatre of Greece and Rome, as in Shakespearean times, female roles were played entirely by men. However, according to Roman literary sources, women appeared on stage in mimes, pantomimes, comic skits, bawdy songs and acrobatics. Many of these performances were erotic in nature, and

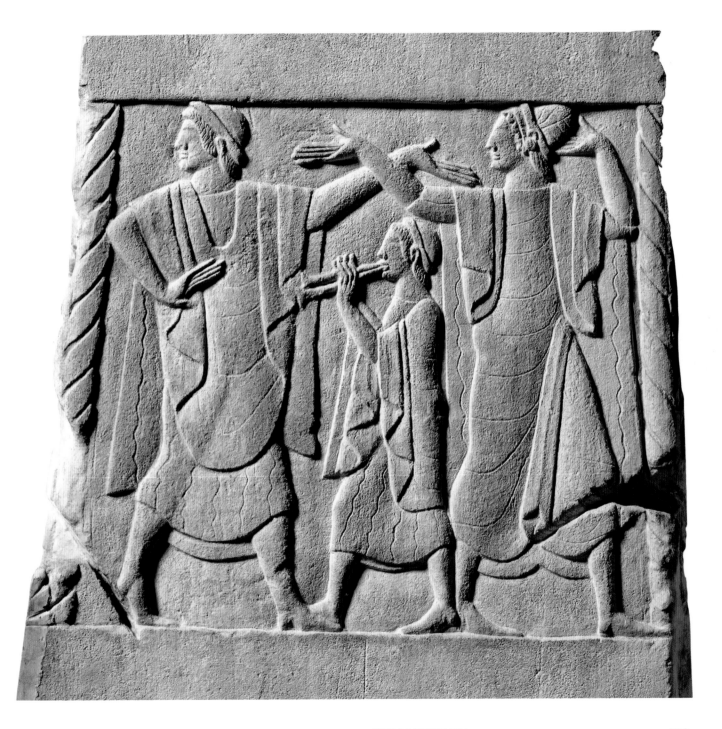

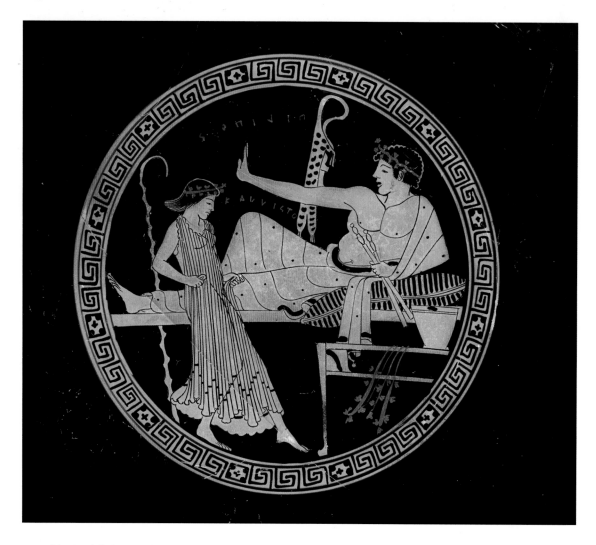

ABOVE: Athenian *kylix* (wine cup), *c.* 490–480
BC. Red-figure pottery, diam. 31.9 cm.
A young girl is dancing at the all-male
symposium before a youth reclining on his
banquet couch. She wears a wreath and
holds up her dress, showing off her ankles.
Her short hair indicates her slave status.

OPPOSITE: Athenian *hydria* (water jar), from
Capua, *c.* 430 BC. Red-figure pottery, H. 39 cm.
A woman is teaching two young girls to dance
while a customer looks on. A lyre hangs in
the background, and the teacher is holding
a money pouch, presumably containing
payment for the entertainment.

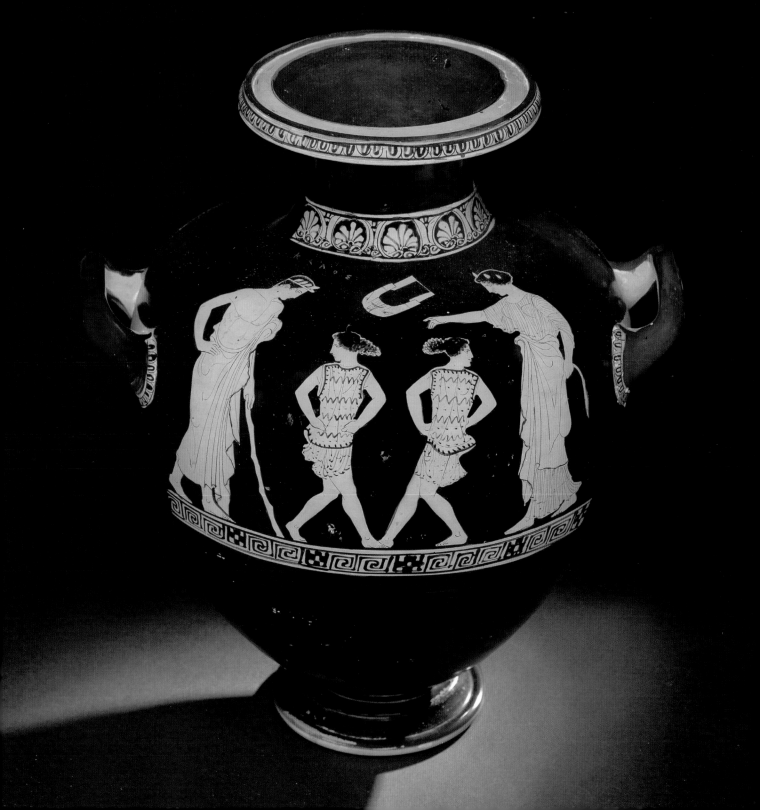

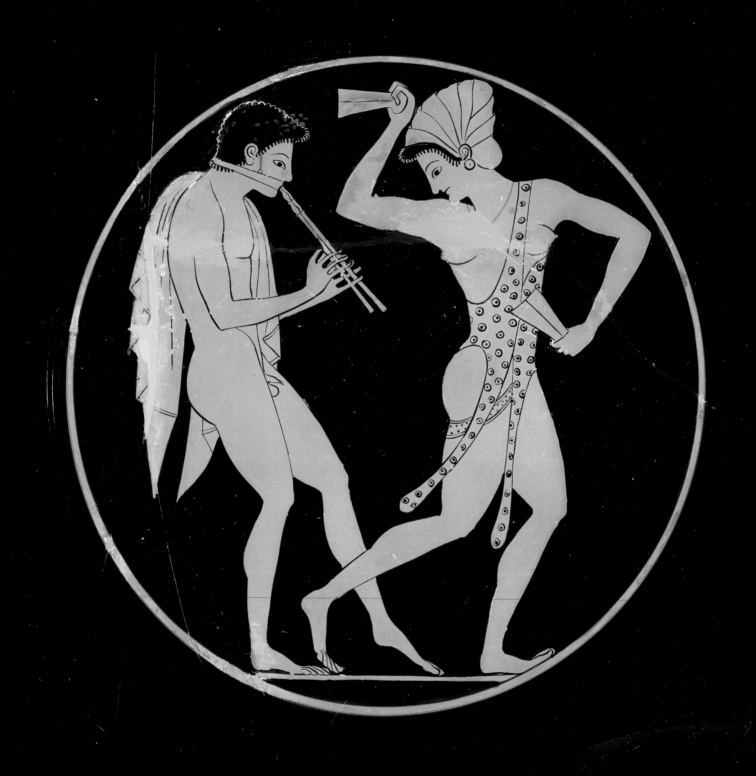

the performers were considered second-class citizens, if not prostitutes. In 54 BC, when a man named Pancius was charged with raping a dancer, Cicero defended him by claiming that it was an old country right to molest dancers.

In Athens only young girls are shown both learning to dance under the instruction of older women and dancing at the all-male *symposium*. Their short tunics, transparent drapery and short hair indicate that they are either paid

RIGHT: **Corinthian cup**, from Tanagra, *c.* 450–400 BC. Pottery, diam. 8.9 cm. Women are rarely shown partaking in male sympotic activities. This well-dressed woman is playing a drinking game called *kottabos*, which involves flicking the dregs of one's wine cup towards a target.

OPPOSITE: **Athenian cup**, by Epiktetos, *c.* 500 BC. Red-figure pottery, diam. 33 cm. Dancing before a youth playing the pipes is a young girl with castanets (*krotala*). Her nearly nude body indicates that she is a *hetaira* and her spotted animal-skin suggests her untamed nature.

LEFT: **Corinthian** *aryballos* (perfume bottle), *c.* 620–610 BC. Pottery, diam. 9 cm. Perhaps the female equivalent of the notched belt, this amusingly inscribed perfume flask is a rarity. The woman shown in profile on the handle identifies herself as Aienta; below are painted the names of nine men, possibly her lovers or admirers.

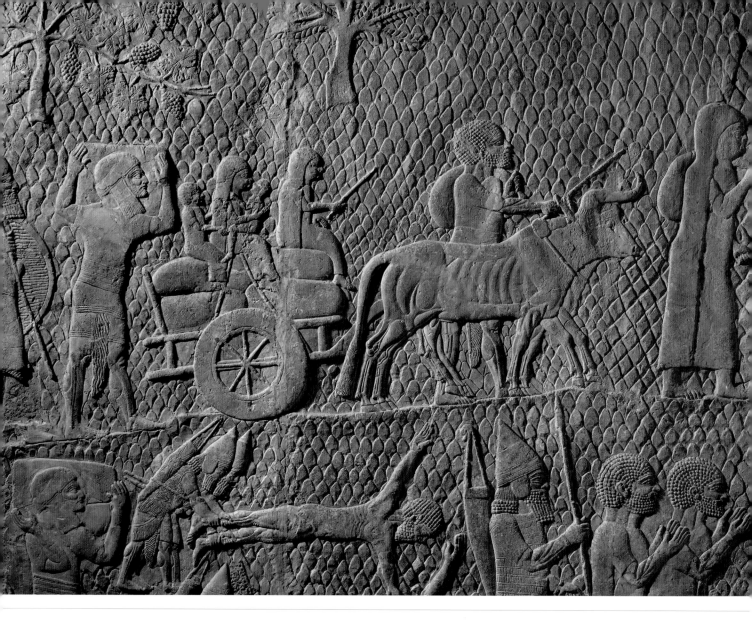

Neo-Assyrian wall relief, from Nineveh, *c.* 700 BC. Gypsum, H. 269 cm.
The battle relief from King Sennacherib's siege of Lachish depicts
Judean prisoners of war in family groups being driven into exile or
slavery with their goods and animals. Many of these prisoners are
women with children, and some of the men are being executed.

WOMEN IN THE ANCIENT WORLD

entertainers or slaves. They clearly represent the hired entertainment for the evening, and not citizen daughters, who would only have danced fully clothed at religious festivals.

PROSTITUTION

Prostitution was legal and common in all ancient societies. The notion of 'sacred prostitution' in the ancient Near East will be addressed in Chapter 6.

Most of our evidence, visual and textual, for prostitution in Greece comes from Athens, although the ancient port city of Corinth had a reputation as the red-light city of ancient Greece. Prostitutes were mostly slaves or foreigners resident in the city, as the law forbade citizen women from selling their bodies. They ranged from street-walkers or lowly *pornai* to high-class, well-educated courtesans known as *hetairai*, somewhat akin to the Japanese *geisha*. The most famous of the latter in classical Athens was Pericles's foreign mistress Aspasia, whom he eventually married. In Athens one could purchase the services of a cheap whore for a mere one *obol*, whereas a high-priced courtesan might fetch 500 *drachma* (or 3,000 *obols*) for the evening. One easy way in which states raised revenue was in taxing prostitutes, usually the cost of one assignation.

Brothels are not always easy to distinguish in the archaeological record, but at least forty have been uncovered in ancient Pompeii. These are identifiable by the presence of a cement bed and often pornographic wall paintings. A building in Athens identified as a brothel produced a number of loom-weights, suggesting that the *pornai* produced textiles when not servicing clients. Although ports were often locations for brothels, there were no 'red-light' districts per se. The Latin term for prostitution, *fornicatio*, actually originally meant 'vaulting', because sex was often for sale under the arches of Roman circuses, theatres and amphitheatres.

LEFT: **Greek statuette**, from Tanagra, *c.* 350–290 BC. Terracotta, H. 19 cm. In Greek art this is the ultimate portrayal of the 'Other', or the opposite of the male ideal: female, old, obese, tattooed. She is certainly a foreign (Thracian) slave and probably also a prostitute.

BELOW: **Egyptian statuette**, 18th Dynasty (1550–1295 BC). Wood, H. 14 cm. Like many domestic servants in Egyptian art this one is young, female and foreign. With the exception of a pair of large earrings and a neck collar she is nude, and somewhat plump. The large chest which she steadies on her head served as a cosmetic container, and the applicator was probably once in her left hand. Her unusual hairdo (three braided pigtails) indicates her foreign origin.

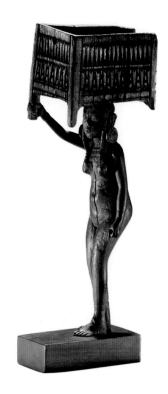

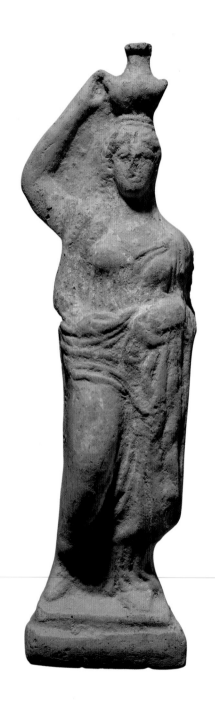

SLAVES

All the occupations addressed thus far were performed by female slaves. Slavery was ubiquitous in the ancient world, and much of the hardest labour was performed by both adult and child slaves. A slave society can be defined as one in which approximately twenty per cent of the total work force is enslaved labour. Surprisingly, democratic Athens had more slaves than most ancient societies; it is estimated that they made up as much as a third of the total population. Female slaves were often acquired as the spoils of war because the male enemy was routinely killed while the women and children were taken into captivity. Piracy in the ancient Mediterranean was also a source of slaves, as described in the *Odyssey*, where the Phoenicians deal in stolen human cargo. Finally, the exposure of newborns who were deemed unfit to live sometimes resulted in their rescue and eventual upbringing as servants. Since more girls than boys were unwanted, this practice may have been a source of livelihood for those dealing in prostitution.

Domestic slaves, many of whom were female, were common in all but the lowest levels of society. Homer described the household of Odysseus on Ithaca as having fifty slave girls (twelve of whom were dishonourably killed by hanging, a form of execution for women, for having slept with Penelope's suitors). A Roman matron had numerous female attendants, both slaves and freedwomen, who served as her personal hairdresser (*ornatrix*), clothes-folder (*vestiplica*), masseuse (*iunctrix*) and page or 'foot-follower' (*pedisequa*).

WOMEN AT THE FOUNTAIN

This chapter closes with a conundrum that illustrates the problems confronting ancient historians and archaeologists when interpreting the silent material record. A series of some seventy Athenian vases, known as *hydrias* or water jugs,

Greek figurine, from Halicarnassus, 4th century BC. Terracotta, H. 16.5 cm. Cheap clay statuettes representing women carrying water vessels are common in votive deposits in Asia Minor. Given their religious contexts, it seems probable that they represent females involved in a ritual.

Athenian *hydria* (water jar), from Etruria, c. 520 BC. Black-figure pottery, H. 49.5 cm. A pair of young girls is filling their jars at the fountain house at the left, while two more are bearing filled hydrias on their heads. Inscriptions identify them as Kallista ('prettiest'), Melissa ('honey bee') and Rhodo ('Rhodian').

WOMEN IN THE ANCIENT WORLD

Athenian *hydria* (water jar), from
Etruria, *c.* 510 BC. Black-figure
pottery, H. 50.8 cm. Four women
dressed in long *chitons* are at a
Doric fountain house filling their
hydrias from two equestrian and
three lion-head water spouts.

Athenian *hydria* (water jar), from
Etruria, *c.* 510 BC. Black-figure pottery,
H. 58.4 cm. Three women are filling
their water jars at an Ionic fountain
house which has lion-head water
spouts. The structure is flanked by
two male divinities, Dionysos at left
and Hermes at right.

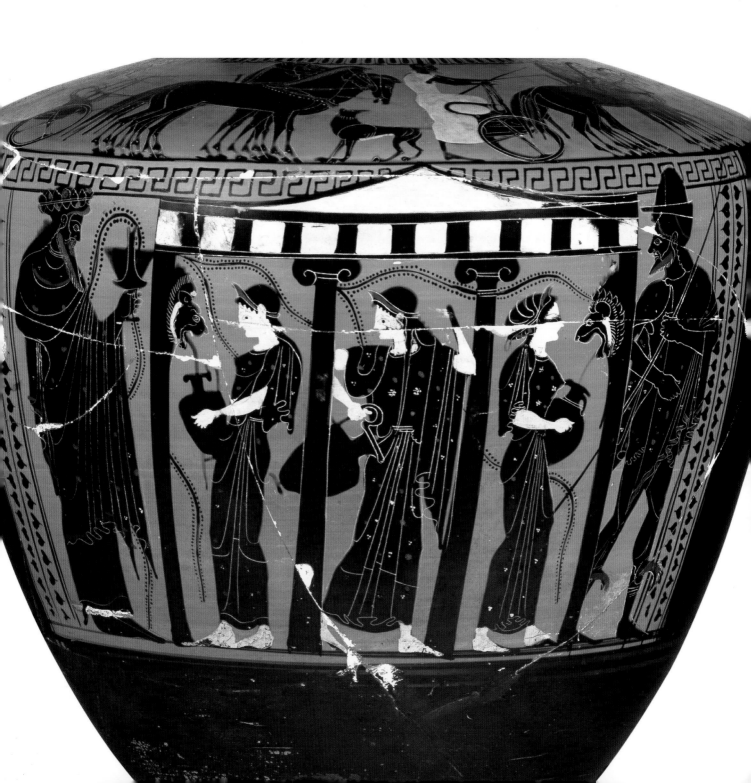

depicts what seems to be a common scene from the past: women fetching water at the spring or fountain house. Vase paintings do not usually include architecture, so these vessels are quite distinctive; they show in detail the roofs, columns and waterspouts of actual structures which on account of their size must have been public buildings. Because the women are carrying or filling *hydrias*, the images are also self-referencing, as if the potter were advertising his wares and their potential use to his female clients.

But who exactly are these women? It has been argued that only slaves would fetch water in sixth-century BC Athens. However, the women are clearly well dressed and some wear jewellery, suggesting that they are aristocrats or wives of citizens. Other scholars argue that because respectable women would not be seen in a public place, the figures at the fountain must be prostitutes. Depending on how one identifies the women, the interpretation of the scene varies. If they are slaves, the scene simply depicts ordinary daily life. If aristocratic women are portrayed, then the context must be one of ritual, either the fetching of water for a wedding purification, or for part of the spring wine festival of Dionysos known as the Anthesteria. This interpretation may be supported by art in other media, namely votive terracottas that represent women carrying water jars. Alternatively, these women could be part of some imaginary past, based on the text of Herodotus, who stated that only in the early history of the city did citizen women fetch water. Others would argue that these images are not 'real' at all, but constructs of Athenian life designed for the export market to Etruria, where women enjoyed greater liberties and where most of these *hydrias* were found.

Underlying these various interpretations is the central question regarding women's roles in ancient society. Were they secluded in the house, forbidden contact with non-relatives, completely submissive to their husbands and exploited as a cheap source of labour? Or were they partners with their husbands, valued for their contribution to the household economy, and active participants in public rituals considered essential to the well-being of the state? The answer undoubtedly lies neither at the pessimistic nor the optimistic end of the spectrum, but somewhere in the

middle. While there is little evidence to suggest that women in antiquity received any formal education before the Hellenistic period, or that they ever participated in political life (except behind the scenes), they exercised authority within the household and on some occasions played a role in public. The prevailing ideology in many cultures militated against any real agency for women, and so their activities beyond the ubiquitous wool-working, which symbolized their virtue and industry, receive little play in art or literature. One exception is the realm of religion, which we will consider in detail in Chapter 6.

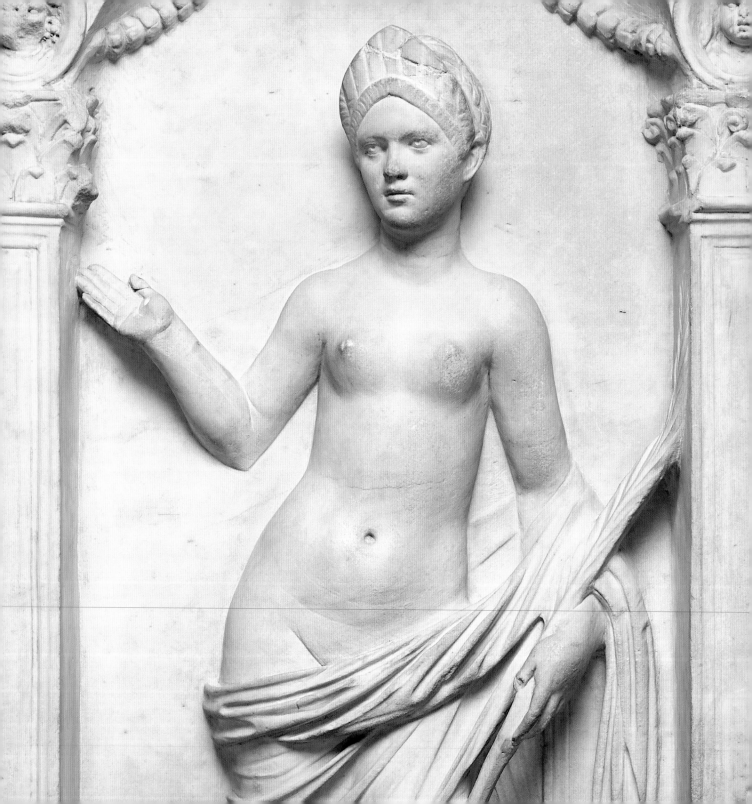

THE BODY BEAUTIFUL

THE BODY BEAUTIFUL

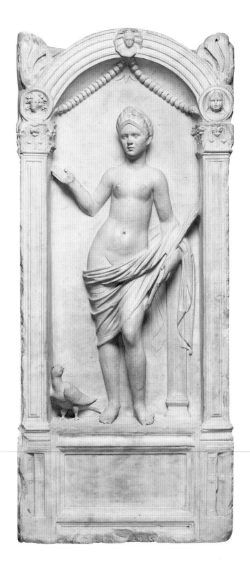

I N THE epic poem *Iliad*, composed in the late eighth century BC, Homer describes in detail the goddess Hera's elaborate preparations from head to foot for the seduction of her husband, Zeus:

> First she cleansed her lovely skin,
> With ambrosia, then rubbed on scented oil . . .
> She rubbed this into her beautiful skin,
> And she combed her hair and plaited
> The lustrous, ambrosial locks that fell
> Gorgeously from her immortal head.
> Then she put on a robe that Athena
> Had embroidered for her, pinning it
> At her breast with brooches of gold.
> A sash with a hundred tassels
> Circled her waist, and in her pierced ears
> She put earrings with three mulberry drops
> Beguiling bright. And the shining goddess
> Veiled over everything a beautiful veil
> That was as white as the sun, and bound
> Lovely sandals on her oiled, supple feet.
>
> (14.167–185, transl. Stanley Lombardo)

PREVIOUS PAGE (DETAIL) AND LEFT:
Roman tomb relief, *c.* AD 120. Marble, H. 162.5 cm. The deceased, possibly a freedwoman, on this funerary relief epitomizes Roman idealization; she is portrayed as the nude goddess Venus sporting an elaborate contemporary coiffure. Her small breasts and wide hips constitute the Roman ideal for female bodies. The palm branch in her left hand symbolizes victory, and the dove at the lower left is a further reference to Venus. In the Roman context female nudity represented the beauty and refinement of the *matrona* (married woman) rather than sensuousness.

Zeus could hardly resist, and the passage ends with them making love enveloped in a cloud. This Homeric scene has a prototype in the Mesopotamian goddess Inanna's hymn of praise for a king of the Third Dynasty of Ur from *c*. 2000 BC:

> Since for the king, for the lord, I bathed,
> Since for the shepherd Dumuzi I bathed,
> Since with paste my sides were adorned,
> Since with balsam my mouth was coated,
> Since with kohl my eyes were painted . . .

The arts of female adornment are age old and show little sign of diminishing to the present day. Although men also underwent considerable bodily grooming, the care and embellishment of the female body was a preoccupation, not to say obsession, of women throughout antiquity. Texts indicate that elite women bound their breasts, curled their hair, depilated their bodies, donned wigs, tattooed their skin, perfumed their flesh, applied facial cosmetics and bedecked themselves in fancy clothes and jewellery, in many instances to attract men or seduce their husbands. The body and its adornment, or lack thereof, constituted important signs of gender, age, status and social roles in antiquity, just as a wedding ring does today, and as we shall see, the processes of beautification have changed little over time.

However, the rhetoric of grooming and dress is not always straightforward and can be obscure to modern viewers. Some Egyptian statues, for instance, have been misidentified as female because of their elaborate double wigs, which are actually a type worn by males. In many instances in ancient art women are shown in archaic costume rather than contemporary dress, the Greek *peplos* being one example, so works of art cannot always be relied upon to record daily attire. Perhaps unexpectedly, in ancient Rome young girls and prostitutes wore the *toga*,

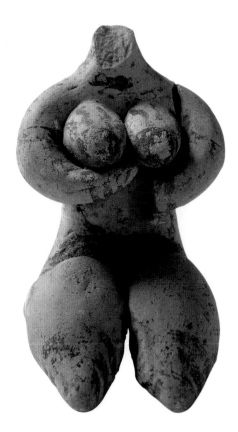

Neolithic figurine, from North Syria, *c*. 6000–5000 BC. Clay, H. 8 cm. Obesity was all the rage for women in the Neolithic period, as evidenced by this seated female figure typical of the Halaf culture of the sixth millennium BC. Neither hands nor feet are indicated and the emphasis is on fertility. The painted decoration on her body may represent clothing, jewellery and/or tattooing.

125

Cycladic figure, *c.* 2700–2500 BC. Marble, H. 76.5 cm. This nude female with folded arms is typical of Aegean Bronze Age sculpture, where male figures are rare. Although they look fairly simple, these statuettes, like most later classical sculpture, were extensively painted, providing evidence for female adornment verging on the garish.

the traditional dress of upper-class men. And some Athenian vases depict bearded men wearing women's garments and carrying parasols. This apparent transvestism has other explanations and warns us to use caution when decoding ancient mores. Likewise the absence of clothing on women in Greek scenes of bathing has led to their consistent identification as *hetairai* or prostitutes, although it is possible that they are simply brides performing their pre-nuptial purifications.

'DEATH BECOMES HER', OR FUNERARY CONTEXTS

As noted in the introduction, women in antiquity, such as the elderly Etruscan lady Seianti, looked younger, lovelier, and more refined in their funerary portraits. Not unlike the photographs in today's newspaper obituaries, the images of women after death immortalized them in the ancient equivalent of an airbrushed, younger, more svelte and more glamorous version of themselves. At least as far back as the beginning of the Bronze Age, if not earlier, and in most ancient cultures, idealized images of women were placed in or on their graves. They are portrayed decked out in expensive jewellery, just as their corpses were often arrayed with their choicest possessions. Thus, while these images may not convey the actual appearance of any individual, they serve to illustrate feminine ideals and preoccupations; this is how they, or their loved ones, wanted them to be remembered. This chapter will first present a gallery of these post-mortem portrayals of individual women, and then consider the many elements – clothing, wigs, make-up, perfume, jewellery – with which ancient women adorned their bodies in life.

Bodily adornment is represented on female figurines as far back as the Paleolithic period, but we know little about its cultural significance. Traces of face and body paint are commonly found on Neolithic clay figurines throughout the Mediterranean and on the Early Bronze Age marble statuettes from the Cyclades known as 'idols', which have survived in the thousands. Lacking a certifiable provenance because most were looted in modern times, these simple, white marble, mostly female figurines are said to have been found in graves. The pared-down female form is in a supine position (note the pointed feet) with arms folded across the abdomen. The stylized shape of the head may indicate a special type of hairdo or hat, but otherwise no clothing is apparent. Traces of red paint on these figurines show that their faces were often elaborately decorated with clusters of dots,

Egyptian funerary stela of Deniuenkhonsu, probably from Thebes, *c.* 950–900 BC. Wood, H. 33 cm. A musician of Amun and wife of Ankhkhonsu, this woman is shown worshipping the falcon-headed god Re-Harakhty-Atum, with a table of food offerings placed between them. She is wearing a full wig, a perfume cone atop her head, and a sheer, pleated garment which reveals her somewhat plump body, the favoured female body type after the New Kingdom.

their eyes were heavily outlined, and their necks adorned with necklaces. It is possible that the facial paint of these statuettes echoes that placed on the female corpse, as also suggested by the mineral pigments, containers and grinders found in Cycladic graves. Whether this custom was also practised in daily life is impossible to say, but in many cultures body paint is routinely applied for special occasions, especially rites of passage such as marriage.

Roman mummy portrait, from the Fayum, Egypt, c. AD 160–70. Encaustic on wood, H. 44.3 cm. In addition to her mascara-laden eyes and painted lips, this elegant woman wears exceptionally rich clothing and jewellery. She is garbed in a purple-blue tunic with a wide golden stripe over which is draped a white mantle. Her perfectly waved hair is topped with a gold wreath, and clasped to her ears are emerald and pearl earrings. Most lavish of all is her heavy gold necklace encrusted with large rectangular emeralds and an oval carnelian.

In ancient Egypt, funerary statues and grave stelae of women alone are rare; they are most often shown stiffly seated beside or standing behind their husbands, occasionally accompanied by their children. Some women, such as the highly ranked musicians of Amun, may have rated their own stelae because of their status in the religious realm. Just like men in Egyptian art, they are always depicted in an idealized mode, and their representations kept pace with the changes in fashions and ideal body type: slender in the Old and New Kingdoms and more rounded in later periods. All persons of a certain status required funerary statues as repositories for their *ka* (spirit) and women were no exception. However, the statues were not individualized, a hieroglyphic inscription being sufficient for identification.

In contrast to Egyptian women, the grande dames of Etruria had sufficient status to be given their own tombs, often fitted with their chariots. In addition to their sarcophagi and cinerary urns, these independent women were celebrated in the famous painted tombs, which show them lounging on banquet couches along with men, bidding farewell to their families, or dancing and playing musical instruments. Ideal bodily proportions were not so important in Etruscan culture and the women often look chubby or overly elongated. They are usually elaborately garbed, bejewelled and wearing the distinctive elements of Etruscan dress: pointed shoes and a *tutulus* or high headdress. The lavish jewellery depicted in Etruscan art often finds its real-life counterpart in the contents of the rich burials.

Greek funerary monuments celebrate three distinct ages for elite females: the little girl shown with her toys or pets, the unmarried virgin standing atop her grave as a girl (*kore*) or on a classical stela, and finally the veiled matron, usually seated on a *klismos* (chair). These relief figures are often accompanied by family members, such as a devoted husband bidding farewell, or by maid servants, whose presence underlines the economic and social superiority of the deceased. And for the first and only time in their existence their names are proclaimed publicly, in inscriptions across the tombstone or on the base of the statue. A poignant example is that of the beautiful Athenian girl Phrasikleia, who died around 530 BC. Her base reads: 'I shall always be called maiden, this name being my fate by the will of the gods who deprived me of marriage.'

The vast Roman empire, not surprisingly, has produced a great variety of funerary monuments for women. In Roman Egypt mummification continued,

Etruscan tomb figure, 625–600 BC. Terracotta, H. 58 cm. This under-life-size statue is one of five discovered in a tomb in Cerveteri, Italy, in 1865. It was seated on a rock-cut throne with a banquet table in front, and may represent an ancestor of the deceased. This woman wears large hoop earrings, a checked cloak pinned at the shoulder with a *fibula* (brooch), and a painted bracelet.

but instead of a modelled face mask, painted bust-length portraits were inserted over the face of the deceased in the area of Egypt known as the Fayum. These were executed on wooden panels in the encaustic technique consisting of coloured wax, and with the use of highlights and shading the images are relatively naturalistic. The portraits of women can be dated by their changing hairstyles and types of jewellery. Although they do display some individuality, the women are usually portrayed as young, refined and delicate. Their social status (or perhaps what they wished it to be) is indicated by their fancy dress and jewels.

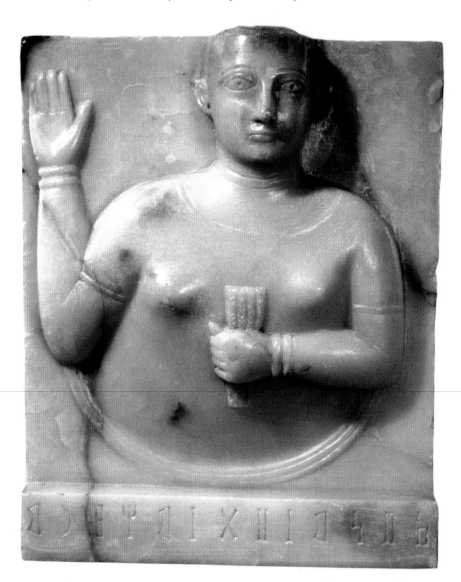

Funerary stela of Aban, daughter of Mahdaram, possibly from Timna, South Arabia, 1st century AD. Calcite, H. 32 cm. Typical of the Arabian peninsula, this alabaster bust was elaborated with inlaid eyes and eyebrows, an old Mesopotamian tradition, and her pierced ears once held metal earrings.

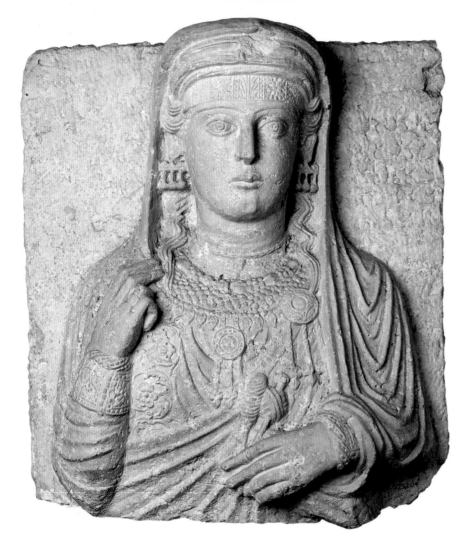

Funerary relief of Tamma, daughter of Samsiqerim, from Palmyra, Syria, *c.* AD 125–50. Limestone, H. 50 cm. With her ostentatious display of jewellery (diadem, earrings, three finger rings, four bracelets, two necklaces and a shoulder brooch) this aristocratic Palmyran matron is clearly signalling her wealth and position. Whether she ever used the spindle and distaff in her left hand, they nonetheless indicate her position within the household.

In the Near East during Roman times, local peoples adopted the earlier Roman practice of funerary reliefs carved with a frontal bust of the deceased in high relief and set into the wall of the tomb. The female portraits show women with the traditional attributes of the good wife (spindle and distaff) or of fertility (sheaf of wheat). They are richly dressed and veiled and wear jewellery, in the Palmyrene examples an excessive amount. In ancient Syria these portraits were similar to the Egyptian *ka*, being known as *nefesh* ('personality' or 'soul') and they enabled the deceased to secure an existence in the nether world.

These female memorials contrast with male funerary monuments, which tend to portray the deceased in a more realistic and less ostentatious manner, and often provide indications of their important roles in society. Whereas in life many of these women led a secluded, private existence, in death they at last show off their fashionable attire, their wealth and their elite status.

COSTUME

In the Mediterranean, a warm climate meant clothing was not a necessity for survival. Reproduction, on the other hand, was of course essential for a thriving community. For this reason, prehistoric statuettes of women often show them wearing some form of attire that draws attention to the genital area, such as a string skirt or amulet belt hung at the hips. This later evolves into a *zone* or belt, a distinctive element of female, as opposed to male, dress. In the Homeric passage cited at the start of this chapter, Aphrodite lends Hera her ornate sash, which she says is inlaid with magic charms: 'Sex is in it, and Desire, and seductive Sweet Talk that fools even the wise' (14.214–17). In Greek art and literature the loosening

Egyptian kohl pot (lid missing), from Thebes, 12th Dynasty (1985–1795 BC). Steatite, H. 7.8 cm. This young girl, her hair in the child's pigtail, is holding a pot for eye paint (kohl). Female servants are often shown naked in Egyptian art, or with just a string of beads around the hips. As seen in the back view these beads are clearly cowrie shells.

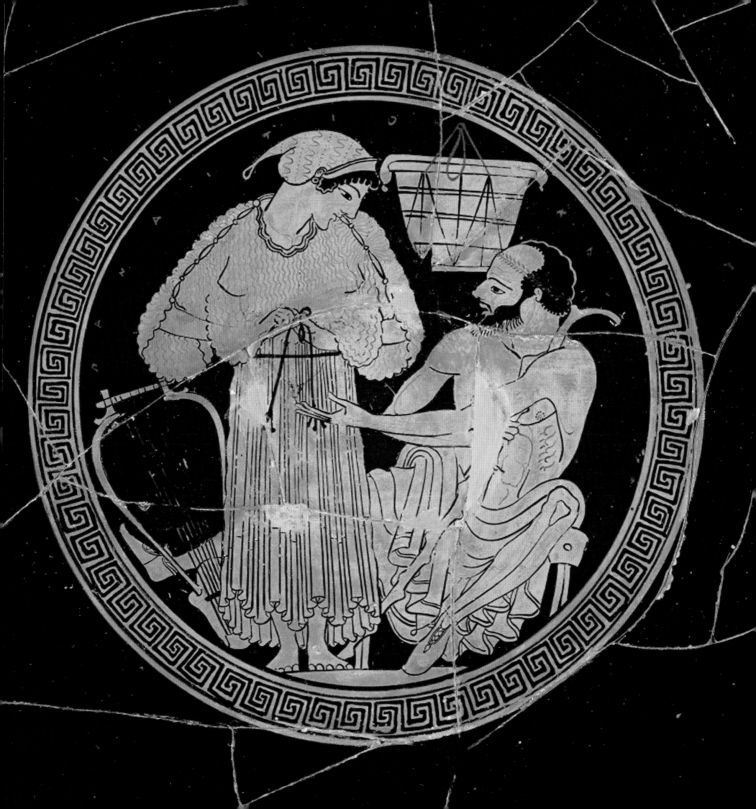

of the woman's belt carried a sexual connotation, and Greek brides traditionally dedicated their belts before going to the marriage bed. The Roman bride's tunic was cinched with a sash of pure ewe's wool, tied into a so-called Herculean knot that was a challenge to undo.

Because so few garments have survived, scholars must rely on literary and artistic evidence for an understanding of ancient dress. In Egypt, where the exceptionally dry climate has preserved various textiles, the articles of dress found in burials often differ from those depicted in the tomb's paintings and reliefs. While most representations of Egyptian women show them wearing form-fitted garments, the surviving ancient dresses are much looser. Given the difficulty of movement in such tight garments, one should perhaps attribute them to the artists' desire to reveal the curves of the female form.

When garments appear in ancient art they are quite simple, usually a piece of rectangular cloth draped around the body. In the ancient Near East the basic garment for women was a cloth hanging over the left shoulder, and reaching to the lower calf, leaving the right arm free. A plain, long, white linen sheath dress is the most popular attire for females in all

Mesopotamian statue, Early Dynastic III, *c.* 2400 BC. Gypsum, H. 22.5 cm. This praying woman wears a fringed robe typical of the Early Dynastic period in Mesopotamia.

Egyptian strung amulets, from Thebes, Middle Kingdom (2030–1650 BC). Electrum, L. 47.2 cm. Cowrie shells were traditionally used for hip belts rather than necklaces. Their cleft form suggests the female genitalia and they were worn by young women either to advertise or to protect their fertility.

135

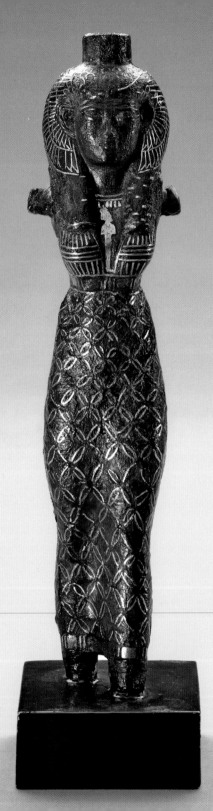

Egyptian figurine, possibly from Thebes, 25th Dynasty, *c.* 716–656 BC. Bronze, H. 21.3 cm. The inlaid silver pattern of this woman's dress may represent a beaded overskirt or fishnet dress. Her cap takes the form of vulture wings and indicates that she is either a queen or a goddess. Her arms and feet, which were made separately, are lost.

periods of Egyptian art, although in later periods it developed a plethora of pleats and appears more voluminous. The women of Greece and Rome draped their bodies with rectangular pieces of cloth in various styles but they always fell fully to the ground, covering their ankles. The Greek *peplos* was a sleeveless woollen tube dress pinned at the shoulder, while the more ample linen *chiton* had buttoned sleeves. Both were belted at the waist and, for outer wear, covered with a woollen mantle or *himation* which could be worn symmetrically over both shoulders or diagonally over one shoulder. Serving girls are depicted wearing long-sleeved ungirt garments. On statues where the colour survives, the textiles are highly decorated with floral, animal and abstract motifs, and ancient texts mention expensive dyes derived from crocus stamens (saffron, yellow) and myrex shells (purple).

The Roman version of this classical garb is the all-enveloping *stola*, a tubular dress worn by wives of Roman citizens, and a cloak known as the *palla*. In his restoration of traditional Roman customs and morality, the emperor Augustus used this protective female garment as an instrument of state. He wished to control women's sexuality as part of his package of measures that included laws regarding marriage and adultery. While the *stola*-cum-*palla* may have been a potent symbol of modesty and respectability, male authors complained that this old-fashioned matronly costume hid women's faces.

In general, the more elaborate the costume the higher the rank of the person depicted. Thus Egyptian women wearing beaded 'fishnet' dresses are usually identified as queens or goddesses. Those without clothes are often slaves or children, but older girls are usually dressed like adults. Women with special religious rank often wore distinctive garments, such as the Vestal Virgins in Rome or the women in the Panathenaic procession in Athens. On the Parthenon frieze the younger women participating in this ritual wear a back-pinned mantle, leaving their arms bared, while the more modest married women are enveloped in their cloaks. The prize for the most elaborate form of female dress in antiquity must surely go to the Minoans of Bronze Age Crete. Their tight bodices contrasted with their wide flounced skirts, and if the works of art are accurate renderings of women's outfits, they regularly exposed their ample breasts.

Millinery per se was not such an obsession in antiquity as it became in later epochs. In spite of the intense sun of Egypt, women are never shown with any kind of sunshade, even in scenes of flax-picking, which must have demanded

Minoan bead, from Crete, *c.* 1500 BC. Gold, L. 2 cm. The distinctive elements of Minoan female dress, bared breasts and flounced skirt, are evident even on this tiny bead.

Greek figurine, from Tanagra, 3rd century BC. Terracotta, H. 19 cm. This stylish woman is wearing a blue *chiton* and rose *pharos*-veil, which she has drawn up over her head. A red sun hat known as a *tholia* completes her outfit, and she holds a floral wreath.

Etruscan tripod attachment, from Todi, *c.* 540–520 BC. Bronze, H. 11 cm. Running to the right, this woman lifts the skirt of her long dress which has a border of crosses. A veil covers her tall headdress (known as a *tutulus*) and she wears boots with upturned toes, both being typical Etruscan attire for women.

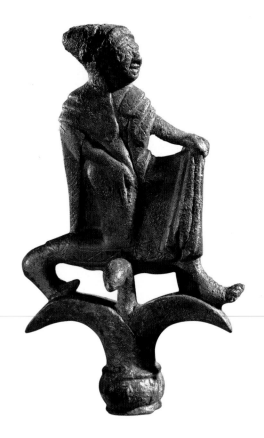

long hours outdoors. The veil was the standard head-covering throughout the ancient Near East, and a strict Middle Assyrian law specified in detail exactly who was required to be veiled:

> Neither wives of lords nor widows nor Assyrian women who go out into the streets may have their heads uncovered . . . The daughters of a lord . . . whether it is with a shawl, robe or mantle, must veil themselves . . . When they go into the streets alone, they must veil themselves . . . A prostitute must have her head uncovered on the street; she must not veil herself . . . He who has seen a harlot veiled must arrest her, produce witnesses and bring her to the palace tribunal; they shall not take her jewellery away but the one who arrested her may take her clothing; they shall flog her fifty times and pour pitch on her head.
>
> Middle Assyrian Law 40

Dress regulations such as this demonstrate the important role the veil, or its absence, played in conveying the modesty and seclusion of the women of antiquity to the outside world. Wives of Greek citizens were regularly veiled in public, and the most common gesture in art denoting a matron or bride was to clutch at her head veil in an apparent attempt to hide her face. According to a Roman anecdote, a consul in the second century BC divorced his wife because she went outdoors unveiled. The Latin verb *nubere* meant 'to marry' as well as 'to veil', and the wedding veil (*flammeum*) was a distinctive yellowish-red colour.

The standard footwear in antiquity for elite women was the sandal, while most others went barefoot. There were various styles, and imported types were all the rage, just as Italian shoes are for women today. In fact, in classical Athens women are said to have preferred 'Tyrrhenian' (Etruscan) sandals, as did their colossal gold and ivory cult statue, the *Athena Parthenos*. Literary sources mention soft slipper-like shoes known as *persikai* ('Persian'), which were worn indoors by

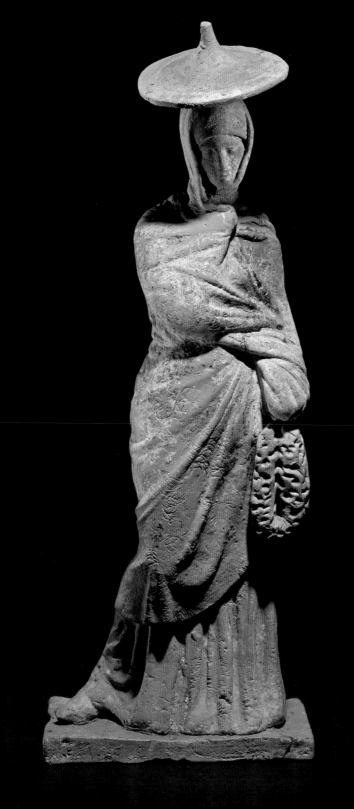

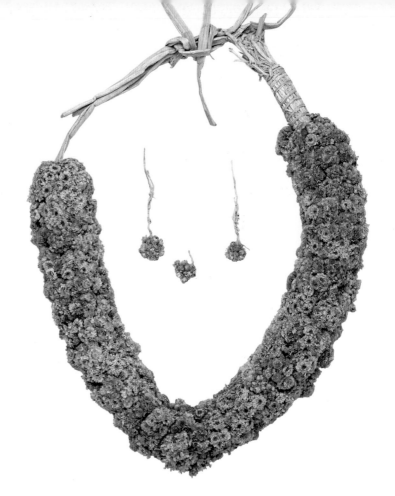

women. A beaked shoe originating in the Near East was popular in Sparta. Greek prostitutes wore saffron-coloured shoes supplied with cork inserts to make them appear taller.

Undergarments are seldom seen in ancient art but Egyptian burials preserve triangular loincloths, worn by both men and women. Under-tunics were worn by Roman females, but not underpants, if Martial's epigram about Lesbia's tunics 'sodomizing' her when she gets up or sits down is to be believed. Breast bands are occasionally seen in Greek and Roman art, but it seems clear that (male) artists were not familiar with this female undergarment. Known as a *strophium* in Latin, respectable married women wore one even during love-making, as seen in some paintings from Pompeii.

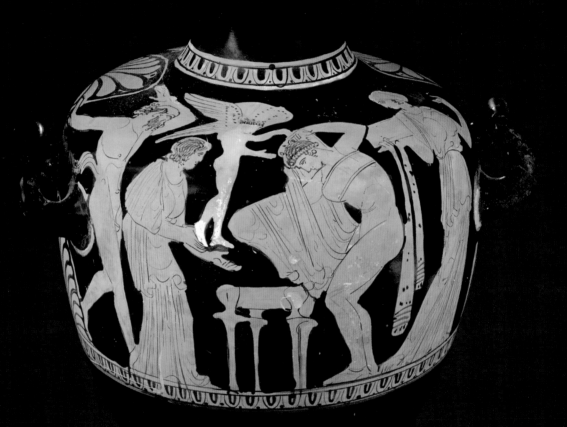

HAIR

The most elaborate hairstyles in antiquity were surely those concocted by Roman aristocrats who took hair to be their crowning glory. Satirists such as Juvenal mocked women with towering hairdos:

> So important is the business of beautification;
> So numerous are the tiers and stories piled upon
> one another on her head! In front you will take her
> for an Andromache; she is not so tall behind; you
> would not think it was the same person.
>
> (6.501–504, transl. P. Green)

The women of the imperial family set the latest fashions which were followed slavishly by their countrywomen throughout the Roman empire. Styles changed so regularly that scholars can usually date female portraits within a decade, and some marble portrait heads may have been retro-fitted with newly carved hairpieces to bring them into current fashion. An elaborate hairstyle was a sign of *cultus* or sophistication and, in contrast to men's hair, that of women was always tamed, parted in the centre, coiled and bound, only to be loosened in states of extreme emotion such as mourning. Many of the more elaborate hairstyles were fabricated with added hairpieces in the form of braids, tight curls, chignons and ringlets.

Greek women wore simpler styles, often tucking their long hair into a net or snood, while girls wore it long and loose until marriage. In the Hellenistic period more elaborate, segmented hairstyles such as the 'melon coiffure', whereby the hair is twisted into clumps resembling the sections of a melon, became fashionable. In mourning, women cut their hair, and female slaves are often shown with bobbed hair.

Egyptians shaved their heads as a way of dealing with the heat and lice. Children of both sexes sport a long lock of hair at the side of their shaved heads, but adults donned wigs which became an essential part of the Egyptian costume. On many statues one can see the painted area of the shaved forehead projecting from the huge wig worn over it. A quote from the *Tale of Two Brothers*, composed in 1300 BC, indicates the close connection between hair and seduction: 'Put on

Athenian *hydria* (water jar), *c.* 360 BC. Red-figure pottery, H. 32 cm. The presence of a winged Eros suggests that the woman undressing may be a bride. She is wearing shoes, earrings and a band across her chest known as a *strophion*, the ancient Greek equivalent of the bra. This particular piece of clothing is rarely depicted in art before the Roman period, but was no doubt a regular item of female dress.

FOLLOWING PAGES, LEFT TO RIGHT:
Roman portrait head, *c.* AD 210–30. Marble, H. 59.4 cm. Although this young girl is wearing a wig, one can see her own deeply drilled hair protruding underneath. The carefully waved hairstyle is typical of the early third century.

Romano-British hairpin, 2nd century AD. Bone, H. 5.5 cm (bust). The row of points at the top of this woman's elaborate coiffure may represent hairpins with finials like this one. The high-tiered plaited coils of this woman's hairstyle suggest a date in the late first or early second century AD.

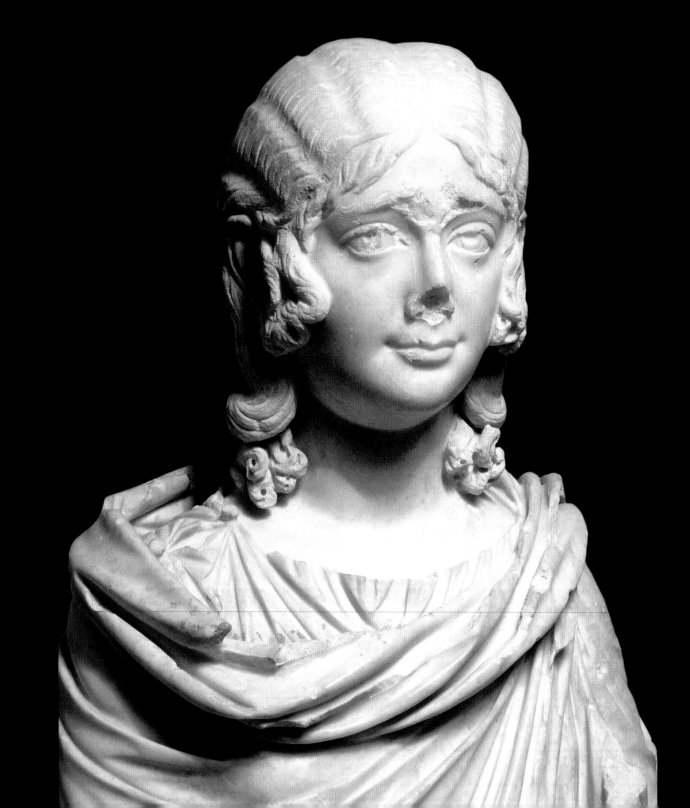

Egyptian miniature wig, from Thebes, New Kingdom (1550–1070 BC). Blue-glazed composition, H. 9.8 cm. The uraeus on this wig indicates that it once adorned a wooden royal statue. Blue was considered the hair colour of the gods and so was also used by the pharaoh and his family.

OPPOSITE PAGE, LEFT TO RIGHT:
Roman comb, 3rd century AD. Ivory, L. 11 cm. The owner's name, Modestina, is cut into the centre of this double-toothed comb, indicating that it is a personal possession.

Greek mirror, c. 460 BC. Bronze, H. 42.5 cm. Produced in Corinth this typical Greek mirror is supported by a standing woman or caryatid. She is wearing a belted woollen *peplos*, the edge of which she holds daintily in her left hand. The disc was once highly polished or silvered to provide a reflective surface.

Egyptian wig-curler, New Kingdom (1550–1069 BC). Bronze, L. 11.6 cm. Metal implements like this may have served as curling tongs for the elaborate coiffures seen on Egyptian wigs. Those who could afford it employed the special services of a hairdresser.

your wig and let us lie together.' Actual wigs packed in their special wig boxes have been preserved in the arid climate of Egypt, and so their intricate methods of manufacture can be studied. Wigs were made of human hair, sheep's wool, or a combination of the two.

For hairdressing, mirrors and combs were used by both men and women, although it is interesting to note that all the combs excavated in the cemetery at Deir el-Medina in Egypt were found in women's burials. Worked pieces of obsidian excavated in the houses of a Neolithic town in southern Turkey may have served as the earliest form of reflective surface, after water. Bronze mirrors in both Egypt and Greece often feature a standing woman as the handle; she is usually nude in Egypt and archaic Sparta, but clothed in other parts of Greece. In both Greek and Etruscan art the mirror is featured as a common attribute of well-to-do women, especially brides. Its association with Aphrodite/Turan/Venus made it an appropriate symbol of female attraction and sexual allure.

Depilation was a feature of many ancient cultures, and tweezers are documented as early as the pre-dynastic period. For the Egyptians, excessive facial and body hair were signs of uncleanliness, so the bodies of both men and women were shaved regularly. In ancient Greece the custom pertained mostly to women, and several Athenian vases show female pubic depilation by tweezing or singeing with a lamp. The hairless female body was an aesthetic ideal, but in reality women in ancient Greece did not completely remove their pubic hair, as demonstrated by numerous vase paintings of nude women.

Roman chatelaine, from London. Bronze, L. 8.7 cm (Museum of London). Affixed to a woman's garment, this handy set of metal hygiene tools travelled everywhere with a Roman woman. It consists of a nail cleaner, ear scoop, cosmetic applicators and tweezers attached permanently to a horizontal bar.

COSMETICS AND PERFUME

If the many ancient tales of women caught in the act of bathing by male intruders (Bathsheba by King David, Susanna by the elders, Athena by Tiresias, Artemis by Aktaion, Nausicaa by Odysseus while doing her laundry) echo daily practices, then female cleanliness was a cultural ideal. Athenian vase paintings show women washing their bodies and perfuming their hair, in what is presumed to be part of the domestic quarters. Roman women, on the other hand, frequented the public baths which were ubiquitous throughout the Mediterranean. Some of these elaborate establishments, as at Pompeii, had separate (but hardly equal) bathing facilities for men and women, as recommended by Vitruvius. In the imperial baths with no separate quarters, women bathed at different hours, probably from dawn to noon, before the water was completely heated. That it was necessary to police this segregation of men and women is indicated by an inscription found in a small bath in Rome: 'By the order of the mighty god Silvanus, women are prohibited from stepping into the swimming pool reserved for men.'

The second-century humorist Lucian parodies the hygiene of Roman women by saying that they do not simply wash with cold water and get on with the day, but rather closet themselves with a posse of serving women who plaster their faces with a variety of cosmetics and salves for improving their less-than-attractive complexion. 'Like participants in a public procession, each servant carries a different object: a silver bowl, a jug, a mirror, a variety of boxes, adequate for fitting out a chemist's shop, jars full of mischief, tooth-powders and stuff for darkening the eyelids.' The poet Ovid provides several formulas for the manufacture of unguents in his 'On Making Up a Woman's Face'. One concoction alone contained barley meal, ground pulse, eggs, ground antlers, narcissus bulbs, gum, honey and wheat flour from Tuscany. Roman women regularly whitened their faces with white-lead chalk over which they applied rouge (*purpurissum*).

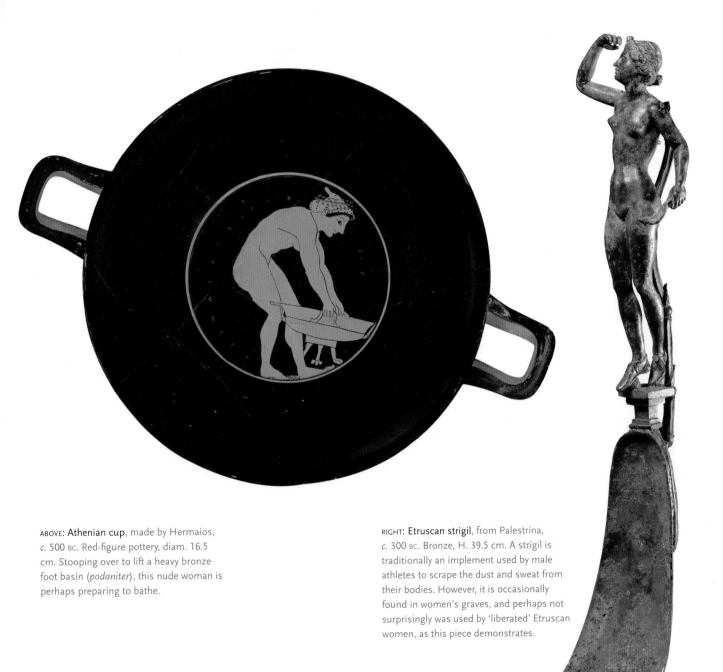

ABOVE: **Athenian cup**, made by Hermaios, *c.* 500 BC. Red-figure pottery, diam. 16.5 cm. Stooping over to lift a heavy bronze foot basin (*podaniter*), this nude woman is perhaps preparing to bathe.

RIGHT: **Etruscan strigil**, from Palestrina, *c.* 300 BC. Bronze, H. 39.5 cm. A strigil is traditionally an implement used by male athletes to scrape the dust and sweat from their bodies. However, it is occasionally found in women's graves, and perhaps not surprisingly was used by 'liberated' Etruscan women, as this piece demonstrates.

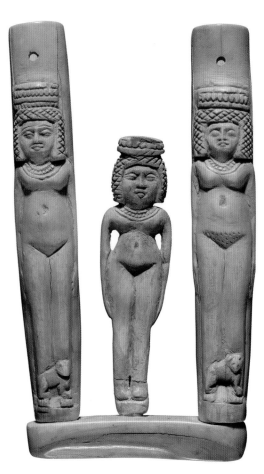

Cosmetics, while enhancing the appearance, were also a necessity in ancient Egypt. In the scorching hot, dry and windy climate oils and unguents were of vital importance for maintaining healthy, supple skin. Dark eye-make-up helped deflect the intense glare of the sun. The black colourant known as kohl was most common, but the Egyptians also used green eye-paint. In Mesopotamian graves excavated in ancient Ur shell vessels filled with cosmetic pigments were among the most common artefacts.

Tattooing, or *stigma* as the ancient Greeks called it, is documented in at least two instances among women of antiquity. Some Egyptian paintings depict women with a tattoo on both their thighs, usually in the form of Bes, the god of childbirth. Paintings on Greek vases show foreign women in general and Thracian nurses in particular with dark lines on their arms and necks (see p. 101).

Perfume was a widely exported commodity in the ancient world to judge by the vast number of perfume vessels found in graves, sanctuaries and houses. The basis for ancient perfumes was oil, rather than alcohol, and so it was often thick or solid. Thin cosmetic spoons, also of various materials, were used to extract unguents from these narrow-necked containers. Scents were created by steeping flowers, fragrant wood, herbs and spices in the oil. Egyptians are regularly depicted in paintings and reliefs with large perfume cones on their heads which contained ox tallow or beeswax impregnated with myrrh and may have been intended to melt onto one's hair; alternatively the cone is simply an artistic device to indicate that the person portrayed is wearing perfume.

Egyptian kohl pot, 25th Dynasty (747–656 BC). Ivory, H. 18.3 cm. The two hollow tubes at the sides are nude female divinities of sexual pleasure known as kadesh figures; they flank a third nude woman carved in the round. Tubular kohl pots replaced the earlier small jars, and the kohl was applied with a slender stick rather than the fingers.

Greek perfume *alabastron*, from Kamiros, Rhodes, *c.* 550 BC. Terracotta, H. 21 cm. This mould-made perfume flask is a typical product of sixth-century Rhodes that was exported widely throughout the Mediterranean. It combines the form of a veiled woman holding a dove for the upper section and the rounded *alabastron* shape for the bottom. Its narrow neck and flat mouth helped preserve its precious contents.

Egyptian perfume bottle, 18th Dynasty, c. 1350 BC. Polychrome glass, L. 14.5 cm. This small flask in the shape of a Nile fish may be the most famous glass vessel from ancient Egypt. It was found buried for safe keeping under the floor of a house at el-Amarna, and once contained some precious perfumed unguent.

Perfume containers in the ancient Mediterranean come in all materials, shapes and sizes, from an Egyptian glass fish-shaped vessel to exquisitely painted Athenian oil flasks showing women at their toilette. Although perfumed oil was also used by men, these moulded vessels more often take the shape of a woman or an animal. The Egyptians had access to expensive scents such as frankincense from Arabia, while the Romans had to import them from afar and at considerable expense. Pliny remarks that Roman ladies expended nearly a million *sestertii* a year in their quest for exotic aromatics from the remote east.

JEWELLERY

As the funerary images attest, elite women in the ancient world wore copious amounts of jewellery, and this is often confirmed by the contents of their burials. Because men also donned diadems, rings, earrings and various armbands, it is sometimes difficult to distinguish male from female adornment. When jewellery is found in burial assemblages on human remains, we can be fairly certain of its gender association, a case in point being the gold bra-like object found on a female skeleton at Lefkandi, Greece, dated to around 1000 BC.

The most spectacular find of ancient female jewellery was that from the royal graves of Ur, discovered by Leonard Woolley in 1928–9. The finest jewellery in the cemetery belonged to Queen Pu-abi. They were, in effect, the crown jewels of ancient Ur. Even her female attendants' elaborate headdresses were constructed

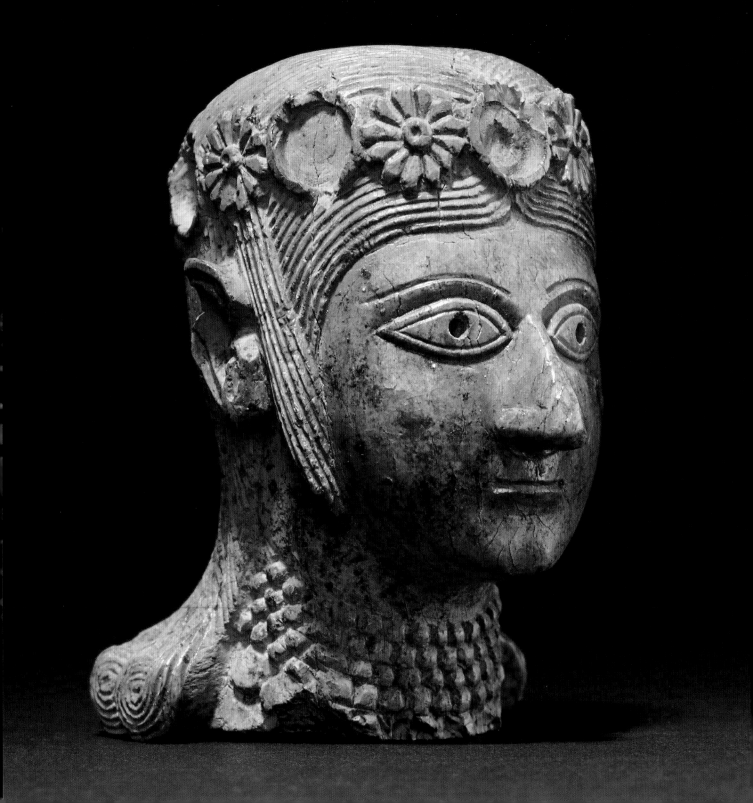

from hundreds of individual gold pieces and precious stones, and they also wore gold hair spirals and earrings, several necklaces and gold finger rings.

It has been said that the ancient Egyptians were addicted to jewellery. Both men and women in ancient Egypt added colour to their plain white linen garments by wearing broad beaded collars (*usekh*), necklaces, bracelets, armlets, anklets and, from the 18th Dynasty onwards, earrings. Gold and semi-precious stones were readily available in Egypt, but silver had to be imported and so was rarely used. Since pre-dynastic times Egyptians also wore a variety of protective amulets, often made of precious materials. Certain amulets such as the cylindrical tube, the frog which was known for its reproductive powers, the pregnant goddess of childbirth Taweret, and head of the cow-goddess Hathor were worn exclusively by women, most likely as fertility charms.

Greek and Etruscan women wore similar jewellery: *fibulae* (pins with catchplates to secure clothing), diadems, earrings, necklaces, bracelets and rings. Gold was the favoured medium, and not until the Hellenistic period were gems added. The serpent bracelet is typically Greek, as are earrings with winged pendant figures, such as birds or *Nikai* (victories) which would flutter as the wearer moved her head. Etruscan women went in for 'bling', or excessively large, flashy items of meticulous craftsmanship.

In their sculpted portraits Roman women are, unusually for the ancient world, devoid of jewellery. Perhaps there was a sense that ostentation was not appropriate in an official portrait, although this certainly did not apply to hairstyles, as we have seen earlier in the chapter. The elder Pliny wrote disapprovingly of Caligula's wife, who attended a modest banquet dripping in jewels:

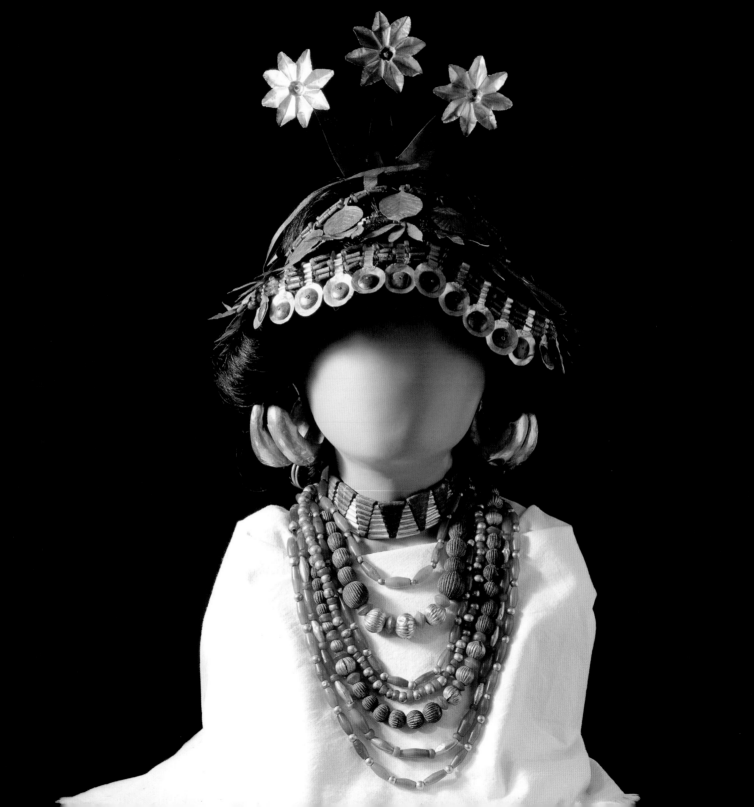

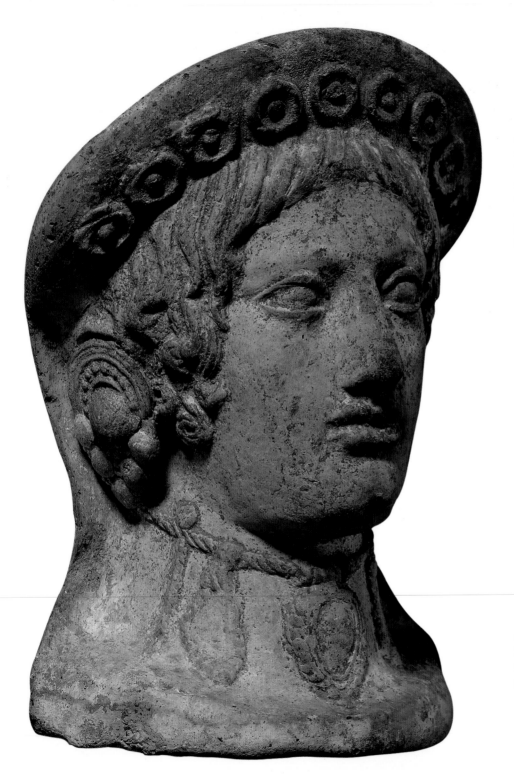

BELOW: **Etruscan earring**, *c*. 400–300 BC. Gold, H. 14.2 cm. This outsized earring is typically Etruscan. It takes the form of a conventionalized grape cluster enhanced with tiny grains of gold. Known as granulation, this sophisticated jewellery technique is one of the wonders of Etruscan art.

LEFT: **Etruscan votive head**, *c*. 325–300 BC. Terracotta, H. 23 cm. This woman is shown wearing the typical Etruscan grape-cluster earrings.

I saw Lollia Paulina . . . covered with interlaced emeralds and pearls, shining all over her head, hair, ears, neck and fingers, the total value amounting to 40,000,000 sesterces . . .

It is clear that, despite the conventions of sculpted portraiture, Roman women were not adverse to adorning themselves with jewels, real and paste, as the tomb finds also indicate.

From these images, both literary and artistic, it is evident that ancient women deployed their bodies to communicate important messages about their and their families' positions in society. As with Projecta's casket (see Chapter 1), grooming was an essential part of women's daily life, and the more time, effort and resources devoted to it, the higher one's status. While many male authors trivialized these often time-consuming and costly activities on the part of women, these beautification rituals nonetheless played a role in affirming the place of women in their culture.

WOMEN AND RELIGION

WOMEN AND RELIGION

AN INTRIGUING parure of gold ornaments hails from an ancient burial in southern Italy known as the 'tomb of the Taranto priestess'. Dated to the mid-fourth century BC, it consists of an elaborate necklace with pendants in the shape of human heads, an oval box-bezel ring decorated with the image of a seated woman, and a unique sceptre-like object. The last consists of a gold net-covered rod (now lost and replaced with a resin tube) nearly half a metre long, terminating in a delicate Corinthian capital. On the top of the capital is a green glass finial in the shape of a fruit (possibly a quince), nestled in a sleeve of gold acanthus leaves. Its identification as a priestess's sceptre is supported by the image on the ring that depicts a woman holding a similar object. Because two of the female heads on the necklace have bull's horns and ears, they have been identified as Io, the priestess of Hera whom Zeus changed into a cow. The inevitable conclusion then, if this group was genuinely found together, is that we have the personal possessions and official insignia of a priestess of the goddess Hera in an important Greek colonial city in southern Italy.

The exceptional quality and rarity of such insignia raises questions about the roles and status of women in the realm of religion. It is now generally acknowledged that one of the arenas (if not the sole one) in which women wielded some authority independent of men was cult and ritual. Recent feminist-driven investigations have perhaps overstated the power and independence of female priestesses, but there is no denying that state-appointed functionaries such as the Vestal Virgins in Rome or the priestess of Athena in Athens had some significant powers within the religious realm – even if they served at the behest of a male priest. Texts affirm that these women came from prominent families and were perhaps wealthy in their own right, and the Taranto tomb group accurately reflects the high social and economic status of such female clergy.

PREVIOUS PAGE:
Greek sceptre, ring and necklace, from Taranto, c. 350 BC. Gold, sceptre: L. 51.4 cm, necklace: L. 18 cm, ring: diam. 2.2 cm. These elaborate objects were perhaps once the personal possessions of a priestess of the Greek goddess Hera, since they were reputedly found together in a tomb.

Roman portrait head of a Vestal Virgin, 2nd century AD. Marble, H. 29.3 cm. Vestals are recognizable by their distinctively old-fashioned headgear: six folds of a long woollen band (*infula*) wrapped around the head and hanging in two loops behind the ears.

Here we will examine not only the cult paraphernalia pertaining to women but also the special imagery of priestesses, the laws regulating their behaviour, the rituals in which they played key roles, including women-only festivals, the types of offerings they dedicated and the regalia they wore, as well as the wider meaning of these rites within ancient societies.

VESTAL VIRGINS

Perhaps the most famous priestesses of antiquity are the Vestal Virgins of Rome. Six in number, they were charged with keeping the fire burning on the altar of Vesta, the Roman goddess of the hearth, and fetching water for the cleansing of her shrine, a round temple at the south-east end of the *Forum Romanum*. Extinguishment of the flame was an inauspicious omen, so much so that if one of the vestals allowed it to go out, she was punished by flogging at the hands of the high priest of Rome, known as the *pontifex maximus*. As their name implies, the vestals were required to be pure, and were chosen at a young age (between six and ten) from patrician families. When their mandatory term of office (thirty years) ended they were free to marry, although few did. Given the importance of their purity to the state, those convicted of a lapse in their celibacy were ceremoniously buried alive in a small subterranean chamber equipped with a token amount of food. One accused vestal named Tuccia was able to escape this fate by reputedly carrying water in a sieve, no mean feat.

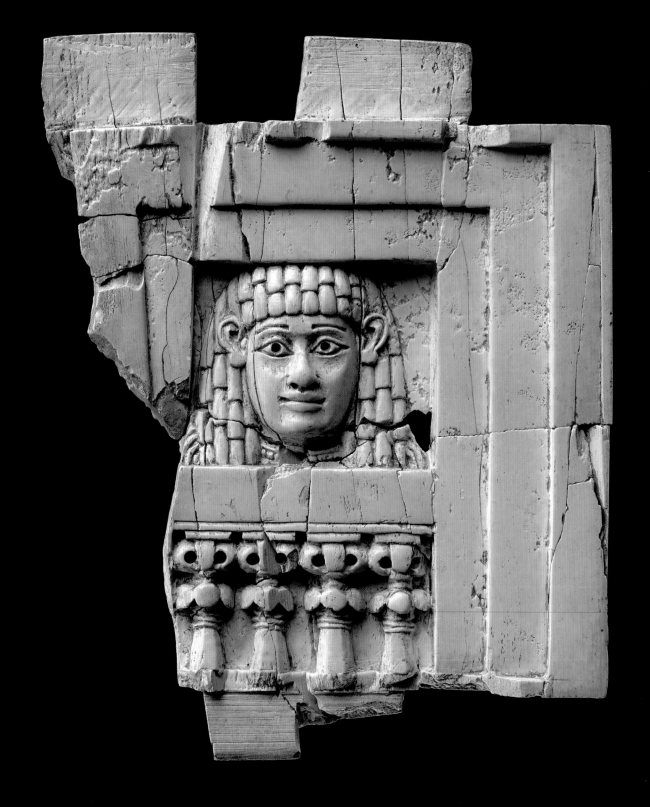

Beyond the arena of ritual, the vestals were prominent in the social and political life of Rome. They commanded the best seats in the theatre and, like other important Roman magistrates, were accompanied in public by a *lictor* (attendant). If they chanced to encounter a condemned prisoner being led to his execution, they had the power to liberate him. The vestals lived in a special dwelling in the forum, the *Atrium Vestae*, next to the residence of the *pontifex maximus*, who was the only religious official allowed into the inner sanctum of their precinct. Here were kept some of the state's most sacred objects, such as the statue of Minerva (Palladium) that Aeneas had reputedly brought from Troy, and the wills of the emperors, not to mention a 'divine penis' according to some texts.

Although the sacred duties of these vestal virgins consisted of seemingly domestic tasks – tending the hearth, fetching water, cleaning the premises and storing objects – their importance to the well-being of the state should not be underestimated. Second only to the highest priest in Rome, who in imperial times was the emperor himself, their tending of the sacred flame was believed to ensure the continued safety of the Roman state and its people.

'TEMPLE PROSTITUTION'

The direct opposite of sacred virginity was ritual prostitution, and it is a myth that dies hard. The evidence for females who engaged in sex for a fee within the confines of a temple derives largely from the fifth-century Greek historian Herodotus's account of ancient Babylon. He states:

> The foulest Babylonian custom is that which compels every woman of the land to sit in the temple of Aphrodite and have intercourse with some stranger once in her life . . . Once a woman has taken her place there, she does not go away to her home before some stranger has cast money into her lap, and had intercourse with her outside the temple; but while he casts the money, he must say, 'I invite you in the name of Mylitta' (that is the Assyrian name for Aphrodite). It does not matter what sum the money is; the woman will never refuse, for that would be a sin, the money being by this act made sacred. So she follows the first man who casts it and rejects no one. After their intercourse, having discharged her sacred duty to the goddess, she goes away to her home; and

'The Woman in the Window', Neo-Assyrian Phoenician-style plaque, from Nimrud, 9th–8th century BC. Ivory, H. 11 cm. Once an inlay in a valuable piece of furniture, this ivory relief was found at the Palace of Ashurnasirpal II by the great Assyriologist Henry Layard. Images such as this have often been identified erroneously as the notorious temple prostitutes of Babylon mentioned by Herodotus (Book 1, 199).

thereafter there is no bribe however great that will get her. So then the women that are fair and tall are soon free to depart, but the ugly have long to wait because they cannot fulfil the law; some of them remain for three years, or four. There is a custom like this in some parts of Cyprus.

There is no independent written or archaeological evidence from ancient Mesopotamia, Assyria or Persia that attests to this specific custom, nor is it mentioned on any of the thousands of cuneiform tablets that survive. Because tales of sacred prostitution are told by outsiders such as Herodotus about foreign and sometimes hostile cultures, often remote in time from the author, they can be interpreted as efforts to discredit foreigners. They are therefore particularly suspect and recently scholars have questioned their authenticity.

What could account for Herodotus's myth of temple prostitution? The deity in whose honour this custom was supposedly undertaken was the goddess of sexual love, the Semitic Ishtar, the Phoenician Astarte or the Greek Aphrodite. This powerful goddess of Near Eastern origins was also a deity of the moon and stars; her relevance to celestial navigation resulted in her being especially worshipped by sailors in port cities. She also counted among her devotees prostitutes, who prayed to her for good business or gave thanks for success; in many ancient sanctuaries one encountered votive offerings dedicated by such women. It would not be surprising to find this mingling of prostitutes and sailors in the vicinity of her temples leading to the fabrication of some sort of authorized temple prostitution. Another ritual that may also have led to such a construction is one that was celebrated in many ancient cultures, namely sacred marriage.

PRIESTESSES

In most ancient religions there exists a chief- or high priestess, often from a royal or aristocratic family. In the ancient Near East she was known as the *Entu* (the feminine form of the Sumerian high priest *En*). Since the Sumerian ideogram also means 'wife of the god', it reflects an early instance of a practice known generally as 'sacred marriage'. Among other duties the priestess acts as the female counterpart during a hallowed rite upon which the fertility of the land depended. The high priest and priestess would re-enact the original coupling of the god and goddess of fertility at every New Year's festival. Such a ritual took place in many

Akkadian seal of Amar-Ashtar, *c.* 2225 BC (present whereabouts not known). The only *Entu* (high priestess) represented on an inscribed seal is Tutanapshum, a daughter of the Akkadian king Naramsin. She is shown seated in what appears to be a garden wearing a flounced robe and diadem and being entertained by Amar-Ashtar, her female servant.

WOMEN IN THE ANCIENT WORLD

Egyptian stela of a high priestess, 26th Dynasty (664–525 BC). Sandstone, H. 54 cm. The pharaoh's daughter Ankhnesneferibra, here labelled 'God's wife', is shown worshipping the king of the gods, Amun-Ra. She holds a sistrum in each hand and wears the elaborate queen's headdress consisting of two feathers, cow's horns, moon disc and uraeus. Behind her, and clearly of lesser status, is a male priest.

religions, including that of ancient Athens where the chief priest, the *archon basileus*, took the form of the god Dionysos and consummated a *hieros gamos* or holy wedding with his wife, who was known as the *basilinna*, in a special enclosure.

In 18th Dynasty Egypt and later, some female members of the royal family held the prestigious title 'Wife of Amun' or god's wife. Pictorial representations

OPPOSITE: **Egyptian pair of clappers**, New Kingdom (1550–1070 BC). Ivory, L. 33.5 cm. This percussion instrument takes the form of a pair of elegantly elongated hands with Hathor-head bracelets at the wrists. As well as being a funerary deity, Hathor was a goddess of love, music and dance, and one of her epithets was 'chantress of Amun'. Thus she makes an appropriate decoration for musical instruments such as these clappers and the sistrum, played by women in honour of the gods.

LEFT: **Egyptian bust of a woman**, 19th Dynasty, *c.* 1279–1203 BC. Basalt, H. 33.8 cm. The use of the dark, hard basalt for this statue indicates that it was made for a temple rather than a tomb. The woman is garbed in the finery of the Ramesside period, and the sistrum she holds indicates her role as a temple musician.

BELOW: **Egyptian sistrum**, from a temple at Thebes, Late Period (743–332 BC). Bronze, H. 41.7 cm. The sistrum is a rattle sacred to Hathor and used as a part of temple ritual to please or pacify the gods. It is often shown in the hands of women. This example is highly decorated with Hathor-heads, figures of the lion-headed goddess Bastet, and vultures.

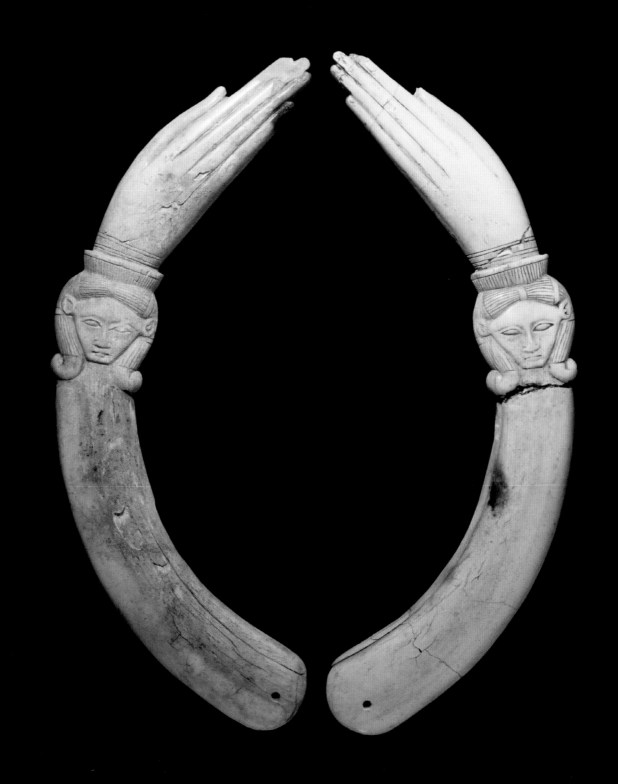

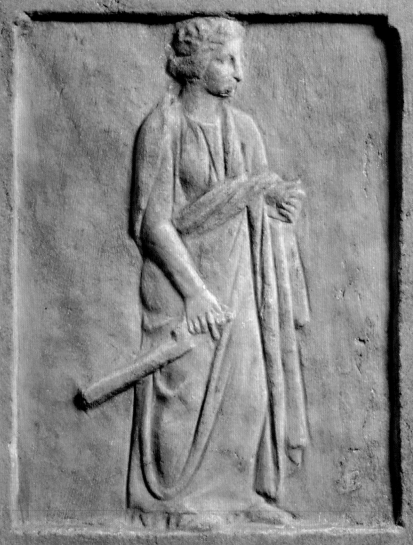

demonstrate that she acted as a high priestess, functioning alongside male priests in various rites, including entry into the inner sanctum of the temple. An inscribed stela set up in the Temple of Amun at Karnak grants an endowment of goods and lands to be associated with this office in perpetuity. In the 26th Dynasty the pharaoh Psamtek set up his adopted daughter as 'god's wife' with an endowment of more than 2,000 acres of fields and a daily allowance of 1,500 *deben* of bread. Another title that might also suggest a wifely function on the part of this priestess is 'god's hand'; her role was to stimulate the god sexually so that he would ensure the fertility of the land forever.

In the Old and Middle Kingdoms in Egypt the most common religious title for upper-class women was 'priestess of Hathor'. By the New Kingdom women were generally excluded from the priesthood, which had become a full-time male prerogative. Rather, they served as temple musicians for both male and female deities. These women were chosen from families of all ranks and played instruments such as the sistrum and tambourine, danced and sang chants.

In Mesopotamia in the Old Babylonian period, cloisters with 'nuns' are attested. Daughters of the elite were sent to this secluded place to pray and make sacrifices on behalf of their relatives. The archives preserve letters in which these women describe their large estates with houses, fields and orchards. On the domestic level the wife in the ancient Near East was to intercede with the gods on behalf of her family.

Greek priestesses are recognizable not by specific dress but by the large temple keys that are their primary attribute. The keys signify their role as *kleidouchoi* (key-bearers), namely those responsible for locking and unlocking the temple doors. Because Greek temples were filled with silver and gold offerings, they in effect served as treasuries and so had to be safeguarded. In this sense women functioned much as housekeepers who tended the storerooms of the Greek *oikos*. While scholars have argued that this is a prestigious role, and the fact that women are depicted as key-bearers on their funerary stelae supports this notion, it seems odd that male priests are never depicted thus. Greek women served mainly in the cults of female deities, and one could assume that male key-bearers were needed for the temples of male gods. However, male priests are most often portrayed holding a sacrificial

OPPOSITE: **Greek grave stela**, from Eleusis, *c.* 370–360 BC. Marble, H. 54 cm. The large temple key held in the woman's right hand identifies her as a priestess, and her name, Choirine, may be related to the Greek word for piglet (*choiros*), an animal that was the standard offering to the goddess Demeter. The stela was found at Eleusis, outside Athens, the site where the Mysteries in honour of this goddess were held annually.

Greek *skyphos* (cup), from Lucania. *c.* 360–340 BC. Red-figure pottery, H. 12.4 cm. Like the woman on the grave stela opposite, this priestess holds a temple key, from which hangs a woollen fillet.

Roman copy of a Greek portrait head, from Tarquinia, original *c.* 430–365 BC. Marble, H. 30 cm. This old woman is sometimes identified as Lysimache, who was a priestess of Athena Polias for sixty-four years.

knife or washing their hands before animal sacrifice. While women offered piglets to Demeter, they are not normally involved in the highpoint of Greek ritual, the slaying of an animal, although they might share in the distribution of meat afterwards.

The most important priestess in ancient Athens was that of the city's tutelary goddess, Athena Polias. The position was hereditary, open to married women, and was held for life. These priestesses were subject to some unusual rules, such as being forbidden to eat fresh cheese produced in Attica. One famous holder of this priesthood was a woman named Lysimache who lived in Classical

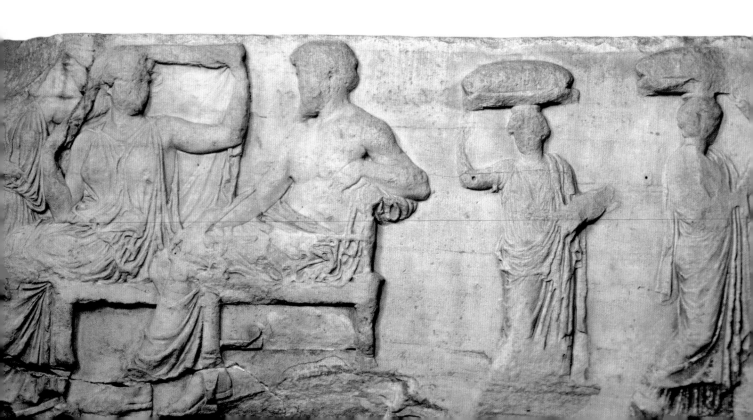

Athens. She raised four generations of children and died at the age of eighty-eight, after serving Athena for sixty-four years. The base of her bronze likeness was found on the Athenian Acropolis, and some have suggested that the portrait in the British Museum of a haggard old woman is this very priestess.

The priestess of Athena Polias is almost certainly the woman standing at the centre of the Parthenon's east frieze, attended by two girls carrying stools on their heads. Behind her and facing in the other direction is the *archon basileus*, who is interacting with a young boy. The two males are folding up a garment known as the *peplos*, a robe specially woven by elite women and presented to Athena at her major festival, the Panathenaia. As the two girls may represent the *arrephoroi* ('carriers of secret things') who served one year under the priestess and set the warp threads on the loom for the weaving of the *peplos*, it is all the more surprising that the robe is being handled by two males. That male religious officials wielded authority over female personnel is also evident in the important Greek realm of prophecy.

Greek temple relief, from the east frieze of the Parthenon, Athens (Block V), *c.* 447–432 BC. Marble, H. 100 cm. The importance of Athenian citizen women to the cult of Athena is demonstrated visually on the centre of the east frieze of the Parthenon just over the entrance to the temple.

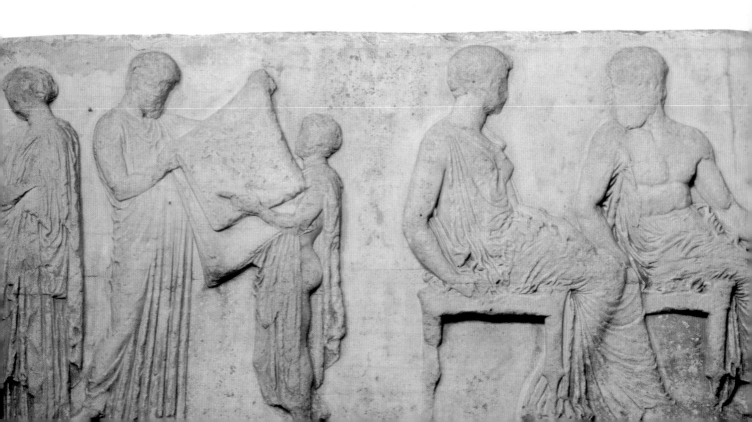

PROPHETESSES AND SIBYLS

The most eminent priestess in ancient Greece was undoubtedly the Pythia, who served as the mouthpiece of Apollo's great oracle at Delphi. In earlier times a young virgin but later an older woman at least fifty years of age, the Pythia provided responses to petitioners asking such questions as 'Should we go to war?' or 'Shall I adopt a son?' Her answers were inspired by the god Apollo and could be provided only once a month when the god was in residence (that is, nine times a year). Unlike the priestesses we have been examining so far, the Pythia was not an aristocratic woman but came from ordinary peasant stock. How she was chosen remains a mystery, but once chosen, she ceased to live with her husband, thus ensuring the physical purity of the god's mouthpiece.

The exact process of consultation is not described, but presumably the Pythia washed herself at the nearby Castalian spring and entered the back room of the temple where she may have seated herself on Apollo's tripod. As a result of some form of stimulus (perhaps vapours rising from the intersection of two major geological faults) she entered an ecstatic trance. Inspired by Apollo, she spoke in his voice and, according to some scholars, her utterances were then reproduced in hexameter verses by the chief priest or *prophetes*. In its heyday the Delphic oracle was so popular that three Pythias were needed to meet the heavy demands being made upon it.

The sibyl (or sibyls) who produced the oracular books so important to the Romans had her origins in Asia Minor, but her best known cult location was Cumae in southern Italy. Here, in the 1930s, Italian archaeologists discovered a cave much like that which Vergil describes in the *Aeneid* (Book 6) with a 'hundred huge openings'. The prophecies of the Sibyl, who lived in the remote past, were originally collected in the Sybilline books, which were stored in a stone chest located in the Temple of Jupiter on the Capitoline in Rome. The books were consulted on occasions of national disaster until they were destroyed by fire in 82 BC.

Roman denarius, minted in Rome, 65 BC. Silver, diam. 1.9 cm (max).
The obverse shows the head of the Cumaean Sibyl (labelled) in
profile to the right, while the reverse depicts a tripod, a reference to
the famous oracle of Apollo at Delphi, and two stars.

Sumerian figurine of a woman praying, from Mesopotamia, Early Dynastic period, *c.* 2600 BC. Gypsum, H. 22.5 cm. Figurines such as these were placed in temples as acts of devotion by both men and women.

Egyptian figurine of a devotee of Isis, 1st century AD. Terracotta, H. 10 cm. This woman wears the full regalia of a worshipper of the Egyptian goddess Isis: long 'Isis' locks of hair, floral and wheat garlands across her chest, a sistrum for making music in her raised right hand, a *situla* (pail) for libations on her left arm, and a voluminous veil over her head.

CULT DEVOTEES

One of the most frequent offerings to divine beings was an image of the worshipper. In ancient Mesopotamia temples were filled with under-life-size stone statues of humans devotees, their hands folded reverently in prayer, as stand-ins for the absentee worshippers. In Egypt where the cult of the dead was pre-eminent, women are depicted on stone tomb reliefs and paintings as perpetually making offerings to their deceased husbands. Greek worshippers who could not afford expensive marble statues, such as the *korai* (maidens) found in abundance on the Athenian Acropolis, dedicated cheaper terracotta figurines. Women are represented in the guise of *kanephoroi* (basket-bearers), *hydraphoroi* (water-jar carriers), or as dedicators of piglets. Later, when the worship of Isis spread from its home in Egypt throughout the Mediterranean, they are shown in the cult regalia of this popular goddess.

Etruscan sarcophagus lid with the portrait of a woman, from Tarquinia, *c.* 250 BC. Nenfro (volcanic stone), L. 221 cm. Bedecked in jewellery, this woman is shown as a devotee of Dionysos, or Fufluns as he was known in Etruscan. She wears a deer-skin knotted at her right shoulder, holds in her right hand a drinking vessel (*kantharos*) typical of the wine god, and a thyrsus or staff crowned with ivy in her left hand. A small deer along her left side seems to be stretching up to drink from the cup.

One classical deity who had a particular appeal for women was the god of wine and theatre, Dionysos/Bacchus. The god himself is often portrayed as effeminate and garbed in flowing robes, and his followers are predominantly female. Known as maenads or bacchantes, they abandoned their homes and took to the mountains in their ecstatic revelry, thereby deviating from the socially acceptable norms for female behaviour. Their all-night revels were the object of intense male curiosity, as evidenced by Euripides's famous tragedy *Bacchae*, and were a frequent subject of Athenian vase painting where they are shown dancing wildly and wielding their distinctive ivy-bedecked staffs known as *thyrsoi*. The first known historical rather than fictional maenad was Alexander the Great's mother, Olympias, who was an ardent devotee of the rites of Dionysos. Certain temples of the god could even be the exclusive domain of women. The traveller Pausanias (3.20.4) mentions a temple of Dionysos in Laconia, where only women were permitted to enter and perform the sacrifices.

WOMEN'S FESTIVALS

Festivals for women only were an important aspect of both Greek and Roman religion, and are sometimes viewed as a much-needed outlet for women whose lives were otherwise constrained. These rites often took place at night at a special location and involved the consumption of wine. Because men were deliberately excluded, the festivals acquired a certain mystique, and they were often satirized as drunken orgies by authors such as the Greek comedian Aristophanes or the Roman Juvenal. The Thesmophoria was an all-female festival of Demeter celebrated throughout the Greek world. Like the bacchantes, the female celebrants left home and spent several nights camping out in a sanctuary of Demeter. After

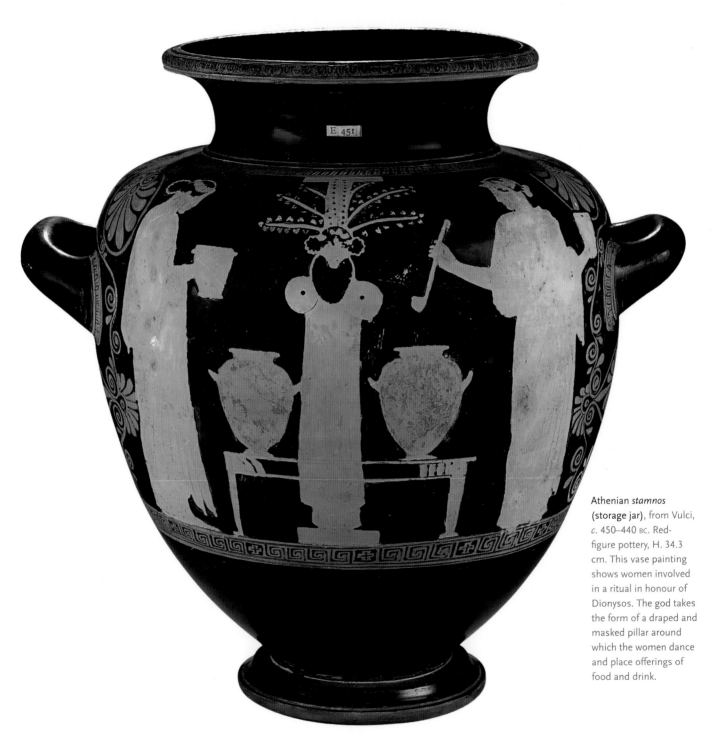

Athenian *stamnos* (storage jar), from Vulci, *c.* 450–440 BC. Red-figure pottery, H. 34.3 cm. This vase painting shows women involved in a ritual in honour of Dionysos. The god takes the form of a draped and masked pillar around which the women dance and place offerings of food and drink.

E 451

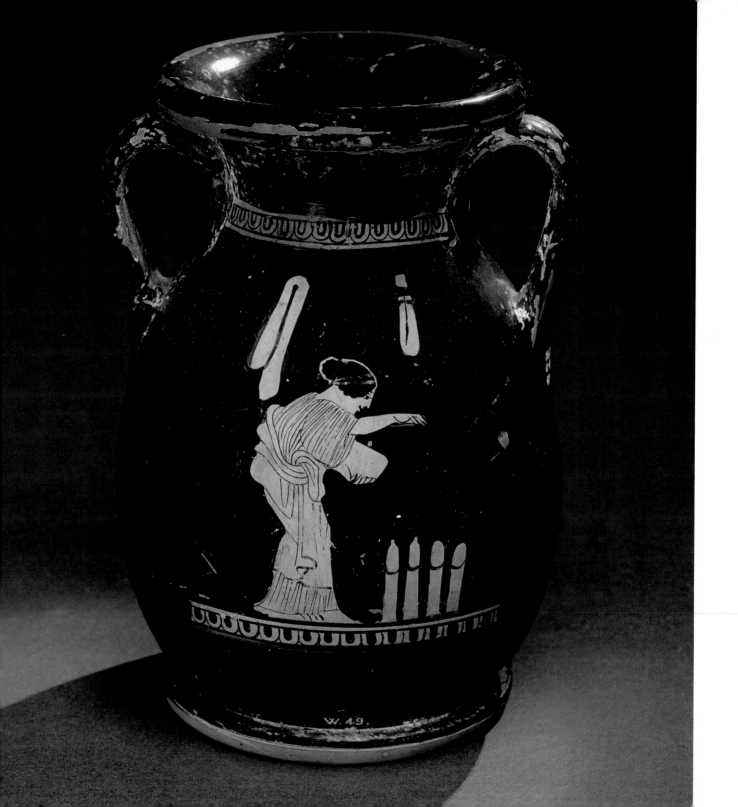

fasting, they feasted and entertained themselves with jokes and foul language. Ultimately, in a religious ritual, a number of women were called upon to bail a compost of rotten piglets out of a pit and mix it with soil on the altar, a fertility rite whose purpose was to ensure a successful harvest.

A conspicuous cult of ancient Rome celebrated only by women was that of the *Bona Dea* (Good Goddess), who was worshipped both on May Day and on a night in early December at the home of a senior *curule* magistrate. All the male members of the household were required to spend the night away, and even statues, mosaics and paintings of males, both human and animal, were veiled for the occasion. The hostess was the magistrate's wife and aristocratic women as well as the Vestal Virgins took part in the celebration, which involved music, drinking and the sacrifice of a sow. Clearly both the cults of Demeter and the *Bona Dea* had a fertility aspect, demonstrated by the sequestering of females, who served to increase the fecundity of the land and its people.

OPPOSITE: Athenian *pelike* (storage jar), *c.* 440–430 BC. Red-figure pottery, H. 17.7 cm. A woman is sprinkling seeds upon a verdant garden of erect phalluses, in some as yet unidentified Greek domestic ritual.

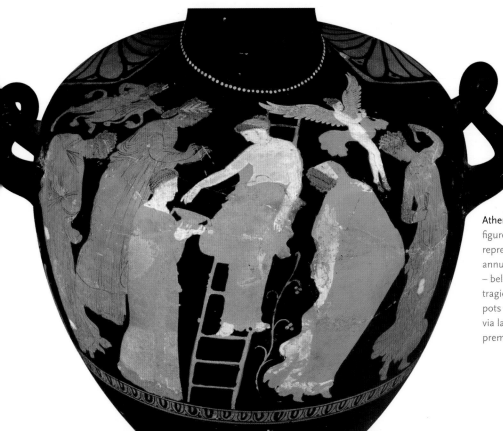

Athenian *hydria* (water jar), *c.* 360–350 BC. Red-figure pottery, H. 38 cm. The all-female festival represented on this vase is the Adonia, held annually in honour of the beautiful youth Adonis – beloved of Aphrodite – who died an early and tragic death. Women planted seedlings in broken pots which they took to the roofs of their houses via ladders; in the heat of the sun the plants died prematurely like the young Adonis.

177

LEFT: **Cypriot pin**, *c.* 200–100 BC. Gilt bronze, L. 17.8 cm. The head of this elaborate pin consists of a Corinthian capital with goats and a pearl set on top. It was found in the sanctuary of Aphrodite at Palaiopaphos and is inscribed, 'To Aphrodite Paphia, Euboula vowed this, the wife of Aratos the *suggenes* [kinsman], and Tamisa'. The two women who dedicated this exceptionally large pearl to Aphrodite were members of the wealthy elite residing in the administrative capital of Hellenistic Cyprus.

WOMEN'S VOTIVES

A wide variety of objects dedicated by women – from personal belongings to curse tablets – have been found in shrines and sanctuaries throughout the Mediterranean. Even more dedications by women are listed in temple inventories, and many of these, such as the used clothing offered to Artemis by postpartum women in Attica, have long since decomposed. Because some of the less perishable offerings are inscribed with the names of their dedicators, we know that many women could afford to make valuable offerings to their favourite deities. The Acropolis inventories, for instance, indicate that of the ten silver *phialai* (libation bowls) in the Erechtheion temple, eight were dedicated by women. Even women of modest means made dedications; a washerwoman named Smithyke inscribed her name on a ritual water basin found inside the Parthenon.

WOMEN IN THE ANCIENT WORLD

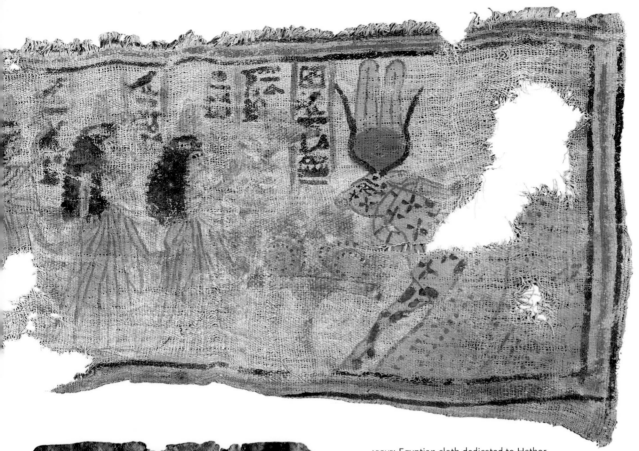

ABOVE: **Egyptian cloth dedicated to Hathor**,
New Kingdom (1550–1070 BC). Linen, L. 49 cm.
Fortunately, textiles survive in the dry climate
of Egypt, and this linen cloth bears a painted
inscription on the back indicating that it was
donated by the six women shown on the front.
Hathor is depicted at right in her bovine form.

LEFT: **Roman curse tablet**, found at a Roman temple in
Gloucestershire, 4th century AD. Lead, L. 8.3 cm.
A woman named Saturnina inscribed this tablet to the
god Mercury imploring him to make the thief of her
linen cloth return it. In the typical fashion of a curse it
states: 'Let him who stole it have no rest until he brings
the aforesaid things to the aforesaid temple.'

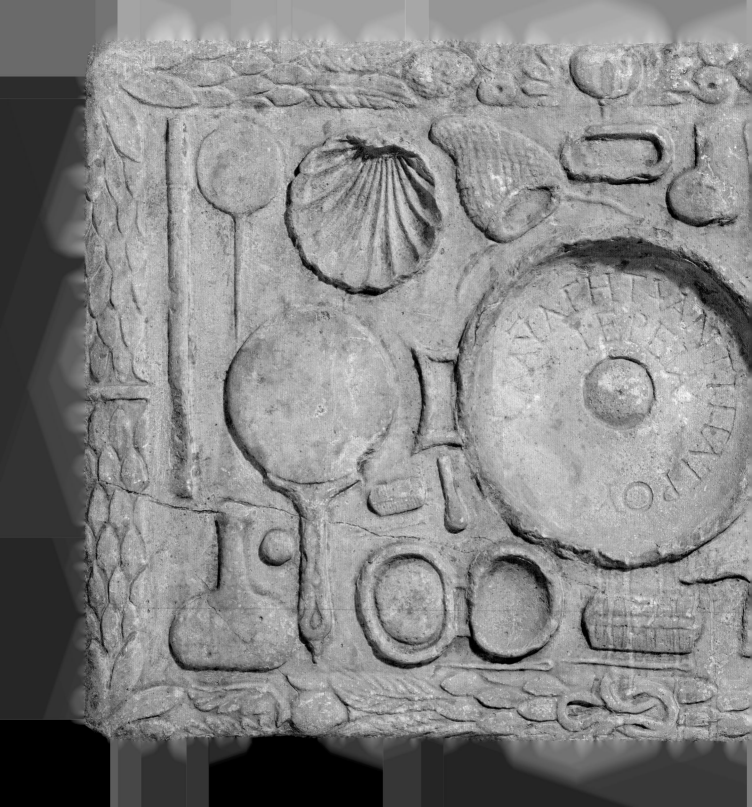

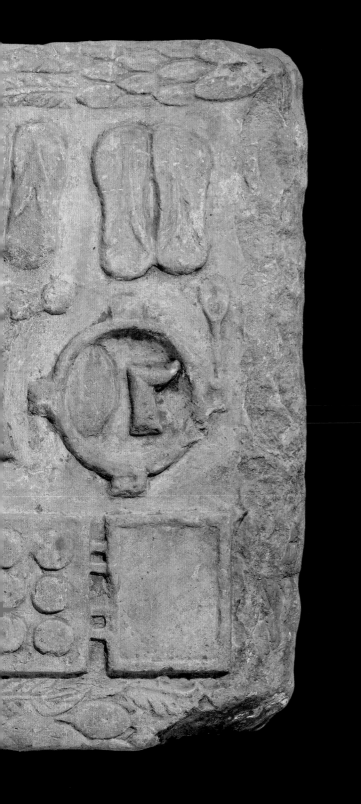

Roman relief depicting offerings made by a priestess named Claudia Ageta, daughter of Antiparos, from Laconia, c. AD 170. Marble, H. 68.6 cm. This Roman relief demonstrates the vast array of offerings which a woman might dedicate: libation bowl, cosmetic boxes and implements, perfume flasks, mirrors, mortar and thumb-shaped pestle, pairs of sandals, and even a hairnet.

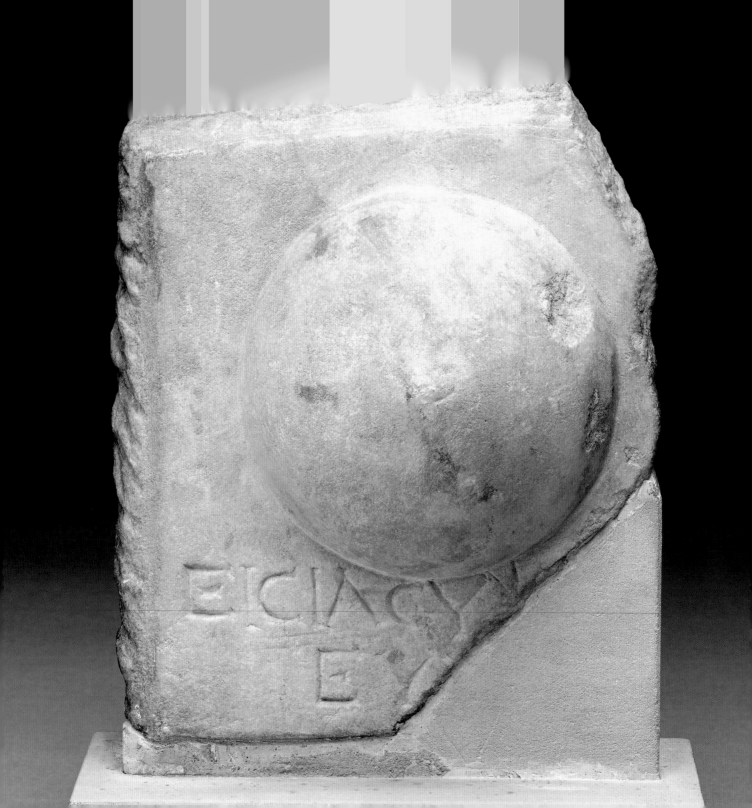

LEFT: **Roman votive relief representing a female breast**, 2nd–3rd century AD. Marble, H. 19 cm. The inscription states that a certain Eisias dedicated this to Zeus Hypsistos (Highest) at his shrine on the Pnyx in Athens either in hope of or thanks for a cure. The god of medicine, Asklepios, was the usual but not the only recipient of such anatomical votives.

RIGHT: **Greek statuette of a woman holding a flower**, c. 490–480 BC. Bronze, H. 12.2 cm. Incised on the woman's skirt is a dedication: 'Aritomacha dedicated (me) to Eileithyia'. Eileithyia is the Greek goddess of childbirth, and so perhaps this votive was a thanksgiving offering for a successful delivery.

DIVINIZED WOMEN

With the exception of some mythological females such as Ariadne, who became the wife of Dionysos, mortal Greek women were never accorded divine status. Rather, some exceptional women became heroines on account of their unusual or violent deaths – being carried away by wind gods, struck by lightning (Semele), sacrificed for a good cause such as averting plague or winning a war (Iphigenia). After their deaths, not unlike saints, they became recipients of a cult, often at their place of burial. Their shrines usually included an altar for libations and food offerings, and a variety of votives. While not on the level of the Olympian gods, heroines were important figures in the religious life of the Greeks.

With the abetting of an auspicious event, such as a comet or the sight of an eagle soaring to heaven, deceased Roman emperors were declared gods by a formal vote of the Senate, beginning with Julius Caesar in 44 BC. The first Roman woman to become a goddess was the sister of the capricious emperor Caligula, a twenty-one-year-old named Drusilla, who died in AD 38. A senior senator testified that he had seen her ascending into heaven and even consorting with the other Olympian gods. When Claudius acceded to the throne he promptly had his grandmother, Livia (d. AD 29), wife of Augustus, deified. We shall encounter her, along with other famous historical women, in the next chapter.

Roman cameo, AD 37–41. Sardonyx, H. 10.7 cm. This stone is carved with a portrait of a female member of the Julio-Claudian family, possibly Julia Drusilla, the sister of Caligula.

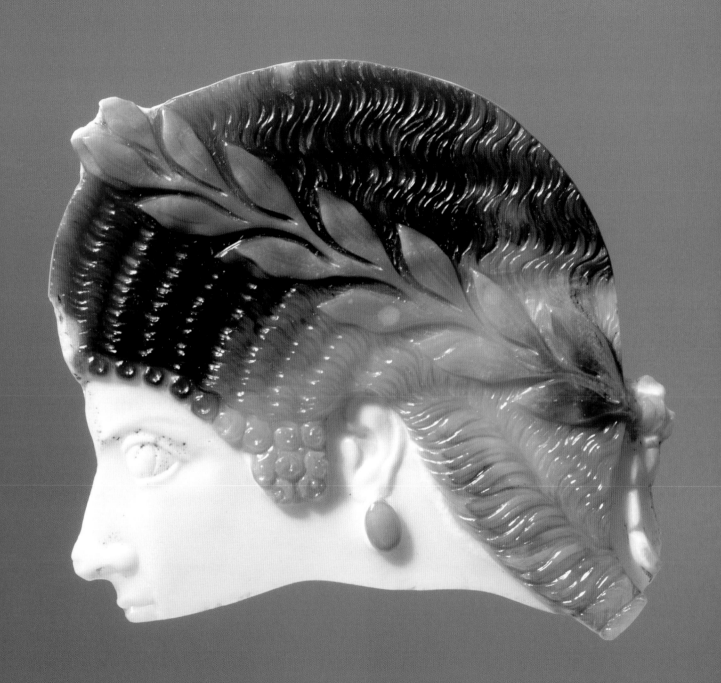

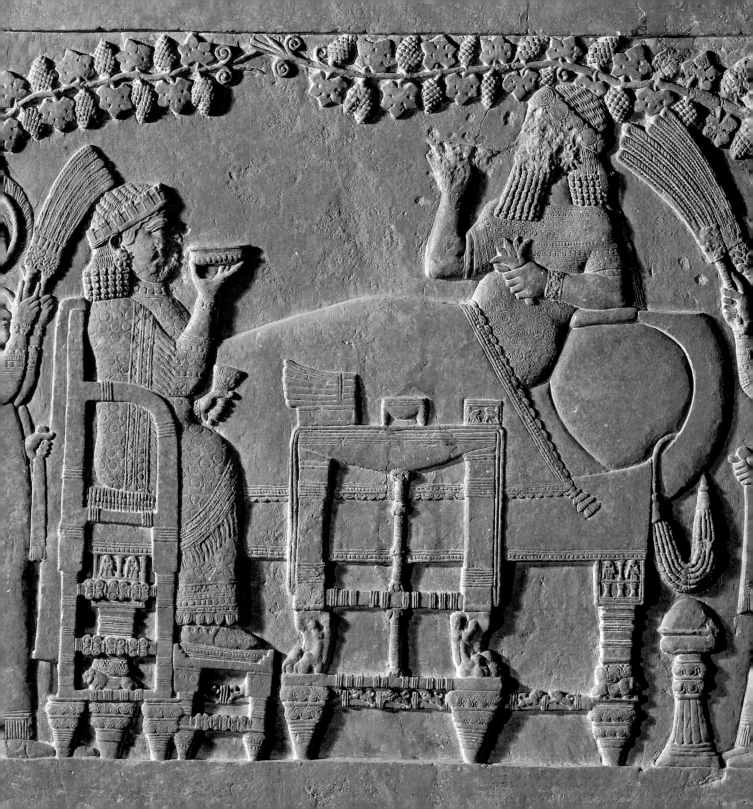

ROYAL WOMEN

ROYAL WOMEN

THE MORE or less unsung women we have examined so far did not make
their mark in history; rather, most of them saw their husbands and
sons off to war, hailed them as heroes if they returned, and lent their
support in their roles within the public sphere. Even when there was a
census, women were not counted; in Rome only heiresses were included in the
population numbers. However, women's contributions were occasionally recorded,
albeit by male scribes, historians and chroniclers, and so we know of some of
their extraordinary accomplishments. Kyniska, for example, the sister of the king
of Sparta, entered the winning chariot at Olympia twice in the early fourth century
BC and was allowed to set up a monument recording her wins. It reads: 'Kings

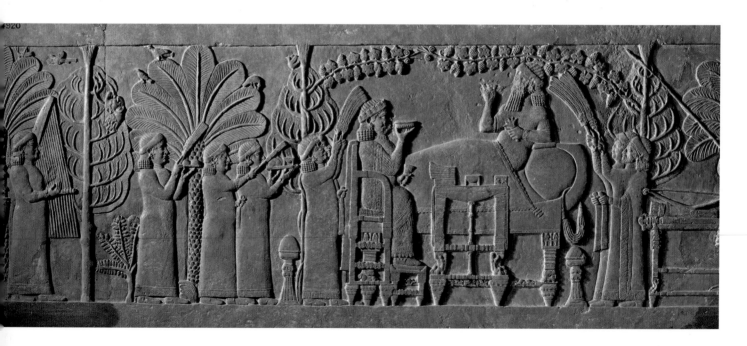

of Sparta were my fathers and brothers, and I, Kyniska, winning the race with my chariot of swift-footed horses, erected this statue. I assert that I am the only woman in all Greece who won this crown.' Alas, Kyniska could not be present to enjoy the thrill of watching her team cross the finish line as women were barred, on pain of death, from attending the games.

We also encounter women's names on various forms of public benefaction. The Roman woman Eumachia is a prime example. The daughter of a wealthy brick-manufacturer, she married into a prominent Pompeian family and became a priestess of Venus. She built and dedicated a large and handsome building in the forum of Pompeii to the guild of clothmakers and dyers, and in appreciation the fullers dedicated a statue to her.

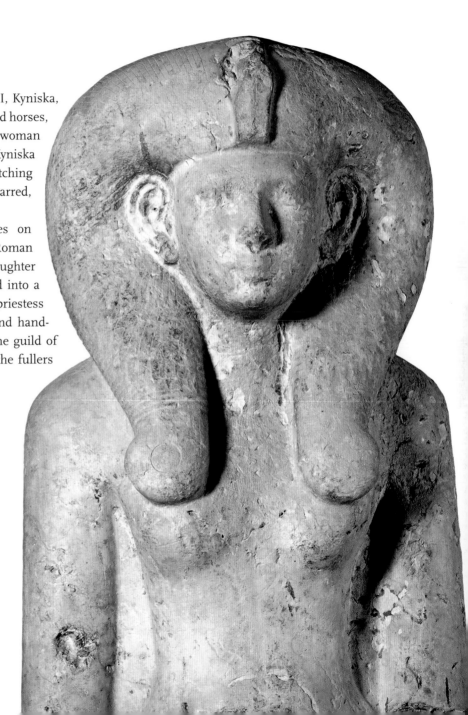

Egyptian statue, from Karnak, 18th Dynasty (1550–1295 BC). Limestone, H. 113 cm. This bust of a woman wearing a Hathor-like wig joins a base still preserved in the Temple of Amun at Karnak. Hieroglyphs indicate that she is one of the queens of Amenhotep I, Ahmose-Merytamun. She, along with her sister Sitamun, was both wife and sister of the pharaoh, and the statue base names both of them. This generic statue may therefore represent two queens in one.

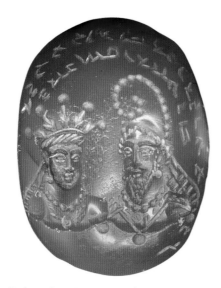

A number of infamous women from antiquity – Jezebel, Aspasia, Cleopatra, Messalina – bear names synonymous with sexual promiscuity, manipulation and treachery. It may be a truism that well-behaved women do not make history, but like many of the tales told by men about women, their flaws (and virtues) are often exaggerated at the expense of their true contributions to history and culture. We hear of the extremes – on the one hand the loyal, steadfast wives, beginning with Homer's creation Penelope and resurfacing in quasi-historical women such as Lucretia, and on the other the crafty, sexy seductresses such as Circe and Salome.

The most prominent women in antiquity were the wives of rulers, kings and emperors, who were regularly portrayed in their official roles alongside their husbands. The royal women whom we will examine in this chapter are queens

Kushano-Sasanian stamp seal, *c.* AD 300–350. Carnelian, L. 3.3 cm. A royal couple is presented on this small seal: the queen on the left wears a radiate crown while the king on the right has a prominent cap. Both wear earrings and a necklace. The inscription identifies the woman as 'Indamic, Queen of Zacanta'.

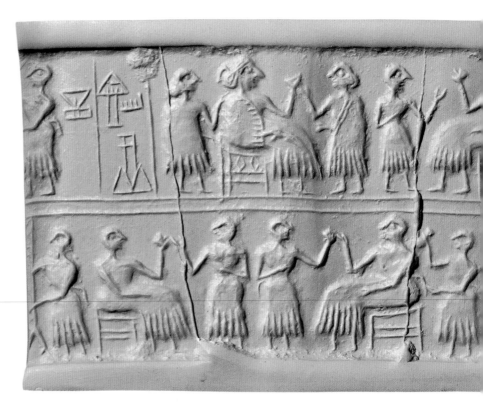

and empresses who wielded considerable political clout in the ancient world. Through their advantageous marriages and their male offspring, they managed to have no small impact on affairs of state. Some commissioned major works of art and so made a lasting impact on the cultural history of antiquity. Some travelled far from their native lands for arranged marriages to foreign royalty; others usurped power in their own kingdoms. Some, like latter-day Amazons, led troops into battle, while others, no less famous, stayed at home and worked behind the scenes.

It was not uncommon for male rulers to arrange politically astute marriages with foreign women. Such unions cemented political alliances or helped bring conquered lands into submission. The powerful Hittite king Hattusili III married a Hurrian priestess, Puduhepa, from Kizzuwatna in south-eastern Anatolia;

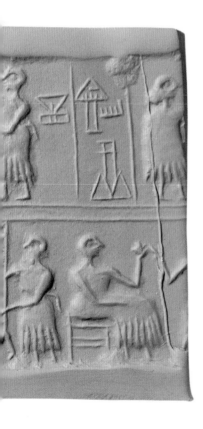

Mesopotamian cylinder seal, Early Dynastic III, *c.* 2600 BC. Lapis lazuli, H. 4.9 cm. This cylinder seal was found by the right arm of the Mesopotamian queen Pu-abi in her burial in the famous 'death pit' at Ur. Unusually for these seals belonging to women, her husband's name is not mentioned. The seated woman receiving a cup from an attendant on the upper frieze may be the queen herself.

Celtic torc, Iron Age, *c*. 75 BC. Electrum, diam. 19.7 cm. Found while ploughing near Snettisham, Norfolk, in 1950, this astonishing neck ornament may be the type said to have been worn by Boudica. The Roman historian Cassius Dio describes the tribal queen charging into battle wearing such a torc as a symbol of her leadership.

he in turn gave his daughter in marriage to the Egyptian pharaoh Ramses II after the conclusion of a peace treaty. Much of Puduhepa's correspondence survives and tells of her efforts to introduce her native Hurrian religion to the Hittites. The queen of Mesopotamia, Pu-abi, whose unplundered tomb was discovered by Leonard Woolley in 1927, is considered to be Akkadian and possibly a queen in her own right. Forensic examination of her remains indicates that she was about forty at her death and was less than five feet tall. She was buried in a cape made up of 1,600 beads and a gold headdress consisting of eight yards of gold ribbon, prompting Woolley to quip, 'I'm sick to death of getting out gold headdresses'. Accompanying her were numerous male and female attendants, their skulls pierced with an axe-like instrument, and a cart with its two oxen still in their traces.

Another powerful foreign queen in the ancient Near East was the Assyrian Sammuramat, known in Greek as Semiramis. She was the wife of Shamshi-Adad V, and when he died, she became regent for their son Adad-nirari. A stela documents the fact that she accompanied her husband on a military campaign, an activity otherwise unheard of in Assyrian history. A woman who led a major insurrection against Roman authority was the queen of the Iceni tribe in Roman Britain, known as Boudica, a name signifying 'victory'. Two Roman authors,

WOMEN IN THE ANCIENT WORLD

Tacitus and Cassius Dio, record her history and appearance: 'In stature she was very tall, in appearance most terrifying, in the glance of her eye most fierce, and her voice was harsh; a mass of bright red hair fell to her hips.' When her husband died the Romans ignored his will, which stipulated that their two young daughters be co-rulers of the tribe with the emperor Nero. Reputedly, Boudica was flogged and the two girls raped, even though rape was a capital offence according to Roman law. The incensed tribes revolted in AD 60, and chose Boudica as their leader. She was successful in destroying three Roman towns, one of which was the relatively newly established London. Because the Britons took no prisoners, the Roman dead numbered in the tens of thousands and the punishment meted out to women was particularly barbaric: the noblest women were hung up naked and had their breasts cut off and sewn to their mouths, and afterwards were impaled on long skewers lengthwise running through the entire body, all to the accompaniment of sacrifices, banquets and wanton behaviour. After her defeat, Boudica, like Cleopatra before her, reputedly killed herself so she would not be taken captive.

There are few women in antiquity who ruled in their own right. Beginning her career as Thutmose II's queen, Hatshepsut went on to assume the role of co-pharaoh on her husband's death and ruled Egypt for two decades (c. 1479–1458 BC). She bolstered her legitimacy by adopting a male persona and taking up the pharaonic symbols of authority; she had herself depicted in male dress, a kilt rather than a dress, and a false beard, wearing the various crowns of Egypt, smiting foreign captives, spearing fish and celebrating festivals of the gods. She set up obelisks at Karnak and had herself portrayed as offering directly to the gods, both usually the prerogative of kings. She had a peaceful and prosperous reign and was an extraordinary builder; her mortuary temple complex on the west bank at Thebes is one of the greatest extant buildings in Egypt. Because there was no

Egyptian statue, possibly from Karnak, 18th Dynasty (1550–1295 BC). Granite, H. 72.5 cm. The pharaoh-queen Hatshepsut commissioned this unique statue for her chief steward Senenmut, who was also the tutor of her daughter Princess Neferure. This high official gently enfolds the young girl in his cloak in a gesture of protection.

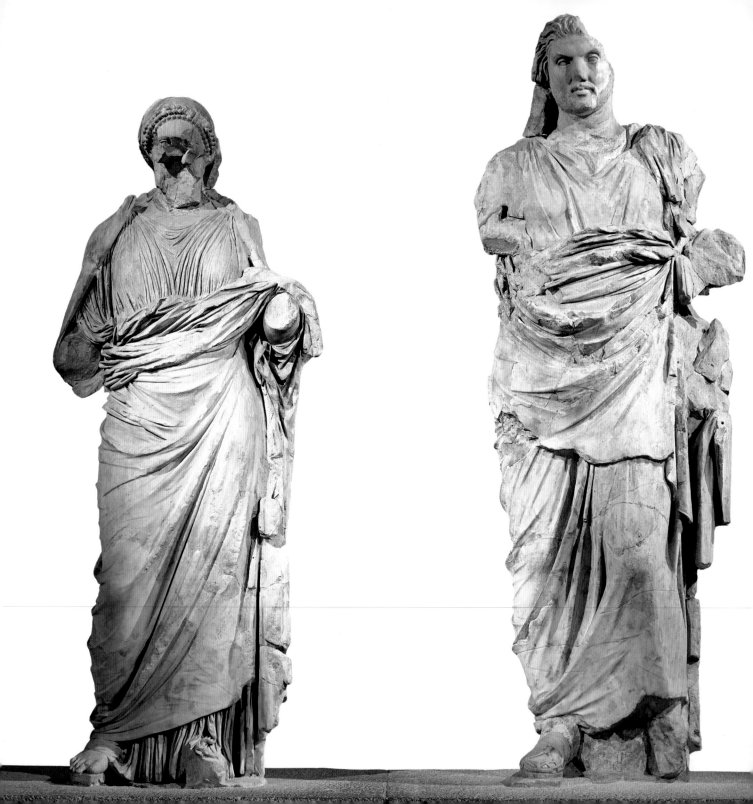

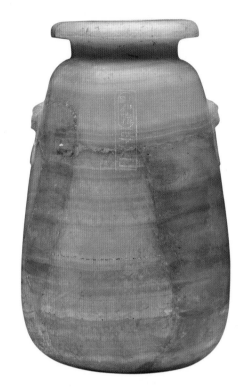

Greek statues, from the Mausoleum at Halicarnassus, *c.* 350 BC. Marble, H. 300 cm (max). The regal over-life-size female on the left is often identified as Artemisia, the sister and wife of the Carian king Mausolus, although she could be any member of the royal family. Artemisia commissioned the famous tomb, which became one of the seven wonders of the ancient world, for her husband. By Roman times, 'mausoleum' had become a generic term for any large tomb building.

Achaemenid *alabastron* (jar), from the Mausoleum at Halicarnassus, *c.* 480 BC. Calcite, H. 28.8 cm. This ointment jar is inscribed in four languages with the name of King Xerxes. It was almost certainly a gift to Artemisia I from the king for her services on behalf of Persia at the battle of Salamis, and kept as an heirloom until it was deposited in the mausoleum over a hundred years later.

place in Egyptian ideology for a female pharaoh, Hatshepsut had to take on a male persona. Long after her death her successor mutilated her monuments and erased her name, perhaps because a woman's rule did not conform to *maat*, the natural order of the world.

Another queen who was an active participant in warfare was Artemisia I, who became ruler of Halicarnassus and a Persian ally on the death of her husband. She commanded five ships on the side of the Persian king Xerxes against the Greeks at the battle of Salamis in 490 BC. The Greek historian Herodotus states that she went to war because of her personal determination and bravery, and that the advice she gave to the Persian king was the best of all the commanders. If Xerxes had followed her recommendation not to take on the Greek navy at Salamis, the Persian wars may have resulted in the enslavement of Greece. When he saw her sink a ship, Xerxes is said to have remarked, 'My men have become women, and my women men'. A token of Artemisia's friendship with Xerxes may survive in an inscribed jar found in the tomb of her successor Artemisia II and her husband Mausolus. By 350 BC it was more than a hundred years old and clearly a valued family heirloom of the Carian dynasty. The later Artemisia is best known for her devotion to her brother/husband who predeceased her; she not only built him an unprecedentedly lavish tomb covered with sculpture, but she reputedly drank his ashes in her wine every day.

Livia Julia Augusta (58 BC–AD 29) was not only the wife of the Roman emperor Augustus, but was the mother, grandmother and great-grandmother of future emperors. In ancient Rome, where men held all the major priesthoods, she was, remarkably, made priestess after the death of Augustus. She was also the first woman in western history to be commemorated systematically in official

FOLLOWING PAGES, LEFT TO RIGHT:
Head from a Roman statue of Livia, from Sicily, AD 30–50. Marble, H. 32.1 cm. Here the empress Livia is highly idealized and portrayed in the guise of the goddess Ceres with a classicizing hairstyle.

Roman portrait head of Livia, *c.* 30 BC. Marble, H. 27.9 cm. In this portrait Augustus's wife Livia is shown with a simple, matronly hairdo, known as the *nodus* style. It is characterized by a section of hair forming a roll over the forehead.

Roman counter, 1st century BC–1st century AD. Bone or ivory, diam. 2.8 cm. This gaming piece has a caricatured female bust on one side and the name Livia inscribed on the other. She is shown with a wrinkled brow, prominent Roman nose and angular chin.

Octadrachm of Arsinoe II Philadelphus, minted at Tyre, 285–246 BC. Gold, diam. 3 cm. Minted by Ptolemy II in honour of his sister and wife Arsinoe, this large denomination gold coin bears the queen's portrait on one side and her special symbol, the double cornucopia on the other. Filled with the fruits of Egypt it symbolizes the queen's role as provider.

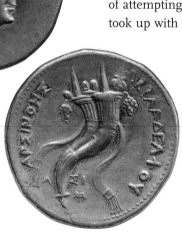

portraiture. She was portrayed in a variety of sculptures in her own right, not simply as an adjunct of her husband or son. Although she lived to the ripe old age of eighty-six, she is never shown wrinkled in her official portraits. At her death she had become one of the wealthiest women in Rome, with an estate of at least 68 million sesterces. (A soldier's annual wage at this time was 900 sesterces per year.) She was deified by her grandson Claudius in AD 42.

In the second century BC, Cato the Elder railed against the erection of statues of women, but with the advent of the imperial period women became more prominent socially and in the arts. More than a hundred images of the empress Livia survive, ranging from southern Spain to western Turkey and from coins to colossal heads. Typically she sports a conservative hairstyle consisting of a *nodus* (hair knot) at the forehead and a bun at the back.

It has been suggested that Livia derived her somewhat winsome appearance from the Greek-style portraits of the short-lived but much loved Ptolemaic queen Arsinoe II, who ruled Egypt from 278 to 270 BC. Before she married her brother Ptolemy II, Arsinoe had a somewhat notorious history. At sixteen she was married to the old Thracian king Lysimachos, who gave her large estates in the Aegean, including Ephesus. When she wrongly accused her husband's son of attempting to rape her, the king put him to death. After the king's death, she took up with her half-brother, who proceeded to murder her children while she

Hellenistic *oinochoe* (jug), from Canosa, c. 270–240 BC. Faience, H. 32.4 cm. When the Greeks came to Egypt they adopted the local ceramic technique of faience for their pottery. This jug celebrated the fortune of Arsinoe II as indicated by the inscription on the back. She is pouring a libation at an altar and holds her familiar double cornucopia. Her hair is in the typical melon coiffure, so called because the deep waves of the hair resemble the grooved sides of a melon.

WOMEN IN THE ANCIENT WORLD

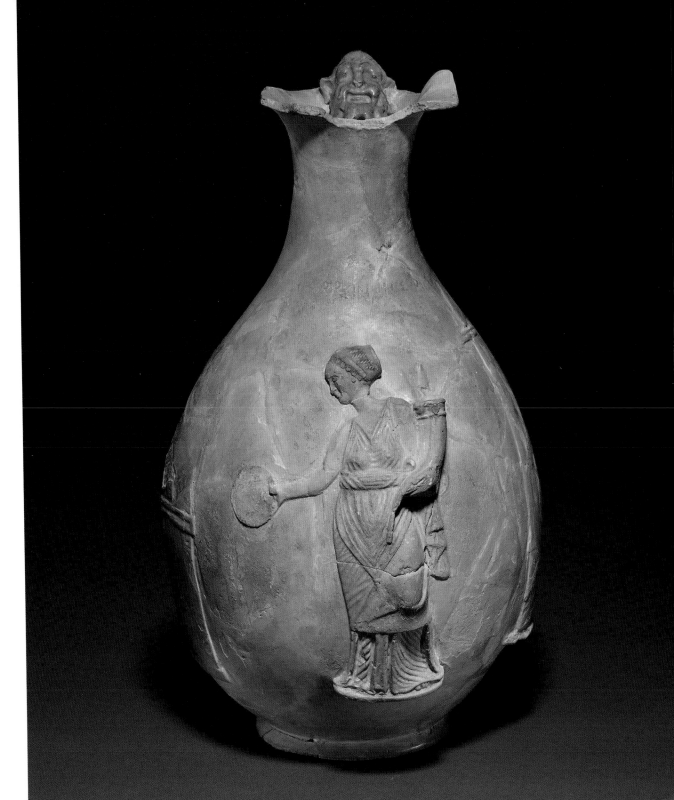

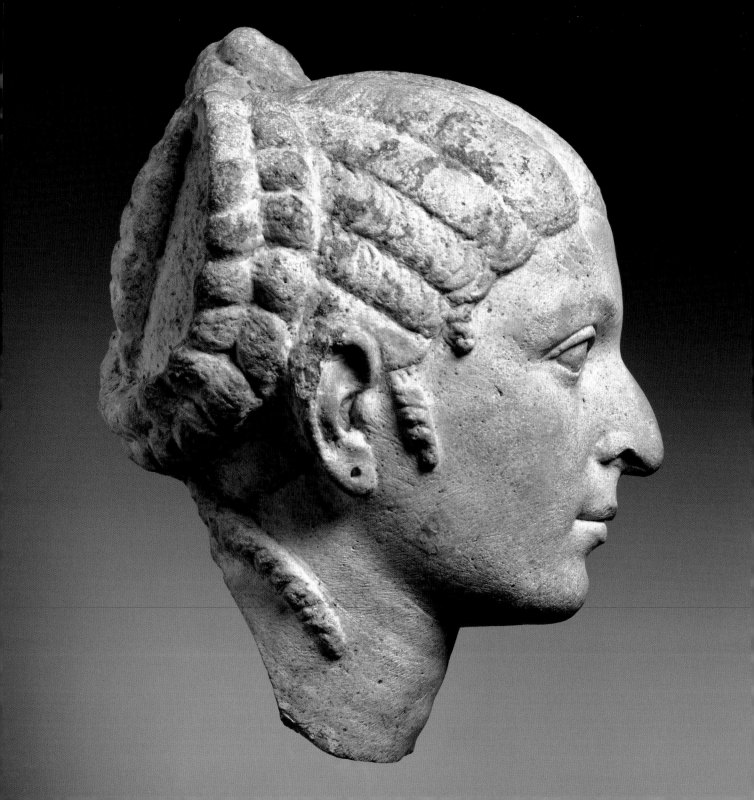

took refuge on the Greek island of Samothrace. Eventually she escaped back to Alexandria, where she married her brother Ptolemy II, who exiled his first wife Arsinoe I. On her death five years later she was honoured with poems, temples and festivals, and was the first Hellenistic queen to be deified in her own lifetime.

Perhaps the most famous woman from all antiquity is the last queen of independent Egypt, Cleopatra VII. Born into the politically weak and fractious family of the Ptolemies, she was nominally co-ruler with her father, her brothers and her sons for the twenty-one years of her rule (51–30 BC). Known as the 'Queen of Kings', she had love affairs with Julius Caesar and his later rival Mark Antony and bore children to both of them. She visited Rome for two years (46–44 BC) on the invitation of Caesar, and he erected a gilded statue of her in the Temple of Venus Genetrix as part of his new forum in the centre of the city. In 41 BC she had her momentous meeting with Mark Antony, who was widely known for his susceptibility to wine and the charms of women. Aided by the enormous resources of Egypt that Cleopatra put at his disposal, Mark Antony had military success in the east, leading to their joint confrontation with Octavian (later Augustus, Rome's first emperor) at the naval battle of Actium, off the coast of north-west Greece in 31 BC. They returned in defeat to Alexandria where Antony died in Cleopatra's arms, after his botched attempt at suicide. She mourned him extravagantly and offered a eulogy at his tomb. For her own death she undertook elaborate preparations, bathing and dressing in her finest clothes, before she applied the two venomous asps to her body. Afterwards, in his triumphal procession in Rome,

Hellenistic portrait head, 1st century BC. Limestone, H. 28 cm. Although she lacks a royal diadem, this portrait is sometimes identified as Cleopatra VII because of its resemblance to her many images on coins. She is portrayed with a strongly aquiline nose and pointed chin, but the hairstyle is not her usual one. The absence of royal insignia may have been deliberate on the part of the sitter, in an attempt to appeal to anti-monarchical Republican Romans.

Roman denarius, minted by Mark Antony, 32 BC. Silver, diam. 1.9 cm. Mark Antony minted coins with all three of his wives on the reverse. The inscription surrounding Cleopatra's head on this issue reads: CLEOPATRAE•REGINAE•REGVM•FILIORVM•REGVM (Cleopatra queen of kings, and of her sons who are kings).

Roman lamp, *c.* AD 40–80. Terracotta, L. 9.2 cm. As she rides a crocodile, this naked woman is shown squatting onto a huge phallus. Her facial features and hairstyle support the reading of this scene as an obscene caricature of Cleopatra.

Roman vessel, known as the Portland Vase, *c.* AD 1–25. Cameo glass, H. 24.5 cm. The most exquisite surviving example of Roman cameo glass, the Portland Vase has defied interpretation. The central character on each side is a half-draped reclining woman but whether the two are mythological figures or women with imperial connections is impossible to say.

Octavian paraded Antony and Cleopatra's children, a fate she spared herself by her suicide. Her effigy, however, showing her at the moment of her death, was triumphantly exhibited by her proud conqueror.

In Rome, and in its later art, Cleopatra came to embody the decadence, sensuousness, gluttony and general lack of self-control that Romans ascribed to the East. She was discredited as the seducer of the otherwise effective commander Antony. The invective includes Horace calling her a 'fatal monster', and Propertius referring to her as the 'harlot queen of incestuous Canopus'. It is these Roman writers who have shaped western perceptions of this remarkable woman. In contrast Cleopatra was held in high esteem in the medieval Arab sources, whose image of her is that of a strong and accomplished monarch who was protective of her country.

In a new interpretation of one of the most famous objects in the British Museum, the Augustan vessel known as the Portland Vase (after one of its modern owners) is seen as presenting the story of Cleopatra and Antony as an allegory. A nude young man is about to embrace a reclining female with a sea serpent at her side, while a bearded, elderly man looks on. The youth is identified as Mark Antony being lured by the wiles of Cleopatra (with the snake being an asp) into losing his manly *romanitas* and becoming decadent, and it is suggested that the older male is his mythical ancestor Anton (a figure sometimes interpreted as a personification of the Nile).

The famous portrait bust of 'Clytie' represents a fitting end to this book. She is all art and artifice, an idealized female: young, beautiful, demure and sexy. She casts her glance modestly away from the presumably male viewer while at the same time her slipped sleeve reveals her left breast and nipple. Her luxurious, untamed locks indicate that she is as yet unmarried, and her Venus-like perfect physiognomy aligns her with the goddesses of antiquity. She is both chaste and seductive, the maiden counterpart to the perfect matron Projecta with whom we began. In spite of the political and intellectual accomplishments of the historic women we have considered in this chapter, in most of antiquity females were valued for their potential as industrious wives, fertile mothers, and sex partners. It is a pity that most of them are silent, but we are fortunate that so many works of art and artefacts survive to tell their stories.

Roman portrait bust, *c.* AD 40–50. Marble, H. 57.2 cm. Found near Naples, this bust of a young girl emerging from a flower is said to represent Antonia, the daughter of Mark Antony. The original owner, the British collector Charles Townley, named her 'Clytie', a nymph who was pursued by Helios and changed into a flower.

GLOSSARY

alabastron Greek term for a long, tubular perfume flask originally made of alabaster and imitated in pottery

amazon a female warrior in Greek mythology

amphora double-handed storage or transport jar of clay or bronze, especially for oil or wine

andron a principal room of the Greek house, often the men's dining room

archon basileus chief magistrate and overseer of Athenian state religion

arrephoros (pl. arrephoroi) Greek term for one of two young girls who assisted the priestess of Athena Polias in Athens and carried sacred objects in a nocturnal ritual

aryballos Greek term for a small globular perfume flask

auletris (pl. auletrides) Greek female who plays the *aulos*

aulos (pl. auloi) Greek musical instrument consisting of double pipes

Book of the Dead a modern term for a miscellaneous collection of formulas and incantations found inscribed on papyri which the Egyptians buried with their dead

cameo a gemstone with layers of different colours, carved in relief

canopic jars 1) in Egyptian art, a set of four vessels used to store the viscera of the deceased after mummification; 2) in Etruscan art, cinerary urns taking the semblance of human form

caryatid a female statue used in place of a column

chatelaine a chain for suspending small cosmetic implements, attached to a woman's dress

chiton Greek term for a linen tunic or dress, buttoned at the shoulders and girded at the waist

cista a cylindrical container, usually bronze, used for toiletries

Corinthian capital a column capital decorated with acanthus leaves and small volutes

cuneiform wedge-shaped characters used in the script of the ancient Near East

curse tablet a magic plaque, often made of lead, inscribed with curses directed against one's personal enemies

cylinder seal a small stone cylinder engraved in intaglio and used in the Near East to create an impression in wet clay

deben Egypt's basic unit of weight varying from 13 to 91 grams

denarius the standard silver coin in Rome

dextrarum iunctio Latin term meaning the clasping of right hands, a symbol of marriage

dioptra Latin term for vaginal speculum

drachma a Greek monetary unit, literally a 'fistful' of six *obols*, approximately a day's wage

electrum a naturally occurring alloy of silver and gold

epinetron Greek term for a semi-cylindrical thigh cover for women working wool

epithalamium a song or poem in honour of a bride and bridegroom

eros (pl. erotes) the winged god of love

faience a glazed frit, often blue in colour, used primarily in Egypt

fibula a dress pin or brooch used to fasten garments

flammeum Latin term for a large, reddish-yellow veil worn by a Roman bride

Forum Romanum open public space in the centre of Rome

freedwoman a female slave who has been manumitted to become a citizen

frieze horizontal band of low relief sculpture

fury one of the avenging spirits in classical mythology, usually female, winged and wielding snakes

gorgon one of three hideous female monsters endowed with wings and large fangs

gyne (pl. gynai) Greek term for a married woman

harem a group of females (relatives, concubines and servants) associated with one man, or the secluded place allotted to these women

harpy a monster with a woman's head and the body, wings and claws of a bird

hetaira (pl. hetairai) expensive prostitute, courtesan, usually free in status

hieroglyphics the pictorial script of the Egyptian priesthood

hieros gamos Greek term for a sacred wedding, usually of two divinities like Zeus and Hera

himation a woollen cloak, used by Greek women as an over-garment

hydria Greek term for a water jar with three handles

hydriaphoros Greek term for one who carries a *hydria* in a religious procession

infula Latin term for a red or white fillet (ribbon) of un-spun wool which represented ritual purity and so was worn by priestesses and vestal virgins

intaglio a hollow-cut gemstone

kadesh figure nude image of the Egyptian female divinity of sexual pleasure

kanephoros (pl. kanephoroi) a person who carries a *kanoun* or specifically an Athenian girl chosen to carry the basket on her head in a ritual procession

kanoun a high-handled basket used in Greek religious processions

klismos Greek term for a wooden chair with a high back

kohl black eye make-up used by men and women in Egypt

kore (pl. korai) Greek term for maiden; a standing draped female statue of the Archaic period

krater Greek term for a mixing bowl for wine and water

kylix Greek term for a shallow, two-handled drinking cup

lekythos (pl. lekythoi) Greek term for a narrow-necked container for perfumed oil

loomweight a stone or terracotta pierced weight tied to the warp threads of a loom to provide tension

loutrophoros Greek term for a water vessel used in the ritual bath of brides

maenad a female follower of Dionysos/Bacchus

matrona Latin term for a respectable, married woman

melon coiffure a female hairdo characterized by twisted lobes of hair encircling the head and which resembles the sections of a melon

mummy portrait painted portraits found on the faces of mummies in Roman Egypt, mostly in the Fayum region of Upper Egypt

nymphe Greek term meaning bride

obol Greek monetary unit; there were six *obols* in one *drachma*

oikos Greek term meaning household, both property and human family members

oinochoe Greek term for a wine jug

okytokion a Greek term for an amulet worn by pre-partum women to speed the birthing process

ostracon potsherd or stone chip used as a surface for drawing or writing

palla Latin term for a voluminous mantle, usually of wool, worn by women as an outer garment

papyrus (pl. papyri) document written on a sheet made from strips of the stems of the papyrus plant

parthenos Greek term for a virgin girl; an epithet of Athena

pelike a type of Greek vase derived from the amphora with a pear-shaped body and wide mouth

peplos a long woollen tunic pinned at shoulders, worn by Greek women

pharaoh supreme ruler of ancient Egypt

phiale a shallow bowl without handles used for making libations in Greek rituals

pithos Greek term for a large, ceramic storage jar

pontifex maximus chief priest of ancient Rome

porne (pl. pornai) Greek term for a low-class prostitute

prothesis Greek term for the laying out of the dead on a bier

pyxis (pl. pyxides) a covered box or box-like jar

repoussé hammered relief in metal work

sakkos Greek term for a hairnet or snood

sarcophagus a coffin made of stone, terracotta or wood

satrap the local ruler of a province of the classical Persian empire

scarab a small Egyptian amulet in hard stone or faience in the form of a sacred dung beetle, a symbol of resurrection

sestertius (pl. sestertii) Roman unit of accounting and a coin worth one quarter of a denarius

shekel Hebrew word for an ancient unit of weight, or a coin of this weight

sibyl a female prophet; one of ten famous prophetesses in the ancient world ranging from Babylonia to Italy

siren a hybrid creature in Greek mythology consisting of part woman, part bird, whose enchanting song lured sailors to their deaths

sistrum an Egyptian hand-held percussion instrument consisting of metal rods that jingle when shaken

spindle whorl a pierced stone or clay bead attached to the end of a stick to provide tension in spinning

stadium a track for a foot race and other athletic contests

stamnos Greek term for a ceramic storage jar with two handles

stamp seal a small stone carved in intaglio and used as a form of identification when stamped on to wet clay

stela an upright stone slab used as a gravestone or other free-standing commemorative marker, often decorated and inscribed

stola Latin term for a matron's long, sleeveless garment worn over a tunic and hung from the shoulders by straps

strophium (Greek, strophion) Latin term for a breast band which functions like a bra

symposium a Greek all-male gathering for the consumption of wine, music and poetry

terracotta baked clay used for figurines, vessels and roof tiles

tholia Greek term for a round sun hat

thyrsus an ivy-bedecked staff carried by the god Dionysos/Baccchus and his female followers

tutulus an Etruscan female hairstyle resembling a French bun atop the head; term is erroneously used for the rounded hat worn by Etruscan women

univira Latin term for a woman who has been married only once

usekhb a broad, beaded collar worn by Egyptian men and women

vagina dentata Latin term for toothed vagina

vestal virgin Roman priestess of Vesta, goddess of the hearth

votive offering an object dedicated or vowed to a deity

zone Greek term for a belt or waist band

GODDESSES

Aphrodite	Greek goddess of sexual love
Artemis	Greek virgin goddess of the hunt and animals
Astarte	Phoenician goddess of sexual love
Athena	Greek virgin goddess of wisdom, war and craft
Bastet	Egyptian goddess of the sun depicted in leonine form
Bona Dea	Roman goddess of fertility and healing
Ceres	Roman goddess of agriculture
Demeter	Greek goddess of agriculture
Diana	Roman virgin goddess of the hunt and moon
Eileithyia	Greek goddess of childbirth
Ge/Gaia	Greek goddess of the earth
Hathor	Egyptian goddess of love, music and dance
Hera	Greek goddess of marriage, wife of Zeus
Inanna	Sumerian goddess of sexual love, fertility and warfare
Ishtar	Assyrian and Babylonian goddess of sexual love, fertility and war
Isis	Egyptian goddess of motherhood, maternity and magic, wife of Osiris, mother of Horus
Minerva	Roman goddess of war, wisdom and craft
Persephone	Greek goddess of the underworld, daughter of Demeter, wife of Hades
Nike	Greek goddess of victory
Nut	Egyptian goddess of the sky
Taweret	Egyptian goddess of childbirth depicted as a hippopotamus
Turan	Etruscan goddess of sexual love
Venus	Roman goddess of sexual love
Vesta	Roman goddess of the hearth

FURTHER READING

GENERAL

E.W. Barber, *Women's Work: The First 20,000 Years. Women, Cloth and Society in Early Times*, New York 1994

A. Cameron and A. Kuhrt (eds), *Images of Women in Antiquity*, Detroit 1983

L. Cleland, M. Harlow and L. Llewellyn-Jones (eds), *The Clothed Body in the Ancient World*, Oxford 2005

M. Ehrenberg, *Women in Prehistory*, Norman, Oklahoma 1989

E. Fantham, H.P. Foley, N.B. Kampen, S.B. Pomeroy and H.A. Shapiro, *Women in the Classical World*, Oxford 1994

C.A. Faraone and L.K. McClure (eds), *Prostitutes and Courtesans in the Ancient World*, Madison 2006

R. Hawley and B. Levick (eds), *Women in Antiquity: New Assessments*, London 1995

S.R. Joshel and S. Murnaghan (eds), *Women and Slaves in Greco-Roman Culture*, London 1998

N.B. Kampen (ed.), *Sexuality in Ancient Art*, Cambridge 1996

G. Lerner, *The Creation of Patriarchy*, Oxford 1986

M. Parca and A. Tzanetou (eds), *Finding Persephone: Women's Rituals in the Ancient Mediterranean*, Bloomington, Indiana 2007

S.B. Pomeroy, *Goddesses, Whores, Wives, and Slaves: Women in Classical Antiquity*, New York 1975

P. Schmidt Pantel (ed.), *A History of Women: From Ancient Goddesses to Christian Saints*, Cambridge 1992

B. Vivante (ed.), *Women's Roles in Ancient Civilizations*, Westport, Connecticut 1999

TEXTS

M.B. Fant and M.R. Lefkowitz, *Women's Life in Greece and Rome*, Baltimore 1992

B. Lesko, *Women's Earliest Records from Ancient Egypt and Western Asia*, Atlanta 1989

J. Rowlandson (ed.), *Women and Society in Greek and Roman Egypt*, Cambridge 1998

NEAR EAST

Z. Bahrani, *Women of Babylon: Gender and Representation in Mesopotamia*, London 2001

M. Brosius, *Women in Ancient Persia*, Oxford 1996

B.A. Nakhai (ed.), *The World of Women in the Ancient and Classical Near East*, Newcastle upon Tyne 2008

M. Stol, *Birth in Babylonia and the Bible, Its Mediterranean Setting*, Groningen 2000

EGYPT

C. Graves-Brown (ed.), *Sex and Gender in Ancient Egypt*, Swansea 2008

R.M. Janssen and J.J. Janssen, *Growing Up and Getting Old in Ancient Egypt*, London 2007

L. Manniche, *Sexual Life in Ancient Egypt*, London 1997

G. Robins, *Women in Ancient Egypt*, Cambridge, Massachusetts 1993

S. Walker and P. Higgs (eds), *Cleopatra of Egypt: From History to Myth*, London 2001

GREECE

S. Blundell, *Women in Ancient Greece*, Cambridge, Massachusetts 1995

L.A. Dean-Jones, *Women's Bodies in Classical Greek Science*, Oxford 1994

M. Dillon, *Girls and Women in Classical Greek Religion*, London 2002

N. Kaltsas and A. Shapiro (eds), *Worshiping Women: Ritual and Reality in Classical Athens*, New York 2008

S. Lewis, *The Athenian Woman: An Iconographic Handbook*, London 2002

S.B. Pomeroy, *Spartan Women*, Oxford 2002

ROME

L. Allason-Jones, *Women in Roman Britain*, London 2005

G. Clark, *Women in Late Antiquity: Pagan and Christian Life Styles*, Oxford 1993

E. d'Ambra, *Roman Women*, Cambridge 2007

S. Dixon, *Reading Roman Women*, London 2001

A. Fraschetti (ed.), *Roman Women*, Chicago 2001

D.E.E. Kleiner and S.B. Matheson, *I Claudia: Women in Ancient Rome*, Austin 1996

K. Olson, *Dress and the Roman Woman: Self-presentation and Society*, London 2008

M. Wyke, *The Roman Mistress: Ancient and Modern Representations*, Oxford 2002

For further reading on specific objects in the British Museum, consult the British Museum website, www.britishmuseum.org, and the following books:

T.D.H. James, *British Museum Concise Introduction: Ancient Egypt*, London 2005

J. Neils, *British Museum Concise Introduction: Ancient Greece*, London 2008

N. Ramage and A. Ramage, *British Museum Concise Introduction: Ancient Rome*, London 2008

D. Williams, *Masterpieces of Classical Art*, London 2009

ILLUSTRATION REFERENCES

Except where otherwise stated, photographs are © The Trustees of the British Museum, courtesy of the Department of Photography and Imaging.

Page

1	GR 1926,0415.32
2	GR 1885,0316.1
4	ME 124954
10, 12	P&E 1866,1229.1
13	EA 59648 (Given by the British School of Archaeology, Egypt)
14	GR 1893,0627.1
15	GR 1805,0703.158
16	GR 1892,0518.2
17 (*left*)	EA 37173
17 (*right*)	GR 1877,0910.16–17
17 (*bottom*)	P&E 1866,1229.42
19	EA 6665
20–1	GR 1887,0402.1
23 (*left*)	P&E Palart.566 (Purchased with the assistance of the Christy Fund)
23 (*right*)	GR 1929,1014.1
24	ME 1919,0712.635
25	ME K.295
26–7	ME 118882
28	EA 35502 (Given by the Egypt Exploration Fund)
29	GR 1899,0219.1
30	GR 1881,0824.104 (Given through Claude Delaval Cobham)
31	GR 1884,0614.34
32	P&E 1986,1001.64
34	British Museum New Media Unit
36	ME 2003,0718.1 (Purchased with the assistance of the Heritage Lottery Fund, the Art Fund (with a grant from the Wolfson Foundation), Friends of the Ancient Near East, Sir Joseph Hotung Charitable Settlement, Seven Pillars of Wisdom Trust and the British Museum Friends)
37	GR 1843,1103.31
38	GR 1893,0303.1
39	GR 1856,1213.1
40	GR 1872,0604.1381
41	GR 1867,0508.1064
42 (*left*)	GR 1897,0401.42 (Bequeathed by Miss Emma Tourner Turner)
42 (*right*)	ME 1856,0909.60
43	P&E 1866,1229.24
44–5	GR 1856,1226.796 & 800 (Bequeathed by Sir William Temple)
46	GR 1897,0727.2
48	GR 1843,1103.76
49 (*left*)	ME 1925,0715.1
49 (*right*)	GR 1772,0302.15
50	GR 1867,0508.1048
51	GR 1926,0930.48
52–3	EA 10554,87 (Given by Mrs Edith Mary Greenfield)
54	EA 67186 (Given by the Egypt Exploration Society)
55	P&E 1904,0702.1
56, 58	ME C.150
60	GR 1805,0703.143
61	GR 1867,0508.1322
62	GR 1982,0302.58 (Given by the Wellcome Institute for the History of Medicine)
63	EA 1203
65	GR 1865,0103.27
66 (*left*)	ME 1924,0920.73
66 (*right*)	ME 1925,0615.4 (Given by Col A H Burn CIE OBE)
67	GR 1836,0224.173
68	GR 1864,1007.189
69	ME 1983,0101.46
70 (*left*)	P&E 1981,1102.1 (Given by A. Rook)
70 (*right*)	GR 1897,0401.1087 (Bequeathed by Miss Emma Tourner Turner)
71	EA 61062
72	ME 124954
73 (*left*)	EA 8506
73 (*right*)	ME 1884,0714.97
74	GR 1865,1118.119 (Given by Dr George Witt)
75	EA 24395
76 (*left*)	P&E 2009,8042.1
76 (*right*)	P&E 1986,0501.31
77 (*left*)	ME 1881,0701.93
77 (*right*)	Wellcome Library London
79	GR 1912,0522.1
80–1	GR 1858,0819.1
82	EA 10470,5 (Given by Sir Ernest A.T. Wallis Budge)
83	GR 1899,0721.1
84	GR 1884,0223.1
85	EA 65347 (Bequeathed by Sir Robert Ludwig Mond)
86	EA 9524
87	GR 1879,0624.1
88–9	GR 1805,0703.144
90	GR 1847,0424.19 (Given by 'Abd al-Majid)
92	GR 1876,0510.1
93	GR 1814,0704.566
94	ME 1937,0323.80 (Given by Sir Augustus Wollaston Franks)
95	GR 1873,0820.304
96	GR 1814,0704.1205 (epinetron); GR 2010,5006.453 (study)
98	EA 40915 (Given by the Egypt Exploration Fund)
99 (*left to right*)	GR 1864,107.136; GR 1856,0902.63; GR 1874,1110.18; GR 1864,1007.1935; GR 1966,0328.22 (Purchased with the assistance of the Shaw Fund)
100	GR 2000,0523.2 (Purchased with the assistance of the Caryatid Fund)
101	GR 1847,0806.58
102	GR 1885,1213.17
103	CM BNK,G.150 (Given by the Bank of England)
104	ME 1856,0903.791
105	EA 5114
106–7	EA 37984

108 (left) GR 1926,0415.32
108 (right) ME 1841,0726.173
109 GR 1865,0729.4
110 GR 1848,0619.7
111 GR 1873,0820.354
112 GR 1843,1103.9
113 (left) GR 1865,1213.1
113 (right) GR 1873,0915.9
114 ME 124908
115 (left) GR 1875,0309.9
115 (right) EA 32767
116 GR 1948,0501.144
117 GR 1836,0224.169
118 GR 1837,0609.53
119 GR 1843,1103.17
122, 124 GR 1948,0423.1
125 ME 1935,1207.366
126 GR 1971,0521.1
127 EA 27332
128 EA 65346 (Bequeathed by
 Sir Robert Ludwig Mond)
129 GR 1873,0820.638
130 ME 1951,0212.1
131 ME 1891,0113,E.1
132 EA 2572
133 GR 1836,0224.25
134 ME 1924,0724.1 (Given by
 the Art Fund)
135 EA 3077
136 EA 54388
137 GR 1859,0301.33
138 GR 1887,0725.1
139 GR 1874,1110.13
140 GR 1890,0519.7 (Given by
 Henry Martyn Kennard)
141 GR 1854,0810.5 (left);
 GR 1928,0117.49 (right;
 given by C.W. Scott)
142 GR 1856,1001.17
144 GR 1879,0712.13
145 P&E OA.245
146 (left) EA 2280
146 (right) EA 36314
147 (left) GR 1904,0204.1168
147 (right) GR 1898,0222.1
148 © Museum of London
149 (left) GR 1892,0718.5
149 (right) GR 1873,0820.2
150 (left) EA 30464

150 (right) GR 1861,1024.7
151 EA 55193 (Given by the
 Egypt Exploration Society)
152 ME N.898
154 EA 37532 (Given by the
 Egypt Exploration Society)
155 ME 1929,1017.223–5
156 (left) GR 1814,0704.856
156 (right) GR 1841,0301.5
158 GR 1872,0604.842 (sceptre),
 GR 1872,0604.146 (ring),
 GR 1872,0604.667 (necklace)
161 GR 1979,1108.1
162 ME 1848,0720.13
164 Repr. in D. Collon, *First Impressions:
 Cylinder Seals in the Ancient Near
 East*, London 2005, fig. 530.
165 EA 835
166 (left) EA 37887
166 (right) EA 38172
167 EA 20779–80
168 GR 2007,5001.1 (Purchased with
 contributions from the British
 Museum Friends and the Art Fund)
169 GR 1867,0508.1174
170 GR 1887,0725.31
170–1 GR 1816,0610.19
172 CM 1843,0116.749
173 (left) ME 1882,0918,A.3
173 (right) GR 1926,0412.1 (Given by
 E.R. Bevan)
174 GR 1838,0608.9
175 GR 1856,0512.14
176 GR 1865,1118.49 (Given by
 Dr George Witt)
177 GR 1856,1001.16
178 GR 1888,1115.2 (Given by the
 Cyprus Exploration Fund)
179 (top) EA 43215 (Given by the Egypt
 Exploration Fund)
179 (bottom) P&E 1978,0102.78
180 GR 1861,0523.2 (Given by George
 John James Gordon, 5th Earl of
 Aberdeen)
182 GR 1816,0610.209
183 GR 1814,0704.1284
185 GR 1867,0507.510
186, 188 ME 1856,0909.53
189 EA 93

190 ME 1870,1210.3
190–1 ME 1928,1010.235
192 P&E 1951,0402.2 (Purchased with
 the assistance of the Art Fund)
193 EA 174
194 GR 1857,1220.232–3
195 ME 1857,1220.1
196 GR 2000,0818.1 (Purchased with
 the assistance of the Duthie Fund,
 the Caryatid Fund and the Art Fund)
197 GR 1856,1226.1722 (Bequeathed
 by Sir William Temple)
198 (left) CM 1987,0649.134 (Bequeathed
 through the Art Fund)
198 (right) GR 1814,0704.1531.2
199 GR 1873,0820.389
200 GR 1879,0712.15
201 CM TC,p237.2.CleMA
202 GR 1865,1118.249 (Given by
 Dr George Witt)
203 GR 1945,0927.1 (Purchased with
 funds given by James Rose Vallentin)
205 GR 1805,0703.79

INDEX

Page numbers in *italics* refer to captions

abortion, 78
Achilles, *46*, 47, 78
acrobats, *32*, *93*
Adam, 36, 40, *40*
Adonis, 78, *177*
adultery, 25, 59, 64, *64*, 137
Agnes of Rome, saint, 47
Ahmose-Merytamun, Egyptian queen, *189*
Akkad, 25
Akkadian language, 25, 64
Amazons, 43, *44*
Amenhotep I, Egyptian pharaoh, *189*
amulets, 19, 49, *49*, 76, *76*, *134*, 153
Amun, 108, 165; musicians of, 19, *127*, 129, *166*
Anatolia, 25
Antigone, 84
Aphrodite, 15, 40, 43, 78, 103, 132, 146, 164, *177*, *178*
Apollo, 172
Ariadne, 184
Aristophanes, 40, 174
Aristotle, 31, *132*
Arsinoe II, Egyptian queen, 198, *198*
Artemis, 31, 47, 74, 76, 148, 178
Artemisia I, 195, *195*
Artemisia II, 195, *195*
Ashur-bel-kala, Assyrian king, *42*
Ashursharrat, Assyrian queen, *188*
Aspasia, wife of Pericles, 115, 190
Assyria, 25, 28
Astarte, 40, *42*, 164
Athena, 31, 38, 43, 94, 124, 148, 160, 170–1

Athens, 15, 61, 64, 84, 94, 103, 113, 115, 116, 120, 137, 138, 160, 165, 170–1
 Constitution of, 104
 Parthenon frieze, 31, 137, 171, *171*
Attica, 170, 178
Augustus, Roman emperor, 33, 96, 137, 184, 195, 201–2

Babylon, 163–4
Babylonia, 25
Bacchus, 174
Bar-Uli, Elamite princess, 24
bathing, 148
beautification, *16*, 17, 124–6
benefaction, public, 189
Bes, 76, 150
Bona Dea, 177
Boudica, *192*, 192–3
breastfeeding, 54, *54*, 59, *70*, *73*, 100, *101*;
 see also wet-nursing
Britain, *33*, 47, *192*, 192–3
brothels, 115

Caesar, *see* Julius Caesar
Caligula, Roman emperor, 153, 184
Cassius Dio, *192*, 193
Cato the Elder, 198
census records, 64, 188
Ceres, 51, *195*
childbirth, 59, 71, *71*, 74, 76–7, 100
childcare, 59, 69, 100, *100–1*
Circe, 38, *38*, 190
Claudius, Roman emperor, 184, 198
clay tablets, *16*, 25, *25*, 28, *77*, 96–7, 164
Cleopatra VII, Egyptian queen, 28, 40, 63, 190, 201–2, *201*, *202*, 204
Clytemnestra, 47

'Clytie', 204, *204*
concubines, 66
Constantinople, 43, *43*
contraception, 78
copulation, 64, 66, *66*
Corinth, 115
cosmetics, 148–9
costume, 132–40
Crete, 24, 137
Cumae, 172
Cyprus, 59, 69, *178*

dancers, 103, *106*, 108, *108*, *110*, 113, *113*, 115
death, 78–86
Deir el-Bahri, 66
Delphi, oracle of Apollo, 172, *172*
Demeter, 51, *51*, 169, 170, 174, 177
depilation, 146
dextrarum iunctio, 15, *15*, *32*, *61*
Diana, 76
Diocletian, Roman emperor, 92
Dionysos, *118*, 120, 165, 174, *174*, *175*, 184
divorce, 59, 64
Drusilla, *see* Julia Drusilla

education, *31*, 93, 121
Egypt, 28 *and passim*; see also individual place-names
Eileithyia, 76, *183*
Eros/*erotes*, 13, *17*, 18, *61*, 103, *143*
Etruria, *32* *and passim*
Eumachia, Roman benefactress, 189
Euripides, 51, 76, 94, 174
Eurycleia, 38, 69, 100
Eve, 40, *40*

femmes fatales, 40–3
fertility, 51, 69, *125*
festivals, religious, 108, 120, 174–6
food production, 97, *98*, *99*
footwear, 138
forensic science, 19, 22, 192
fountain house, 116–20
funerals, 82, 103, 108
funerary portraits, 15, *15*, *18*, 19, *19*, 22,
 31, 32, *78*, *85*, *86*, *86*, 96, *124*, 126–32,
 127–31, *168*, *174*
Furies, 49

Ge/Gaia, 51
Geb, 51, *52*
genitals, terms for female, 64
Gilgamesh, epic of, 25, 36, 40
Girsu, 93, 96
gladiators, female, 92, *92*
Greece, 31 *and passim*; see also individual
 place-names

hair, 143–6
Halicarnassus, 195
Hammurabi, Code of, 25
Hathor, 153, *166*, 169, *179*
Hatshepsut, Egyptian pharaoh-queen, 193,
 193, 195
Hattusili III, Hittite king, 191
Hekat, 76
Helen, queen of Sparta, *28*, 40, 96
Hera, 17, 31, 61, 63, *92*, 93, 124–5, 132, 160
Herodotus, 31, 94, 120, 163–4, 195
Hesiod, 31, 40, 51
Hippocratic scientists, 77–8
Homer, 94; *Iliad*, 17, 124, 132;
 Odyssey, 36, 38, 69, 96, 100, 116
Horus, 54, *54*
Hypatia of Alexandria, 92

Iliad, *see* Homer
Inanna, 78, 125
incest, 63–4

infertility, 49, 59, 64
Io, 160
Iphigenia, 47, 184
Ishtar, 36, 40, *42*, 43, *66*, 78, 108, 164
Isis, 47, 54, *54*, 63, 78, 82, 173, *173*

Jason, 47, *48*
jewellery, 151–7
Jocasta, 47
Julia Drusilla, sister of Caligula, 184, *184*
Julius Caesar, 184, 201
Juvenal, 143, 174

Karnak, 169, *189*, 193
Kyniska of Sparta, 188–9

Lamashtu, 49, *49*
Lamia, 49
Lesbos, 103
Lilith, 36
Lilitu, 36
Livia, wife of Augustus, 33, 96, 184, 195,
 195, 198, *198*
Lucretia, 47, 96, 190
Lysimache, priestess, 170, *170*

make-up, *see* cosmetics
Mark Antony, 201, 204
marriage, 59–64, 69; contracts, 16, 25, *25*,
 59
martyrs, 47
Mausolus, Carian king, 195, *195*
Medea, 40, 47, *48*, 76
medical instruments, 77, *77*
medicine, 100
Medusa, 49, *51*
Mentuhotep II, Egyptian pharaoh, 66
Mesopotamia, 25, 28 *and passim*
Middle Assyrian Laws, 138
midwives, 74, 76–7, 100
millinery, 137
mirrors, *17*, 17–18, 32, 146, *146*
misogyny, 31, 49–51

Mormo, 49
mothers, 32, 54, 59, 69–76
mourners, 78–84
musicians, 103–4, *103–6*, 169

Nausicaa, 38, 148
Near East, 24–8 *and passim*; see also
 individual place-names
Nero, Roman emperor, 193
nursemaids, *see* childcare
nursing, *see* breastfeeding
Nut, 51, *52*

Octavian, *see* Augustus
Odysseus, *36*, 38, *38*, 69, 100, 103, 116, 148
Odyssey, *see* Homer
Olympia, 92, 93, 188–9
Osiris, 22, 47, 63, 78

Pandora, *38*, 40
Penelope, 38, 69, 82, 96, 116, 190
perfume, 150–1
Persephone, 51, 59
Persia, 25, 66, 195
Phaedra, 47
Phoenicia, 59
polygamy, 63
Polyxena, *46*, 47, 78
Pompeii, 115, 140, 148, 189
Portland Vase, *202*, 204
pregnancy, 71, *73*
prehistory, 22–4
priestesses, 31, 160, 164–71
Projecta's casket, *12*, 12–13, 17–18
prostitution, 115;
 'sacred prostitution', 163–4
Ptolemy II, Egyptian pharaoh, 198, 201
Pu-abi, Mesopotamian queen, 151, *191*,
 192
Puduhepa, Hittite queen, 191–2
Pylos, 96–7
Pythia, 172

'Queen of the Night', 36, *36*

Ramses II, Egyptian pharaoh, 192
remarriage, 64, 84
Rome, 12 *and passim*

Salamis, battle of, 195, *195*
Salome, 108, 190
Sammuramat, Assyrian queen, 192
Sappho, 103, *103*
Semiramis, *see* Sammuramat
service economy, 93–4
sex goddesses, 13, 15, 24, 36, *42*
sexuality, female, 64
Shamshi-Adad V, Assyrian king, 192
Sibyls, 172, *172*
Sirens, *36*, 38
Sitamun, Egyptian queen, *189*
slaves, 62, 116
social status, 15, 18, 25, 28, 32, 120, *131*, 160
Soranus, 74, *77*, 100
Sparta, 61, 93, 140, 146, 188–9
Suetonius, 92
Sumer, 25

Tacitus, 100, 193
Talmud, 74
tattooing, *101*, *115*, 150
Taweret, *74*, 76, 153
textile production, 94–7
theatre, 108
Thebes (Egypt), 193
Thutmose II, Egyptian pharaoh, 193
Townley, Charles, *204*

undergarments, 140
Ur, 96; royal graves, 78, 151, *153*, *191*, 192
Uranus, 51
uterus, *see* womb

vagina dentata, *51*
veils, *15*, 22, 108, *108*, 138, *138*
Venus, 13, 15, 17, *17*, 18, 40, *124*, 146
Vesta, 161
Vestal Virgins, 47, 137, 160, 161, *161*, 163, 177
Virgin Mary, 54, *54*
virginity, 61
votives, 31, *74*, 76, 120, 164, 178, *178–83*

warriors, 43, *44*, 191–3, 195
weddings, *61*, 62, 103
wet-nursing, 100, *101*
wigs, 125, 126, *127*, 143, *143*, 146, *146*
witches, *38*, 47
wives, 15–16, 32, 59–66, 84, 138; rulers' wives, 190–1
womb, 74, *74*, 76, *76*, 77; 'wandering womb', 78
Woolley, Leonard, 151, 192
wool-working, *see* textile production

Xenophon, 92, *93*
Xerxes, Persian king, 195, *195*

Zeus, 17, 40, 61, 63, 124–5, 160, *183*